WHEN ELEPHANTS PAINT

The Quest of Two Russian Artists to Save the Elephants of Thailand

KOMAR AND MELAMID

WITH MIA FINEMAN

INTRODUCTION BY DAVE EGGERS

PHOTOGRAPHS BY JASON SCHMIDT

Perennial

An Imprint of HarperCollins*Publishers*

HarperCollins books may be purchased for educational, business, or sales promotional use.

For information please write:

Special Markets Department, HarperCollins Publishers Inc.,

10 East 53rd Street, New York, NY 10022.

FIRST EDITION

Library of Congress Cataloging-in-Publication Data is available.

ISBN 0-06-095352-7

00 01 02 03 04 RRD/❖ 10 9 8 7 6 5 4 3 2 1

WHEN ELEPHANTS PAINT

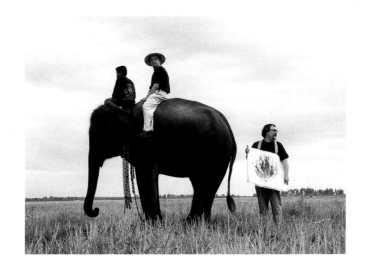

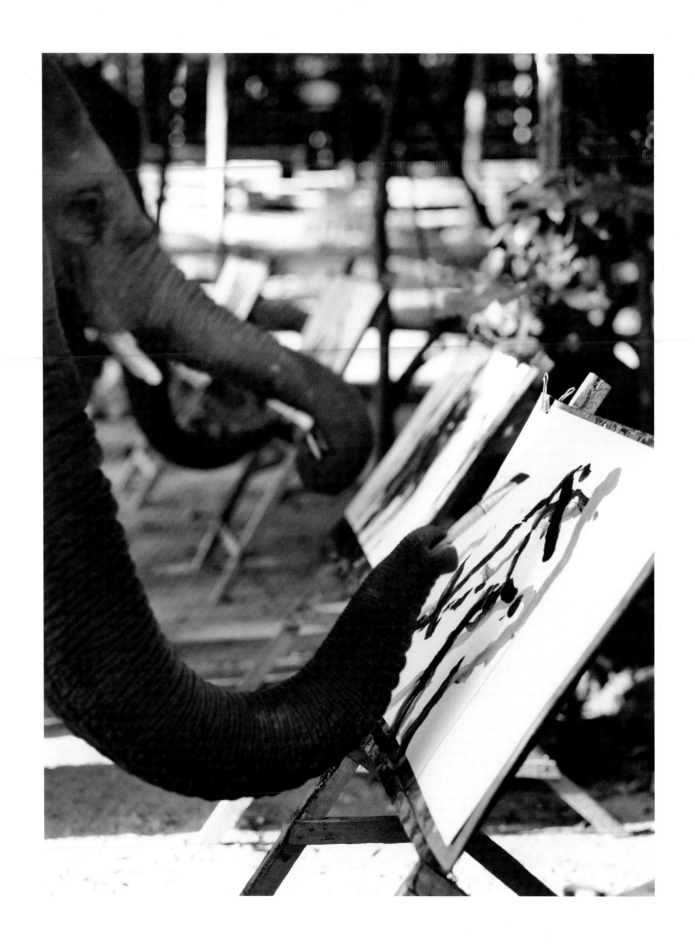

CONTENTS

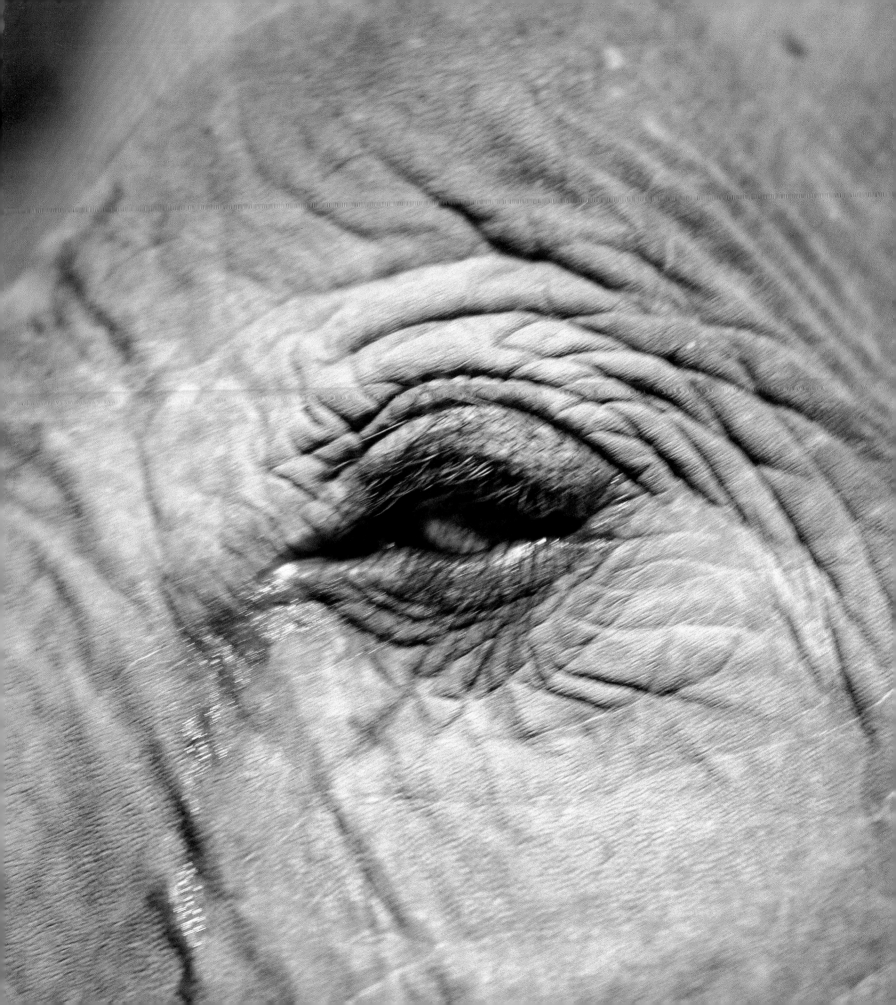

ACKNOWLEDGMENTS

The arduous process of turning what, at first blush, appears to be some kind of ludicrous joke into a concrete and beneficial reality has been, frankly, awe-inspiring. To everyone who, over the past five years, has been infected with the elephant art virus, to all the people who have bought, displayed, admired, and written about elephant paintings, we say, thank you! We are especially grateful to the members of the Asian Elephant Art and Conservation Project's honorary board of directors, who so bravely shrugged off the mockery of their friends and their own better judgment and allowed their good names to grace the project's masthead—a project that of course would not have been possible without the generous support of our illustrious patrons: Jim Ottaway, Nancy Abraham, Stuart Pivar, Christine Sperber, and Deborah Iskander. We owe special thanks to the World Wildlife Fund for standing behind the project from the beginning.

To the intrepid few who unstintingly devoted their time, energy, intelligence, and charm to making the project happen, who stayed up way past their bedtimes night after night, concocting brilliant schemes, and then woke up the next morning and turned their ideas into action, to the Elephant Girls—Linzy Emery, Amy Douthett, Rosemary Ewing, Jennifer Essen, Erika Kawalek—we say, thank you. We would like to marry all of you. We owe an enormous debt to the following friends who in a variety of ways left their mark on this project: Jane Bausman, Katya Arnold, Anna Halberstadt, Zinovy Zinik, Shafi Quraishy, Don RedFox, Elizabeth Hardwick, Elsa Longhauser, and Greta Gruber. We are sincerely grateful to Christie's, New York, for hosting the world's first auction of elephant art, and to the individuals on the volunteer auction committee who helped make this event such a success.

This book would be a sad and colorless thing without the brilliant photography of Jason Schmidt, who, despite a continuous collective hangover, made us rise before dawn every morning for three weeks. We extend our thanks to Todd Pruzan for his generous help with writing and research, to Alex Halberstadt for his translation, and to our agents, Chris Calhoun and Elyse Cheney. We are immensely grateful to our editor, David Hirshey, and his assistant, Jesse Gerstein, for their patience and perseverance, and to everyone at HarperCollins who had a hand in this thing.

In our travels throughout Thailand, we were fortunate to meet many individuals who generously shared their knowledge and elephant expertise. Our special thanks go to Manoonsak Tantiwat, Soraida Salwala, and Dr. Preecha Phuangkam in Lampang; Sompast Meepan and his crew in Ayutthaya; Pittaya Homkalitat in Surin; and the Forest Industry Organization of Thailand for its ongoing support of elephant art. We gratefully acknowledge the warm hospitality and exceptional largess of hoteliers Bilaibhan Sampatisiri, Khunying Chodchoy Sophanpanich, Marc Dumur, and Kamala Sukosol, who lightened our souls with song. For their generous cooperation and support we extend our thanks to Her Royal Highness the Princess Galiyani, William Warren and Ping Amranand, Robert Steele and the Chao Praya Barge Program, and Thai Air. To Richard Lair, elephant lover and bon vivant, we cannot say enough. He has guided us, inspired us, and drunk us under the table so many times that just thinking about it makes us dizzy.

Finally, we would like to thank the elephants and mahouts of Thailand for their hard work, patience, and unflagging good humor. This book is dedicated to them.

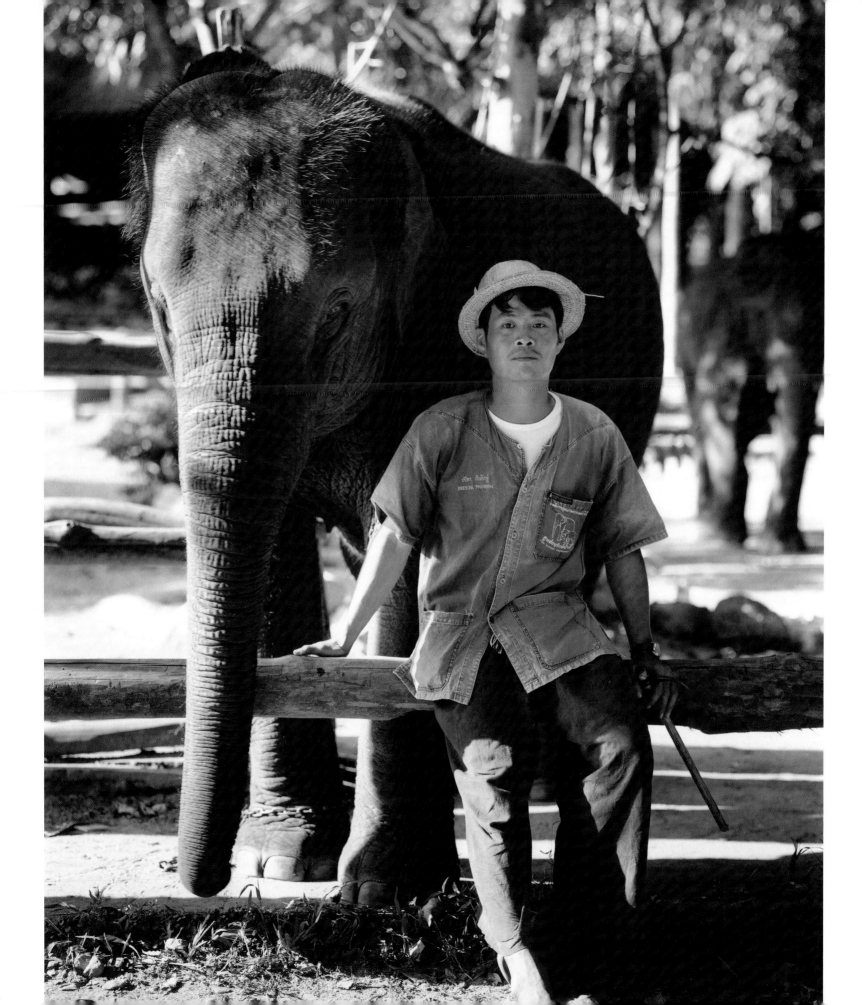

INTRODUCTION

We could have begun this Introduction a number of ways. I offer you choices below because you are Americans, and when fitted together, these beginnings might form, in your mind's eye, a beautiful mosaic, much like those they made in other countries in olden days. Janet Malcolm, please pick up the white courtesy phone.

BEGINNING 1

My interest in all of this started out in the art theory category. Was I interested in elephants and their plight? Well, now. I thought elephants were nice; if one came to my door looking for food, I would look in the pantry to see what I had. If an elephant stopped me on the street and needed some money, yes, I would give him or her whatever change I had handy—if they asked nicely, and did not block my exit from the inviolable space of the ATM area. And yet, overall, when I accompanied Komar and Melamid to Thailand in the summer of 1998 as they scouted locations for their elephant art schools, I intended to focus less on the elephants themselves, and instead more on the art-theoretical implications of Komar and Melamid's teaching elephants to paint. However . . .

BEGINNING 2

It was brutally hot in Thailand in July. Now, I am not old and decrepit or Russian, as Komar and Melamid are, and yet still I, as a healthy and robust American like yourself, was uncomfortable. I thought, immediately after landing in Bangkok—which is a very crowded place with many people living in it, the vast majority of whom ride motorcycles and scooters, all of which make the most high-pitched of motor sounds, all at once, at all hours of the day and night—I thought that I had made a mistake. I was writing a story for a magazine about Komar and Melamid's efforts, and once I had completed the flight to Bangkok, and had been relayed to a downtown hotel, I was exhausted and doubtful that any of this was such a good idea. Like most who hear about the project, I found it amusing but thought that they, Komar and Melamid, were, frankly, lying about it all. But I soon learned the following things:

1. That the truth at the heart of art is not a garden-variety sort. That the truth at the heart of art is not a simple thing.
2. and that Komar and Melamid, who at first blush seem glib, nihilistic even, are the opposite: They care more about their art, and art-making in general, than anyone, really. They are visionary, world-traveling art optimists who are not afraid of injecting a degree of levity into their relentless examination of what we consider art and what art does to us and for us. . . .

BEGINNING 3

People do not all seem to like when you mix fun and philanthropy. We know this from our high-flying fraternity and sorority days, and we know it by witnessing the trajectory of and response to Komar and Melamid's Asian Elephant Art and Conservation Project. People who want to endorse the aiding of the Thai elephants in peril are often put off by Komar and Melamid's solution, the teaching of these elephants to paint.

Conversely, many of the duo's longtime fans, who know of their taste for the absurd and the occasional very funny prank, want to chuckle at this elephant art notion and move on and are confused when informed that the project is not a joke at all, that the paintings are real, that the elephants are real, that the schools are real, that the benefits are tangible, concrete even.

Elephant artist Juthanam with his mahout Preeda Phundish.

BEGINNING 4

Again and again during that trip to Thailand and in the time since, Komar and Melamid have expressed their amazement at the progress of the project, how many people have joined their efforts, how many agencies have endorsed their plans, how many people have written about and bought elephant art. Did they know the project would take off as it did? That the schools would become real, that Christie's would auction the art to a packed house of art world glitterati? They did not. Did they know that their silly idea would be taken seriously at all? They sincerely hoped it would.

You can choose among those beginnings, but you sadly have only one choice for middles. Here it is:

MIDDLE

I traveled around Thailand with the Asian Elephant Art and Conservation Project and its ten-person entourage for nine days. There was much sweating, and the white minivan that took us from place to place featured a comically ineffectual impersonation of air-conditioning, and so all present were happy when it was announced that the trip's final destination would be Phuket, the country's lush resort island, where we would visit the elephants kept there, and swim in the soft and cool Andaman Sea.

On the way there, the van's passengers were engaged in a general discussion of the painting elephants, the prices their work might fetch, and how this would provide for them a pleasant and relaxing way of life. And this is when Alex Melamid, with a sigh, complained, as he very often does, about being "just a poor artist from New Jersey."

One among the entourage suggested that if Komar and Melamid concentrated more diligently on creating art within consistent parameters, exploring a narrower thematic and stylistic envelope, they could be very well off. After all, given their talent and classical training, their work, when they pushed their efforts into the four corners of the traditional canvas, was ravishing. Like most artists in any medium or genre, the passenger continued, Komar and Melamid should determine what their audience wants and produce it repeatedly. There is no money in doing the kind of nonsense that Komar and Melamid do. You can't make money by traveling around Thailand, sweating through your underwear, watching large gray mammals throw paint on canvas in rural Thailand. And it's worse when you give

any money made at the school to the elephants and their trainers. Komar and Melamid are talented men, but as businessmen they are morons. Their way is no way to make a living, and no way to accumulate wealth and lofts and summer homes. To do that your surest course is by making art that can be hung in the homes of wealthy people, and by doing so with little variation over a long period of time.

It does not pay to change much, or to experiment more than just a little outside one's oeuvre. Jackson Pollock dripped and tossed paint onto unprimed canvas, and people wanted and expected him to continue to do that ad infinitum (and for the most part, he did). Barnett Newman divided huge canvases with one vertical line—and made a career of it. It was 1961 when Roy Lichtenstein first created a large-scale version of a comic book panel. His first one-man show, at the Leo Castelli in 1962, though initially controversial, was soon embraced by all those who mattered, and he soon after became a blue-chip commodity, a leader of the Pop Art movement, a made man. For the next thirty-five years, until his death in 1997, Lichtenstein painted, with the occasional small tinkering with subject matter and style, the same picture—comic book dots, dialogue bubbles, stripes, etc.—roughly seven hundred times. For this he is eulogized as a modern master, and his pictures sell in the low millions. Not to disparage the man, but still—

Melamid, in the van, expressed his admiration for this sort of single-mindedness. "The painting stripes your whole life," he said, "this is ultimate brilliance, because it's suicide. It's like the monks, doing the same thing forever—it's key to immortality." Melamid giggled wildly, then stopped.

"It's funny, but it's tragic.

"Jackson Pollock, the first time he splashed paint on the canvas, it was exhilarating, but the third time, the fourth time? Every day, just to drip this paint—it's tragic. There was no way out. When the paint's flying in the air, he had all the freedom, but once it landed on the canvas, he lost all freedom. It's interesting that in search of freedom, they came up with the worst prison—the art world."

The Phuket landscape was drunkenly green, the foliage falling over itself. We were descending, heading into downtown Phuket.

"It's like the Russian Revolution," said Melamid, "this pursuit of freedom that went all sour—Communism was result." He mentioned Oleg Kulik, a Russian artist recently famous for occupying a gallery in Manhattan for two weeks, naked, acting like a dog. Wearing only a dog collar, Kulik crawled around, growled at passersby (he was on public view), and slept there, on the floor. Shortly after the performance, Kulik went back to Moscow, hoping to move on to

something else, explore other artistic impulses. The art world, however, had other plans.

"He was thinking, 'Maybe today I bark, maybe tomorrow I meow . . .'" Melamid said, giggling, "but art world says, 'No way! Shut up and bark!'"

Downtown Phuket was a disaster—an Asian Fort Lauderdale, but with a red-light district, always open. Not far from the meet-a-special-new-friend bars and around the corner from the new Titanic Pub, between a T-shirt shop and a film-developing outlet, there is a gallery. From the street we catch a glimpse of large Picassos, Renoirs, and Warhols and assume they are selling poster-sized reproductions of classic or at least well-known paintings, for use in one's new beachside condominium, over couch or toilet. But once we are inside the gallery, it is clear that it isn't a glorified poster shop at all. It is both a warehouse and a sweatshop for the making and sale of to-size oil reproductions of famous Western paintings. All over the walls—perfect copies of Lichtensteins, Hoppers, Boteros, Gauguins. The accuracy was startling. They all looked like originals. They were hung floor-to-ceiling, a crazy quilt of the century's greatest art hits. It was incredible.

Even more startling though, was that everything was being painted on-site. Just off the main showroom, six people, men and women, aged twenty-two to forty, were sitting in two rows, painting from tiny art-history-book reproductions taped to the corner of the canvas. Without using any sort of grid, or projector—freehand! unheard of!—they were rendering the paintings with uncanny fidelity. For instance, there, on the wall. It was perfect: a painting of a man, bald and in a grey suit, hands clasped behind his back, staring politely at what's obviously supposed to be a Jackson Pollock. The painting was a Norman Rockwell, a 1962 comment from the crotchety old illustrator on the incomprehensibility of modern art, a not unclever picture that did a neat job of re-creating a Pollock inside an otherwise realistic Rockwellian setting.

Of course, this was a *copy* of the Rockwell take on the Pollock, a copy rendered by a Thai craftsperson working shoulder-to-shoulder in sweltering heat between a T-shirt shop and a film-developing outlet, in a country that until ten years ago did not even have a word or expression for abstract art.

The mind reels. Does not the mind reel?

What could be more indicative of the state of the medium, in the way we commodify and sanctify (in that order, really) art, than this assembly-line art crafted by Thai artisans more technically adept than those they are aping (Rockwell used photographs), selling perfect reproductions of Western art masterpieces to overfed European tourists? Is it such a stretch, after all, when most artists spend much or most of their careers imitating themselves, to allow craftsmen to do it for them? Is there really such a difference between Botero's umpthousandth painting of rotund people frolicking, and a variation on the theme rendered in two or three hours by a twenty-two-year-old Thai drone? And most important, does either display more vigor or result from an inspiration any more profound than the work of Thai elephants? Melamid is amused by the gallery. "Yes, you see," he says, "people will say that is not great art. But these people are technically the best artists alive. They can do anything. But no one knows what art is. The pretending to know is the same as the pretending to know about God. Both rely on faith, faith that faith will heal and reward. And this is beautiful. The best kind of art is what we make of our faith. The faith is the art, you see?"

END

I would regret, if I were to leave the Introduction as I have, that I did not talk more about the realness of all of this. About the substantive changes in the lives of elephants and their trainers that have been realized as a result of this endeavor. I can't emphasize that enough. Or maybe I could, but it would take a long time, and you people are starting to bore me.

But finally, I also would posit this, which I think is the central point to much of this—a point that, if I had to do it over again, I would have made the central aspect of this Introduction (Damn!). My point would be that philanthropy, along with paintings done by large trunk-bearing mammals, can also be, and perhaps should also be, art. And great art at that. It is possible, therefore, to combine altruism and hard work and ingenuity on a micro level and still, on a macro level, be creating something that qualifies and succeeds as art. Conceptual art, sure. Conceptually philanthropic art maybe, or philanthropically conceptual art. Yes, conceptual art can be terrible. When it does not work, it is awful; but when it does—for example when people and animals are helped, when everyone is happy, when something has been changed and many things created, including thousands of paintings, often beautiful paintings, appropriate for any den or dining room—even if created in Thailand, where it is much too hot in the summer.

Do not go in July.

—Dave Eggers

WHEN ELEPHANTS PAINT

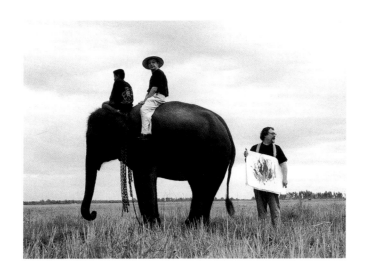

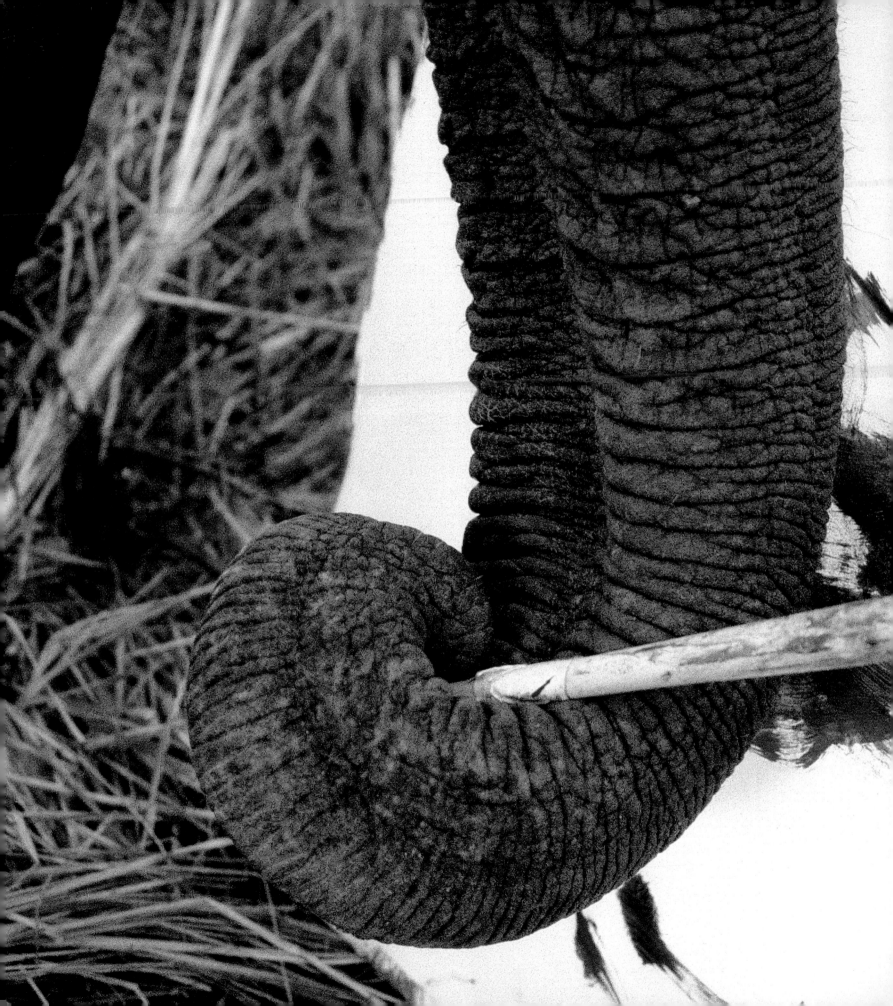

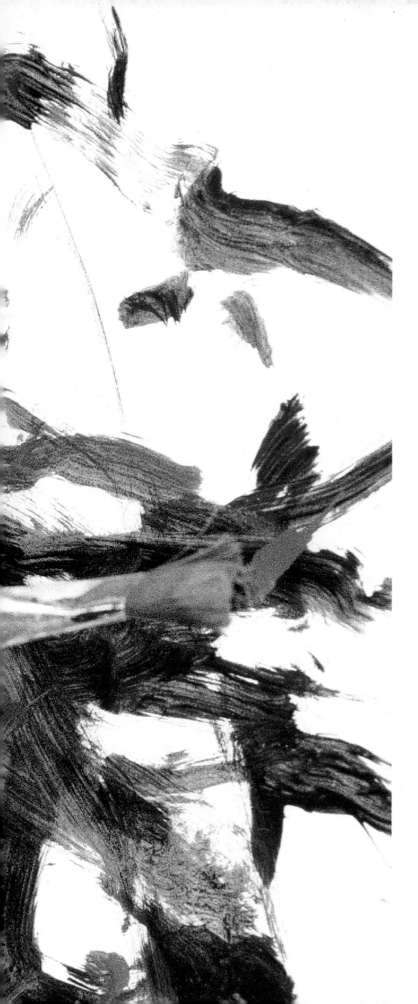

I.

EITHER THE GREATEST IDEA OF ALL TIME OR THE STUPIDEST BY FAR

Khunying Chodchoy Sophanpanich sits comfortably at the head of a long table in the restaurant of the posh Dusit Thani Hotel in downtown Bangkok, her face frozen in a polite smile. Thin as a rail, impeccably coifed, and dressed in an off-white suit with fist-sized gold buttons, she is among the richest and most powerful women in Thailand. (Khunying is an honorific title conferred by the royal family—the gender-neutral Thai equivalent of the British Sir or Dame.) The lobby of the hotel (which she owns) is cool and airy, with gleaming floor-to-ceiling windows that look out on a busy Bangkok street. Outside, cars and people and motorcycles seem to drift by in slow motion, swimming through the sticky, sidewalk-melting heat like bottom-dwelling fish in a giant aquarium.

KOMAR AND MELAMID IN AMERICA: THE FIRST THIRTY YEARS

1965

Vitaly Komar and Alexander Melamid meet at Moscow's Institute of Physical Culture, where both are drawing cadavers for their art class. Shortly thereafter they collaborate for the first time.

1971

Komar and Melamid become known for their satiric appropriation of socialist realism, a sort of Eastern European Pop Art known as "Sots Art."

1973

Double Self-Portrait, the artists' rendition of an iconic image of Lenin and Stalin from 1950, is destroyed by authorities in a Moscow exhibition henceforth known as the "Bulldozer Show."

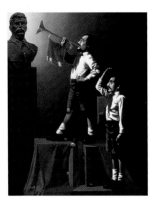

1975

The artists, frustrated at being denied visas to leave the country, convert Soviet passports into coding for symphonies and abstract canvases.

At the moment, Khunying Chodchoy is looking down at a colorful assortment of abstract paintings on paper which have been spread out on the table for her perusal—paintings that were executed a week earlier by a small struggling group of elephants in the northern Thai countryside. Seated to her left and right are two frazzled-looking Russian artists, Vitaly Komar and Alex Melamid, who, along with an enthusiastic entourage of journalists, filmmakers, art experts, animal experts, and various helpers and hangers-on, have traveled halfway around the world to save the elephants of Thailand by teaching them how to paint.

Like most wealthy Thais, Khunying Chodchoy is deeply concerned with the welfare of Thailand's elephants. Since the early nineteenth century, domesticated elephants were used to haul timber out of Thailand's roadless rainforests—a vocation that supported both the elephants and their lifelong handlers, called mahouts. But when massive deforestation led the Thai government to ban all logging in 1989, thousands of elephants and mahouts were left suddenly unemployed. As they scramble for survival, many of these elephants perform tricks for tourists by day and illegal heavy labor by night, leaving them exhausted and malnourished. And the lack of proper care has begun to take its toll—a population that once numbered in the tens of thousands has now dwindled to an estimated 1,500 wild and 3,000 domesticated elephants.

Khunying Chodchoy nods politely as Melamid, a wiry man in his mid-fifties, details his proposal with the adrenaline-fueled fervor of a televangelist. Komar and Melamid have come to Thailand to teach the nation's beleaguered domesticated elephants how to paint, to market their paintings worldwide, raising hundreds of thousands of dollars that will be distributed among the impoverished elephants and their mahouts. A key part of the plan—and the reason they are sitting here in the Dusit Thani with Khunying Chodchoy—is that hotels, each of which must decorate hundreds of rooms with inexpensive art, might buy elephant paintings in bulk. Then tourists visiting Thailand will see the paintings, inquire about their provenance, and will buy paintings of their own. Then they will bring them back to their own countries, further spreading the word of art-making elephants in Thailand, boosting sales worldwide, and ultimately turning what at first glance seems to be a laughably improbable idea into a stunning international reality.

"We want to flood the world with elephant art!" Melamid proclaims, his eyes blazing. "Our goal is to have thousands of elephants producing hundreds of thousands of paintings. For the first time in history, human art will get some competition. We live in a society, after all, that cherishes competition."

"But is all of this really feasible?" asks Khunying Chodchoy. "I mean, how much do the paintings sell for?"

"It varies. Last year an elephant in Arizona made $100,000 selling her paintings. But this is just the beginning. These elephants are incredibly prolific—sometimes they'll churn out thirty paintings in less than an hour. They don't think too much—that's what makes them such good artists."

Khunying Chodchoy raises a perfectly manicured hand. "Forgive me, I'm terribly sorry to interrupt, but the photographer from the *Bangkok Post* society page is here. Would you mind?"

The artists and their entourage rise and stand with their hostess in front of a large mural—an exact replica of an Audubon landscape of the Eastern United States, complete with birdlife native to that area. What it's doing in a Bangkok hotel is anyone's guess, but it seems eminently more logical than the music being piped in from above—a series of mutated versions of American pop songs from the seventies, altered to sound something like a cross between oriental chamber music and department store Muzak.

As everyone settles back into their seats, Melamid reaches under the table and pulls out a copy of the new, best-selling edition of Marx and Engels's *Communist Manifesto,* the cover of which features a painting of the waving red Soviet flag that Komar and Melamid did years ago. He presents it to Khunying Chodchoy.

"I didn't write it," he says, giggling, "but it's an interesting book, actually."

"I will treasure it," she says as she accepts the gift, smiling graciously. She picks up one of the paintings and looks at it intently. "These really are quite attractive. And your timing is impeccable—we're just in the process of redecorating. I'll have to speak to the designers, of course, but perhaps we can arrange to display a few of the paintings in the lobby—maybe over there, next to the elevators."

Komar and Melamid are beaming.

"Now, may I offer you some refreshments?" With a quick glance, Khunying Chodchoy beckons one of the dozen or so waiters who have been lingering near the table in rapt anticipation and, in perfect British-accented English, orders mango juice and ice cream for everyone.

Komar and Melamid emigrated to New York from the Soviet Union in 1978, and they have spent most of their joint thirty-year career cheerfully deflating whatever tyrannies of taste happened to cross their paths, from the ubiquitous agitprop of post-Stalinist Russia to the smug elitism and bloated self-importance of the contemporary art world. Both immensely skilled painters, Komar and Melamid are also restless experimenters who employ virtually any medium available, changing styles about as often as other artists change their clothes. Together, they have created a body of work remarkable in its scope and prickly complexity: conceptual yet rendered with a high degree of technical finesse; parodic yet essentially hopeful about the potential of art to examine, enlighten, and provoke; and unerring in its ability to root out the comic aspect of any subject—from Joseph Stalin to George Washington to the industrial wastelands of Bayonne, New Jersey.

Komar and Melamid met in a Moscow morgue in 1963. At the time, they were both students at the Stroganov Institute of Art and Design (named after the

1976–78

Komar and Melamid, finally granted visas, emigrate first to Israel and later to the United States. They settle in New York City.

AUCTION
THE FIRST AUCTION OF UN-OFFICIAL AMERICAN ART IN THE SOVIET UNION SIMULTANEOUSLY IN NEW YORK AND MOSCOW ON SATURDAY, MAY 19, 1979, 12:00 P.M. NEW YORK TIME

KOMAR AND MELAMID
WE BUY AND SELL AMERICAN SOULS. 18 OF THE CORPORATION'S FINEST SOULS HAVE BEEN SELECTED FOR THIS AUCTION. ANDY WARHOL, ETC.

RONALD FELDMAN FINE ARTS
420 WEST BROADWAY, 5TH FLOOR

1978

Komar and Melamid attend their first opening at the Ronald Feldman Gallery in Manhattan. After setting up Komar and Melamid Inc., the artists announce a project trading human souls. Andy Warhol's sells to a Moscow bidder for 30 rubles.

1980–84

The artists produce a series of large dark paintings in the style of "Nostalgic Socialist Realism," looking back to the "Stalin time" of their childhoods.

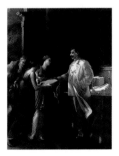

1991

Komar and Melamid paint a large mural of the Annunciation and Crucifixion above the altar of the Holy Rosary Church in Jersey City, New Jersey.

1993

In December telephone surveys begin for the first "most wanted" painting.

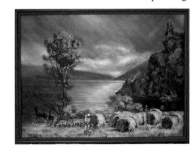

nineteenth-century Russian aristocrat better known for his culinary namesake) where they were rigorously trained in the state-sanctioned style of socialist realism, churning out heroic images of robust Russian workers gazing confidently at the perpetually blue skies of a glorious socialist utopia. After eight hours of academy-style art classes, they would head out to a remote suburb of Moscow, where they spent their nights studying anatomy by drawing cadavers in the morgue of the Institute of Physical Culture. As they smoked cigarettes to offset the suffocating stench of formaldehyde, the two young artists bonded over a bottle of cheap Armenian cognac and discovered in each other a similar taste for sardonic comedy and a similar distaste for the rigidly imposed aesthetic dictates of the Party. They began collaborating a few years later, carving out a small space for themselves in the shadowy no-man's-land of samizdat culture. "We were very lonely, really," Komar recalls. "We were not part of official establishment, we were not part of left-liberal establishment. Later we became part of dissident movement. But nobody liked dissidents."

The two artists learned this firsthand when, after inventing a movement they called Sots Art (short for *sotsialisticheskii*, or socialist), a parodic Soviet version of American Pop Art, they were expelled from the Moscow Artists' Union, charged with "distortion of Soviet reality and deviation from the principles of socialist realism." They applied for exit visas repeatedly and were repeatedly turned down. In frustration, they retreated into a kind of inner exile, secretly producing art with a sharp satirical edge, which they sometimes exhibited in the privacy of friends' communal apartments. They renounced their Soviet citizenship and created their own nation, TransState, a federation of countries, each consisting of a single person, each with its own constitution, language, passport, and currency. They made a series of monochrome paintings that they claimed could cure impotence, obesity, insomnia, laziness, and alienation. They invented a one-eyed realist painter, Nikolai Buchomov, and fabricated his biography along with his life's work. Finally, in 1977, Komar and Melamid were granted visas to emigrate to Israel, and from there made their way to the United States.

Upon arriving in New York, Komar and Melamid were surprised to find they were already famous. While they were still in the Soviet Union, a New York art dealer, Ronald Feldman, had mounted a show of their work (smuggled past customs agents who mistook their brightly colored abstract canvases for tablecloths) that dazzled the critics and earned them instant notoriety as insurgent emissaries from the far side of the Iron Curtain. Instant celebrities, Komar and Melamid stumbled upon their singular knack for transforming the solemn rituals of high art into high comedy.

"Two weeks after we came to the United States," Komar recalled in an interview, "we realized that we had comedic careers. The Wadsworth Atheneum in Hartford, Connecticut, put on a show of our work, and we were invited to give a talk. Alex could speak a little English, I none. So they found a translator. They set up a podium with a microphone in a big auditorium full of people. Suddenly it was time to go on stage. My God."

"The translator said, 'Let's go,'" Melamid continued, "but Vitaly was like a stone. I tried to push him but he wouldn't move. We got out onto the stage and I tried to say something. 'Well-uh-we-uh.' And the translator said, 'Well-uh-we-uh,' and so on. The audience rocked with laughter. They were absolutely hysterical."

Melamid began to relax; he leaned on the podium and knocked it over with a huge crash. "The audience went completely wild," he recalled. "That's when I realized we were in a different world."

Melamid, now in his mid-fifties, is wiry and kinetic and expansively articulate. For several years he sported heavy black glasses and a thick reddish mustache that earned him frequent comparisons to Groucho Marx. Today, his bushy eyebrows and electrified mop of graying hair place him closer to the mad-scientist look cultivated by Albert Einstein. He speaks English with a heavy Russian accent, and often underscores what he says with extravagant open-handed gestures. When addressing an audience of three or more, he tends to hold forth like the charismatic leader of a very small country, mesmerizing his listeners with a flood of rapid-fire pronouncements about history, literature, world politics, and the state of art, past and present, interspersed with modest descriptions of himself as "a poor artist from New Jersey" (where he now lives with his wife) and punctuated by droll one-liners, which are followed, more often than not, by his own wildly infectious giggle. Komar, two years older than his partner, is

ELEPHANT THE PAINTER

In 1947, at the request of the Ministry of Culture, Russian poet Sergei Mikhalkov wrote a book of fables for children. It quickly became required reading for all grade-school children in Russia, including two young boys named Vitaly Komar and Alexander Melamid.

One of the tales, shown below, involved an artistically inclined elephant who wanted to paint a picture that would appeal to all of his animal friends. Before he did so, however, he sought the opinions of all the other animals in the forest. "What would you like to see in a picture?" he asked.

Every animal had an opinion. The hedgehog declared that he would like to see many shrubs and logs in the picture. The pig requested a nice big mud puddle. The alligator wanted a blue, cloudless sky, while the walrus wanted a number of tall leafy trees.

The elephant took their feedback and went back to work—day and night he labored, for many weeks, honoring all of the animals' requests. For the hedgehog he painted beautiful shrubs and logs. For the pig there was a nice big mud puddle; for the alligator there was a blue sky; for the walrus an array of tall leafy trees. When he was finished, the elephant was quite confident that he had fulfilled all the desires of his animal friends. He could not wait to show it to them.

He gathered the animals around, and removed his handkerchief to unveil the picture. "Ta-da!" he said, expecting that they would shower him with praise and affection.

But they did no such thing. "Ick," said the pig, summing up the sentiments of all observers. "That wasn't what we had in mind, not at all." The elephant was perplexed. How could he have taken everyone's desires, mixed them together, and ended up with something no one liked?

Komar and Melamid hold a People's Choice town meeting in Ithaca, New York, 1994.

heavyset, slower and more deliberate in his movements. With his black horn-rimmed glasses and carefully trimmed goatee, he bears a vague resemblance to a nineteenth-century Viennese professor, and there is an old-world, professorial quality to his speech as well: leaning back slightly, hands folded over his ample belly, he is prone to erudite abstractions, sweeping theoretical statements, and spiraling mystical flights that effortlessly resolve themselves into well-wrought ironic non sequiturs.

In the early 1980s, Komar and Melamid began working out of a noisy studio on Canal Street, between Little Italy and Chinatown. ("Just like Russia," notes Melamid, "between Europe and Asia.") There they made a series of dark paintings of Stalin, the omnipresent "Uncle Joe" of their early childhoods, built up through thin glazes of oil paint in a re-creation—at once ironic and nostalgic—of the socialist realist style they had trained in. They held an international auction of

human souls, successfully selling the soul of Andy Warhol to a Moscow bidder for thirty rubles. They rented a bus and took groups of SoHo art mavens on tours of the sprawling steel mills and modest row houses of Bayonne, New Jersey. They painted a series of pictures of Lenin and George Washington, the founding fathers of their old and new countries.

More recently, they embarked on a massive project, The People's Choice, to explore the merits of democracy and its relation to the artistic impulse. The project began in earnest shortly before Christmas 1993 with an eleven-day telephone poll to American households. The survey gauged thousands of Americans' tastes in visual art to determine those features the majority particularly cherished (sweeping Hudson River Valley landscapes incorporating historic figures, nature, and themselves) and despised (tiny, hard-edged abstract canvases, thickly painted in dodgy colors like yellow, purple, mauve, and teal).

The resulting artworks, at once soothing, amusing, and startling, resulted in more surveys in countries from Iceland to Kenya, Canada to Ukraine—and more "wanted" and "unwanted" paintings; inevitably, an internet survey fostered poll-driven paintings displayed online. On its heels came a survey of popular musical tastes, preceding the 1997 release of the "most wanted" song in the world—a five-minute-long R & B love ballad calculated to be enjoyable to 72 percent of the world's audience—and its "most unwanted" counterpart, a twenty-two-minute piece combining an absurdist orchestra (banjo, tuba, harp, accordion) with irritating lyricism (an opera soprano rapping about cowboys and Wittgenstein).

Since the artists' original national polls, art museums and municipal governments in several American towns and cities—Ithaca, New York; Akron, Ohio; Santa Barbara, California; Ridgefield, Connecticut; and Seattle, Washington—have invited Komar and Melamid to conduct town hall meetings to produce "most wanted" paintings based on the demands of as many as two hundred citizens.

"Mostly the meetings are in churches—sacred places," says Melamid. "Artists are holy anyway, but in a church, they're double holy. We introduce ourselves, saying we want to fulfill their wishes in art. We ask people what they want and try to accommodate every wish. We prefer people who are not interested in art. In a democratic society, it's kind of a collective dream to make true."

Adding to the nearly religious veneer of these civic meetings is the attire of Komar and Melamid, who typically attend dressed in black to approximate clerical gravity. "Sometimes the audience is really passionate, and that's what made us believe that art is a new religion. Because people keep art in a very high esteem, totally untouchable, not to be dirtied by the hands of laypeople."

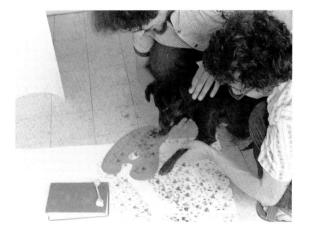

Meetings, held once in each location, generally don't last longer than a few hours. After the artists tally their results, they return to their studio and paint the picture that the citizens have asked for. And as uniform as the national "most wanted" paintings may have appeared, the artwork derived from the local polls varies wildly, Melamid says. "In Akron, they wanted a lot of tires, because it used to be the center of the tire industry. And, most unusual, they wanted all the presidents who came out of Ohio, eight of them, with dogs' bodies and wings. Not only dogs, but people also wanted bunnies and frogs. And a girl approached us with her mother, who said, 'Listen, I really want my daughter to be in the painting.' So we took a picture of her and painted her. We aim to please."

Irritated by the fundamentally romantic notion of the artist as a solitary genius, Komar and Melamid tend to think of themselves along the lines of a corporate partnership, a brand name. "It's like Smith & Wesson," Komar explains, "You can't say, this is Smith, but Wesson's not around. Conscious coauthorship is only fundamentally new direction in art since discovery of the abstract. Our interpretation of polls is our collaboration with various peoples of the world. It is collaboration with new dictator—Majority."

A seemingly insatiable hunger for fresh blood has driven Komar and Melamid beyond the borders of the human art world and into the previously uncharted territory of interspecies collaboration. During their brief sojourn in Jerusalem in 1978, they collaborated with a stray dog who made his home in the Soviet refugee camp where they were housed, teaching him to draw by dipping his paw in black ink and pressing it to paper to produce an image of a chicken bone that was propped up on their old art school textbook, *How to Draw the World Realistically.* They have been working on a long-term project with beavers and termites in national parks throughout North America, attempting to introduce right angles (in the form of two-by-fours) into their organic architecture. Last year in Moscow, they placed a camera in the hands of a trained circus chimpanzee named Mikki, who produced an evocative series

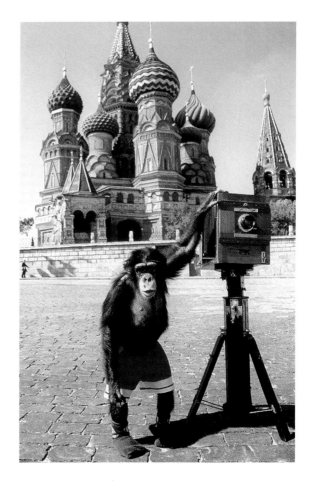

TOP: *Komar and Melamid teaching a dog to draw.*

MIDDLE: *Tranda the Dog's drawing of a bone.*

BOTTOM: *Mikki the Chimpanzee photographs Moscow's Red Square.*

A BRIEF HISTORY OF ART-MAKING ANIMALS

1875

The director of Berlin's Zoological Institute witnesses his son drawing in pen and ink with a chimpanzee who imitates him with his own pen, ink, and paper—the first recorded account of a chimpanzee creating abstract art.

1913

Russian scientist Nadjeta Kohts makes the first detailed investigation of the psychological development of chimpanzees.

1935

Kohts releases a study of drawings by her young son, Roody, and an infant chimpanzee, Joni.

mid-1930s

First account of elephants being taught to paint, in Berlin.

1941

Dr. Paul H. Schiller undertakes the first systematic study of the graphical responses of an ape.

1947

Soviet poet Sergei Mikhalkov publishes a fable about an elephant who polls the other animals about what kind of art they would like to see, and paints the results.

1951

First publication of a study specifically exploring ape drawings.

1953

First published accounts of finger paintings by Christine, Betsy, and Dr. Tom, three chimpanzees at the Baltimore Zoo.

of blurry photographs of Red Square. "Early modernists were fascinated by art of early human societies," explains Komar. "Picasso, for example, studied early African art. In our work with animals we were venturing even farther or, in Darwin's terms, to the beginning of time. Soon we will make photographs through the eyes of a potato, and paint with brushes tied to tree limbs, collaborating with the wind."

On a dusty shelf in Komar and Melamid's studio, wedged between a plaster bust of George Washington and a copy of the *Communist Manifesto,* is a bronze statue of the Hindu elephant-headed god, Ganesh. The figure is endowed with four human arms and an elephant's trunk and it stands as a fitting emblem of what turned out to be their most momentous three-way collaboration: a series of paintings made with Renee, a sixteen-year-old African elephant at the Toledo Zoo in Ohio. Komar and Melamid first got wind of the nascent elephant painting movement in the spring of 1995. They had just returned from an international art fair in Finland where, Melamid recalls, they found themselves dwarfed by the monumental scale of the abstract paintings that filled the exhibition halls. "They were so huge, so nonhuman in a way. Then, when we came back to New York, we heard about this elephant in Arizona who painted, and we realized that human artists were trying to do something that could probably be done just as well—or maybe better—by an elephant."

The elephant in Arizona was Ruby, and she was, at the time, the most famous resident of the Phoenix Zoo. Born in 1973 in a lush forest in northern Thailand, Ruby spent the first few months of her life tagging along in the underbrush while her mother, a logging elephant, labored with two mahouts in the roadless teak forests of the north. Her life changed radically when, seven months old, she was captured and shipped to Arizona, where she became the star attraction of the Phoenix Children's Zoo. Physically, Ruby thrived in her new environment but in most other respects she was a problem child. She threatened her keepers, bumping and shoving them when they tried to approach her. She played sadistically with the ducks and geese who sometimes wandered into her enclosure, luring them closer with grain from her trough, then stomping them to a pulp with her front foot when they waddled within range. She masturbated obsessively, rubbing herself against logs and terrorizing zoo employees with her amorous advances at dump trucks, bulldozers, and other large lumbering machines.

One day Ruby's bad-girl behavior suddenly disappeared. Her keepers noticed that she was becoming increasingly engrossed in a sort of solitary doodling—arranging pebbles in neat piles or, with a stick held in her trunk, scratching lines in the sandy soil of her enclosure. At first they dismissed this behavior—relatively common among Asian elephants in captivity—as a harmless quirk, another of Ruby's peculiar habits, less provocative, at least, than her erotic preoccupation with heavy machinery. Then in 1987 one of her keepers heard about an elephant in the

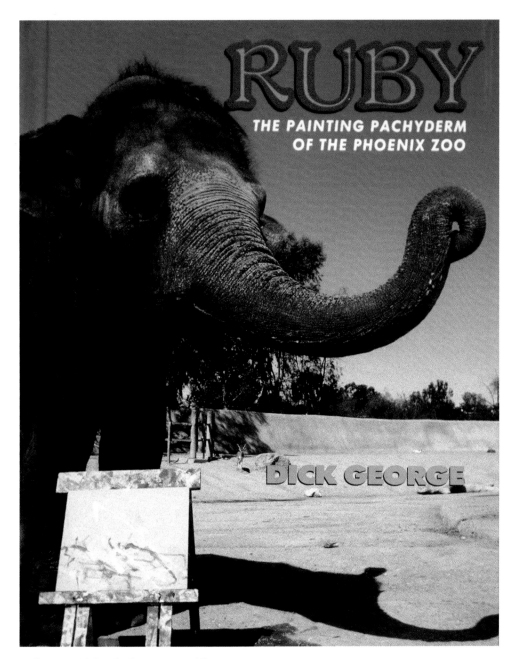

RUBY
THE PAINTING PACHYDERM OF THE PHOENIX ZOO

DICK GEORGE

Ruby, star of the elephant art world.

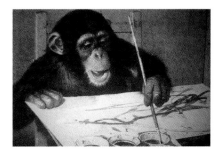

1956

Desmond Morris begins instructing Congo, a one-year-old chimpanzee at the London Zoo, in the techniques of pencil drawing.

1957

The Institute of Contemporary Arts in London hosts an exhibition of paintings by Congo and Baltimore Betsy.

1962

Morris publishes his controversial *Biology of Art: A Study in the Picture-Making Behaviour of the Great Apes in Its Relationship to Human Art*

1978

In Jerusalem, Komar and Melamid teach Tranda, a "Russian-Jewish immigrant dog," to draw realistically.

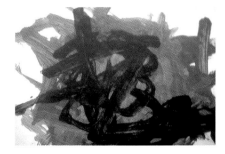

1990

Thierry Lenain publishes *La Peinture des singes: histoire et esthetique,* later published in the U.S. as *Monkey Painting.*

1993

Ape painting is discussed at the sixteenth annual meeting of the European Sociobiological Society in Amsterdam.

1995

Komar and Melamid collaborate on abstract canvases with Renee, an African elephant at the Toledo Zoo.

San Diego Zoo who had learned to paint, and decided to cultivate Ruby's artistic bent with some art lessons. The keepers laid out a few pots of acrylic paint and taught Ruby to grasp a brush with the tip of her trunk and sweep it across the surface of a canvas propped up on a low wooden easel. Within a week Ruby had mastered the basics; within a few months her painting style had evolved from crude, childlike scribbles to monumental abstract arabesques rendered in vibrant colors that exploded on the canvas like fireworks. Before long, Ruby's paintings caught the eye of a local art dealer, Bill Bishop, who offered to mount an exhibition of her

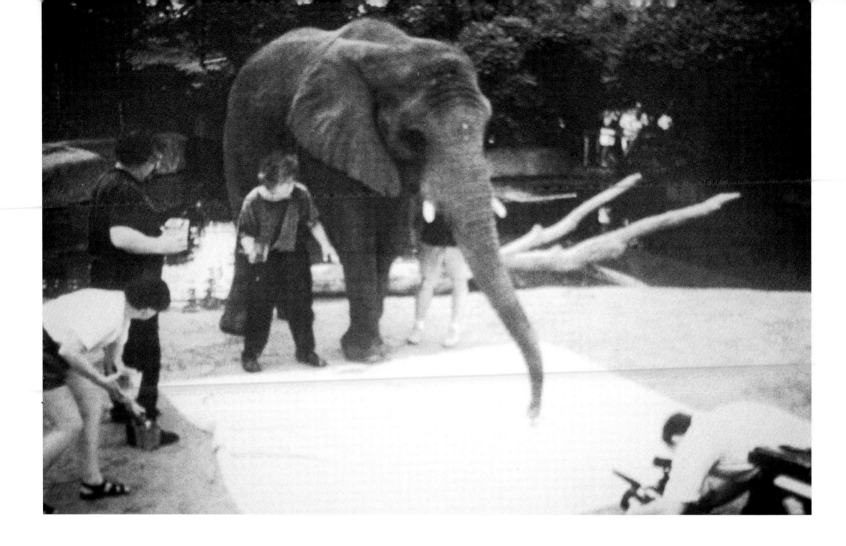

work at his Scottsdale gallery. After some initial hesitation and considerable soul-searching about the ethics of exploiting Ruby's creative talents in a commercial venue, the zoo officials handed over thirty-nine of her best paintings, with the stipulation that—if the work sold—all proceeds would go to the zoo's wildlife conservation fund.

Ushered in by a whirlwind of local publicity, the show drew huge crowds; by the second afternoon all of the paintings had been sold and the Phoenix Zoo was $20,000 richer. Ruby was a hot commodity. Critics breathlessly applauded her fine sense of color, compared her canvases to the work of Abstract Expressionist painters like Robert Motherwell and Helen Frankenthaler, celebrated her as a "pachyderm Picasso." The zoo published an illustrated monograph on her life and work. Demand was high, and the prices of her paintings skyrocketed. Word of Ruby's success spread like wildfire among elephant trainers, and soon zoos across North America began plying their elephants with paint-soaked brushes, pushing them in front of blank canvases, and waiting for the spark of genius. The ranks of elephant artists were growing rapidly: there was Scarlett O'Hara in Atlanta, Siri in Syracuse, Kamala in Calgary, Annabelle in Alaska, Mary in Little Rock, Winky in Sacramento, Sri in Seattle—about twenty in all, each churning out abstract canvases that bore an uncanny resemblance to the messy, all-over, expansively gestural work of American artists of the 1950s, such as Jackson Pollock, Willem de Kooning, and Franz Kline.

But underlying the excitement, the novelty, the pleasant absurdity of elephant painting, lurked the inevitable question: What exactly do these elephants think they're doing when they slap paint onto canvas? Does the fact that elephants can learn to paint—and that when they do, they often produce work that not only looks like human art but rivals the work of some of the most celebrated artists of the twentieth century—have anything to do with what we call art? Most zoo trainers remain deeply skeptical about the aesthetic intentions of their

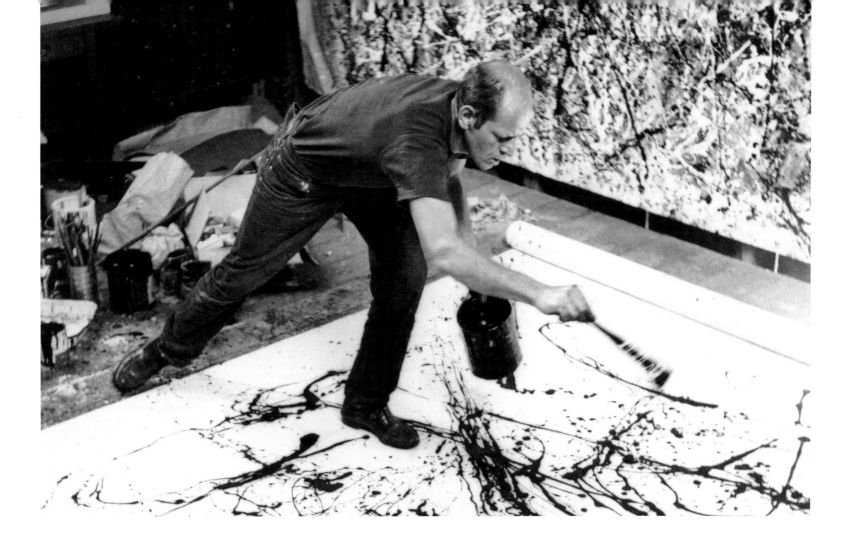

ABOVE: *Jackson Pollock painting, 1950.*

FACING PAGE: *Komar and Melamid and Renee at work, 1995.*

painting—boredom and hunger—really so far removed from the circumstances that motivate human beings to pick up a paintbrush?

four-legged protégés. For elephants, they insist, painting is nothing more than a trained behavior intended to alleviate the overwhelming boredom of captivity and earn them an edible reward. "An elephant doesn't look at a canvas the way a painter would," one trainer explains. "They're thinking, 'When I hit this thing, I'll get a carrot.'" And yet, as zoologists have observed, many captive elephants, like Ruby, will independently pick up sticks or pebbles and scratch lines in the dirt—a behavior that may suggest some innate, untutored impulse to draw. Certainly, the leap from doodling in the sand to painting on canvas requires training, encouragement, and art supplies—but this is true for both elephant and human artists. Elephants may not be guided by the musty old dictum of "art for art's sake," but are their alleged motivations for

When the tide of Ruby's fame touched the shores of the New York art world, Komar and Melamid immediately called the Phoenix Zoo to ask about a possible collaboration. They were promptly turned down. They wrote to dozens of other zoos with painting elephants in residence, and were refused, laughed at, or brushed off by each in turn. Finally, the Toledo Zoo, home to Renee, a sixteen-year-old female African elephant who paints, consented, and in July 1995 Komar and Melamid headed for Ohio.

For three days the two Russians and the elephant painted side by side in the zoo's simulated African savannah, filling one large canvas after another with bold, swirling strokes of color. "We would follow her movements, and she would follow

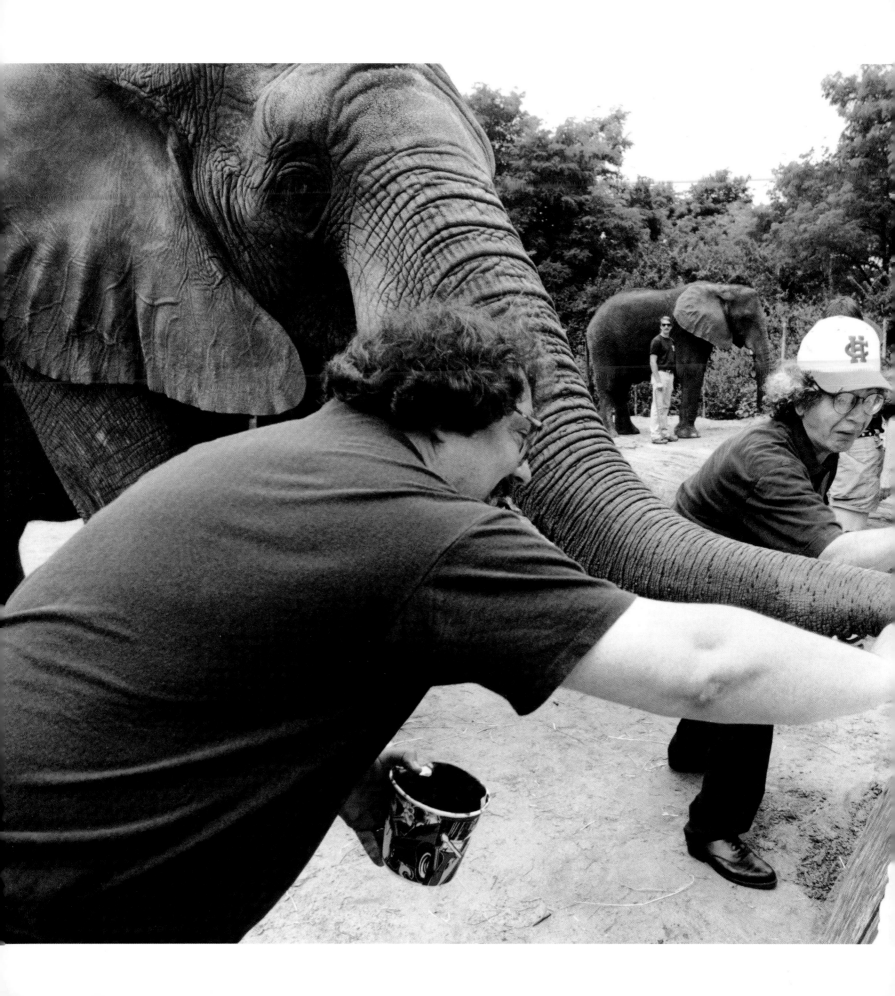

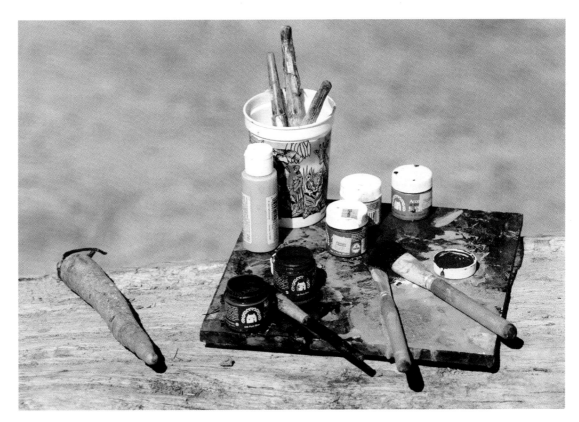

ABOVE: *Renee's palette of water-soluble paints.*

LEFT: *Komar and Melamid and Renee lost in an artistic frenzy at the Toledo Zoo, July 1995.*

ours," Komar recalls, describing the experience as one of "artistic frenzy" fueled by the hot July sun and by the carrots and bananas they continually tossed into Renee's open mouth as she painted. They were particularly impressed by Renee's unbridled spontaneity, by her responsive intelligence: "She understands it when you talk to her," says Komar, "even with Russian accent."

Komar and Melamid identified with Renee as a kindred spirit, a fellow immigrant haunted by a similar sense of loneliness and displacement, relegated to the marginal position of a perpetual outsider. "As a Russian-American Jew and one of the last Modernists," says Komar, "I feel like a member of an endangered species that is gradually becoming extinct. Despite my American passport, I will never be a full-fledged American and will never be able to return to my native environment—a country where I had the misfortune to be born, and which no longer exists."

A few months after their sessions with Renee, Komar and Melamid came across an item in the *New York Times* about the plight of elephants in Thailand. HUNGRY AND JOBLESS, ELEPHANTS WANDER THE STREETS, the headline said. As they read about Thailand's dispossessed elephants begging for change on the streets of Bangkok, Lenin's revolutionary call to action— "What is to be done?"—welled up from somewhere deep within their Russian souls. Komar and Melamid started thinking. They thought about their painting sessions with Renee; they

CIRCUS POLKA

In 1942 the Ringling Bros. and Barnum & Bailey Circus commissioned the great Russian ballet star George Balanchine to choreograph a ballet for elephants. Balanchine agreed and eagerly phoned his longtime mentor Igor Stravinsky to ask him if he would compose the score.

"Igor," began Balanchine, "how would you like to compose a ballet for some circus elephants?"

"Elephants?"

"Yes."

Stravinsky paused. "How old are they?"

"Oh, they're pretty young."

"All right, if they're young," said Stravinsky, "perhaps I can do it."

The two great Russians put their heads together and created a modern classic, *Circus Polka,* a ballet for "fifty elephants and fifty beautiful girls." Working closely with Ringling Brothers' head elephant man, Balanchine found his charges to be true professionals. "Elephants," he said, "are no harder to train than ballerinas."

The ballet premiered at New York's Madison Square Garden in the spring of 1942 and sustained a triumphant run of 425 fully booked performances. While some critics judged the performance to be "a show of extraordinary beauty," others found Stravinsky's dissonant score "weird" and "out of place."

"The circus," observed the *New York Post,* "has gone intellectual."

PROGRAM of DISPLAYS

DISPLAY NO. 18 "THE BALLET OF THE ELEPHANTS"

FIFTY ELEPHANTS AND FIFTY BEAUTIFUL GIRLS IN AN ORIGINAL CHOREOGRAPHIC TOUR DE FORCE

Featuring MODOC, premiere ballerina, the Corps de Ballet and the Corps des Elephants

Directed by GEORGE BALANCHINE
Music by IGOR STRAVINSKY

Staged by JOHN MURRAY ANDERSON
Elephants trained by WALTER McCLAIN

Costumes designed by NORMAN BEL GEDDES

DISPLAY NO. 19 INTERNATIONALLY RENOWNED ACROBATIC TROUPES

LOS MONTES	CRISTIANI ZERBINIS	THE RITTERS	THE ORTANS	THE PUCINIS

DISPLAY NO. 20 "PROMENADE OF THE CLOWNS"

RED-NOSED, CHALK-FACED, SLAP-HAPPY FUNMAKERS FROM THE EARTH'S FOUR CORNERS

DISPLAY NO. 21 THE WORLD'S FOREMOST MID-AIR MARVELS

FLYING COMETS	THE FLYING CONCELLOS	FLYING RANDOLLS

(Program of Displays continued on page 70)

Showbill for Ringling Bros. and Barnum & Bailey's Circus Polka *with drawings by* The New Yorker *cartoonist Peter Arno, 1942.*

thought about Ruby in Phoenix, pulling in over $100,000 a year through the sale of her paintings; they thought about the thousands of domesticated elephants in Thailand—hungry, unemployed, desperately trying to scrape together a meager living as itinerant entertainers, banking on their wits, their looks, their talent.... And suddenly, a solution dawned on them—so simple, so obvious. If Thai elephants could be taught to paint like their American kin, if their paintings could be marketed to collectors, sold at benefit auctions, maybe even hung in museums, these disenfranchised timber workers could reenter the global economy in a triumphant new guise—as working artists. Komar and Melamid knew instinctively what they had to do: open the world's first quadruped occupational retraining program—an art school for elephants in Thailand!

With this revolutionary idea burning in their minds, the artists immediately set about doing what they do best: they started talking. They talked to anyone who would listen, zealously pitching their plan to the endless parade of journalists, art dealers, filmmakers, collaborators, and sundry charlatans who passed through their Canal Street studio. In order to realize this project, which stretched far beyond the traditional art-world nexus of studio-gallery-museum, Komar and Melamid desperately needed to infect the right people with their own enthusiasm, to make these people understand that art was by no means useless, that, in fact, art could have a very real and very concrete effect on the daily lives of impoverished Thai elephants.

Komar and Melamid proselytized for nearly a year, with little to show for it. Then, in November 1997, they met Linzy Emery, a young independent film producer who turned out to be absurdly well-qualified as a manager for the project. Fluent in several East Asian languages, Emery had studied Thai and forestry at Berkeley, and had spent a few years working in Thailand's upcountry forest before moving to New York to make documentary films. An organizational powerhouse in her early thirties who looks like a cross between Goldie Hawn and Baby Spice, Emery also happened to be between jobs. Intrigued by Komar and Melamid's idea and charmed by their enthusiasm, she offered to make a few phone calls to Thailand on their behalf, maybe contact a few old acquaintances....

For the next few months Emery was unstoppable. Komar and Melamid's studio was transformed overnight into the U.S. headquarters of the Asian Elephant Art and Conservation Project, a half-hypothetical organization with its own letterhead, business cards, bank account, and unpronounceable acronym—AEACP. Letters were written, faxes sent, budgets drawn up, elaborately detailed proposals concocted, phone calls placed to far-flung corners of Asia and the United States. Slowly but surely, the pieces began to fall into place. The World Wildlife Fund agreed to a meeting at the studio. Disney, Starbucks, and the BBC returned Emery's phone calls, asking for more information. Richard Lair, Thailand's foremost expert on Asian elephants in captivity, agreed to make the necessary introductions to key people in the politically convoluted world of Thai wildlife conservation. The owner of the Siam City, a four-star hotel in Bangkok, agreed to comp some rooms for the artists and their entourage. The only thing missing was money. Komar and Melamid had few resources of their own to draw on—their careers as dissident conceptual artists may have earned them a certain degree of fame, but fortune lagged far behind—the artists hadn't sold a painting in years. If the project was going to move forward, they needed some sort of financial backing—a patron, perhaps.

Enter Jim Ottaway, a mild-mannered man in his late fifties with wire-rimmed glasses, graying hair, and a conservative blue-suit-and-paisley-tie wardrobe. He's a senior vice president at Dow Jones, a publisher of the *Wall Street Journal,* heir to a family newspaper conglomerate, a trustee of the World Wildlife Fund, and, as Komar would later christen him, "the Lorenzo Medici of elephant art." Komar and Melamid first met Ottaway when a German journalist brought him by the studio to look at the "People's Choice" paintings. He liked the project ("It struck my funny bone," he later said), but to the artists' disappointment, he left the studio that day without reaching for his checkbook. Though his wife likes to paint on Sundays, he's not much of an art collector. To Ottaway, artists in general—and Komar and Melamid in particular—are intriguing in the same way as Chinese red pandas or African gazelles, as a fascinating form of exotic wildlife that has made its habitat, conveniently, in his own backyard.

When Komar and Melamid called Ottaway to tell him about their idea for an elephant art school, he chuckled.

"You can't be serious?" he asked, with a discernible note of hope in his voice.

"People often ask us this question: Are you serious or are you joking?" said Komar. "Sometimes we don't know answer ourselves. Because sometimes serious idea, like Communism, turns out to be tragic joke. And sometimes even bad joke can have serious result. According to Hegel, art is like pyramid with tragic drama at the top. But above it is something even higher—comedy—which makes the whole pyramid obsolete and senseless."

"One thing we know for sure," added Melamid. "This is either the greatest idea of all time or the stupidest by far."

Ottaway paused for a minute, cleared his throat. And then, for reasons that remain mysterious even to him, he uttered the four words that Komar and Melamid had been desperately hoping to hear: "Maybe I can help."

Three weeks later Ottaway showed up at the studio with some of the top brass from the World Wildlife Fund, about ten people in all, each with a tiny black panda (WWF's mascot) pinned to his lapel. They arranged themselves on the red plastic chairs in the front room of the studio, skeptically eyeing the large paintings by Renee that Komar and Melamid had propped up against every available inch of wall space. After a long and meandering conversation about tagging sea turtles in the Philippines, the songs of humpbacked whales, and the intricate nests of New Guinea bower birds, Melamid moved in for the kill. Leaning forward in his seat, arms flailing, talking a mile a minute, he explained to them the best way—maybe the only way—to save the elephants of Thailand and, in the process, to save art from its impending obsolescence.

"We live in one world," he said. "Wilderness doesn't exist—it's a dream of the eighteenth century that we desperately try to keep alive in public television shows like 'Nature' and 'Wild Kingdom.' What we want to do is to unify wilderness and civilization. Animal culture is part of our culture. We want to go beyond the human, to extend the limits of art. There's a nonhuman element in all great art. Previously people thought about it as something divine, going beyond the human. But we can also look to other species for this. Art can be seen as a sort of common denominator between humans, animals, and God."

The people from the World Wildlife Fund shifted in their seats; a few glanced down at their watches. Ottaway cleared his throat and shot a quick glance at Scott McVay, the biggest of the assembled bigwigs. "Okay, here's what we can do," said McVay, "WWF can't allocate funds to help captive animals—it's not in our mission statement—but we can help you raise the funds on your own. The person you should really talk to is Nancy Abraham—she's our elephant lady. Just donated two million to our Asian elephant fund. Maybe she can help you out."

Three weeks later Nancy Abraham, dressed in a bright yellow Chanel suit, her auburn hair stiffly coiffed, strode briskly into the studio with Ottaway close at her heels.

"May I make a quick phone call?" she asked Melamid as she shook his hand and quickly glanced around the studio. He pointed to a phone on the desk. "Okay, listen, I need you to sell two hundred shares of AT&T," she instructed her assistant at Paine-Webber, "and split it between Viacom and Intel."

Abraham hung up the phone and turned around to face Melamid, who was trembling with combined awe and amusement at this brassy display of big business wire-pulling. "So," she said, "tell me about these painting elephants." She listened to the pitch, firing back questions at Emery and the two artists: Do you have a business plan? How feasible is it? Who will supervise the project in Thailand? What do the conservationists have to say about all this? After a tense hour of high-concept proselytizing and creative cajoling, she seemed to come around.

"I don't usually give money for feasibility studies," she said. "But last night I had another dream about those poor, suffering animals in that terrible heat—I woke up in tears. Anyway, I trust Jim's judgment implicitly, and if he's supporting the project, then I will too."

Abraham and Ottaway stepped into the back room of the studio for a private conference. Melamid paced nervously, straightening piles of paper on the desk and giggling quietly to himself. Komar sat in a folding chair and gazed contemplatively at the ceiling. Emery tried to send a fax to Bangkok. Ten minutes passed, then twenty. Melamid retrieved a piece of blue chalk from his pocket and ground it to a fine dust between his fingertips. At last Abraham and Ottaway emerged from the back room, smiling.

"Pack your bags," said Ottaway. "You're going to Thailand."

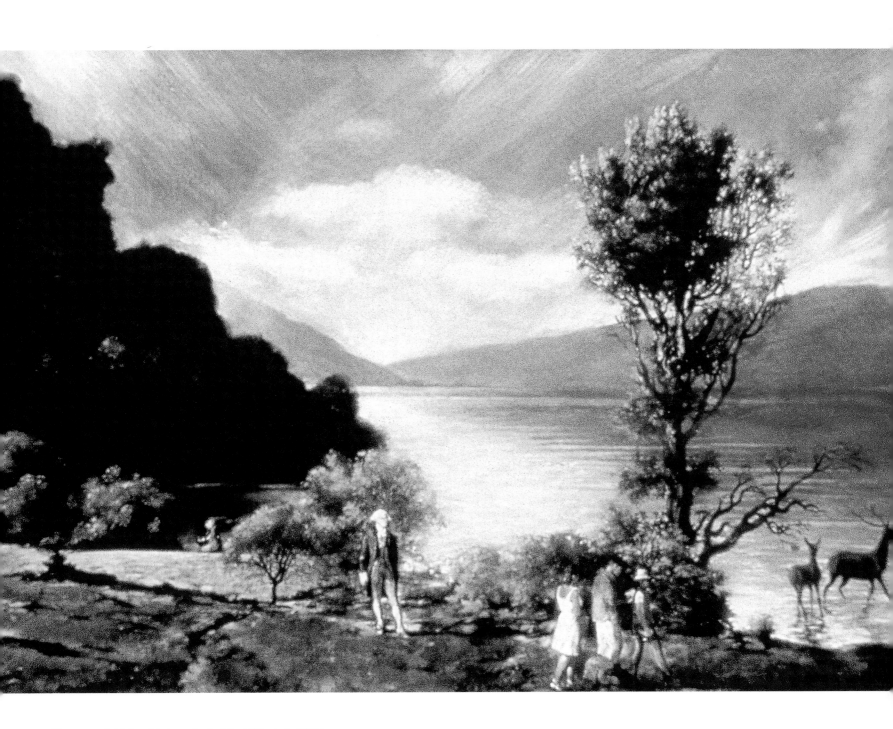

Komar and Melamid, America's Most Wanted, *1994.*

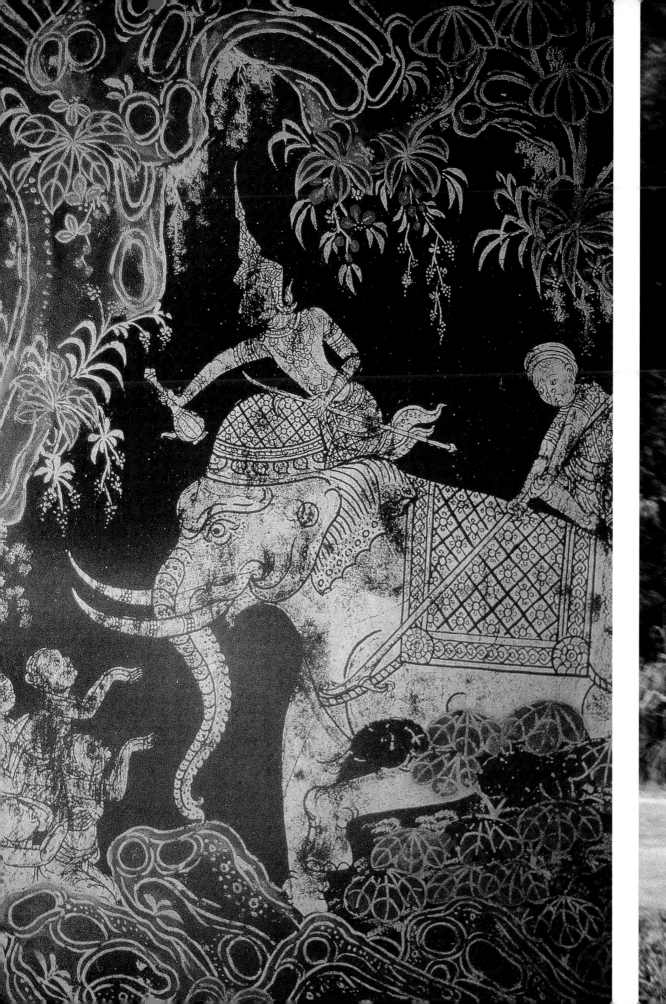

II.

THE ELEPHANTS OF THAILAND: SACRED YET IMPERILED

In February 1861 King Mongkut of Siam (famed as the bald patriarch of *Anna and the King*) sent a letter to the White House, offering a gift of "several pairs of young male and female elephants" to the United States. Noting that "elephants are regarded as the most remarkable of the large quadrupeds by the Americans," he suggested that they be released into the forests, where they would easily multiply into herds. They could then be captured, tamed, and forced into service as beasts of burden. Abraham Lincoln wrote back the following year, thanking King Mongkut for his generous offer, but declining the gift. "Steam," he explained, "has been our best and most efficient agent of transportation." To Lincoln, embroiled in a raging Civil War, the notion of a large, gray,

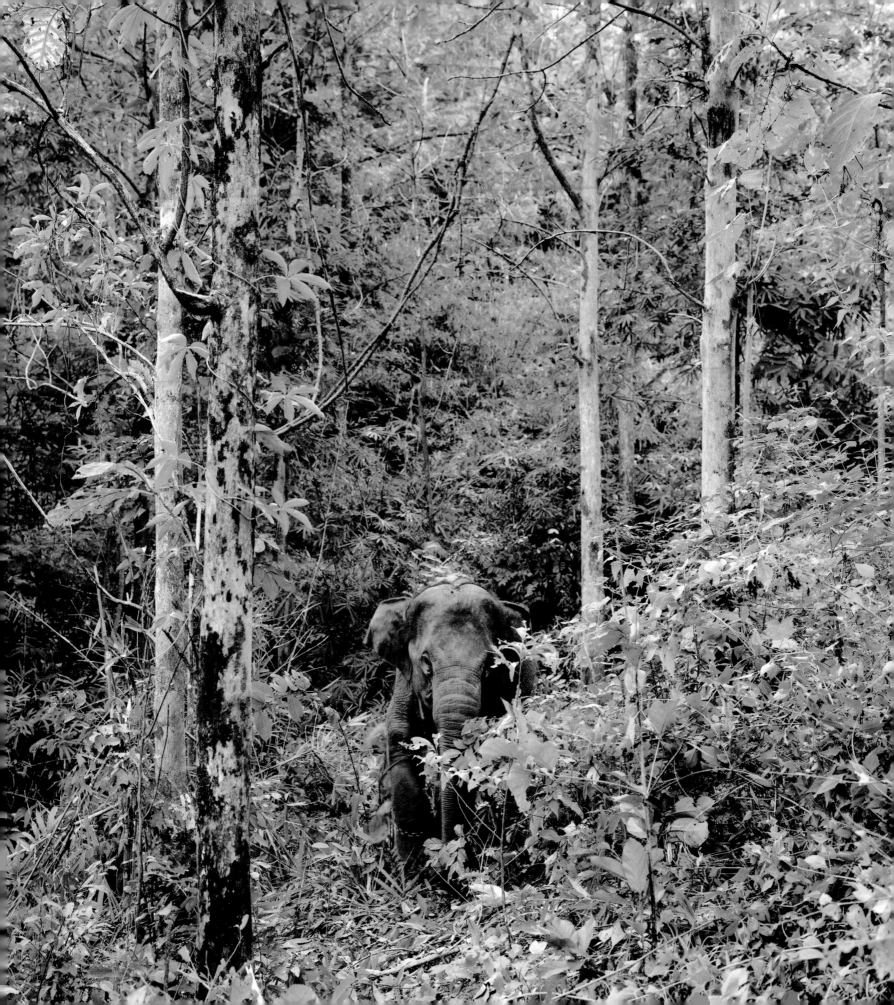

quadruped labor force ferried to the New World on a modern-day Noah's Ark must have sounded whimsical, to say the least. But to the King of Siam, as Thailand was then known, the offer made perfect sense.

Elephants in Asia have been captured, trained, and employed as beasts of burden for the last four thousand years. Since the days of Alexander the Great, the Asian elephant was used in warfare as a warm-blooded forerunner of the modern armored tank. Armies would charge into battle led by brigades of javelin-wielding warriors mounted on elephants, who were often clad in elaborate leather or metal armor. Spurred on by their riders, these well-trained fighting machines would seize enemy soldiers in their powerful trunks, tossing, trampling, or impaling them on their tusks. "The most dismal thing of all," recalled one Macedonian warrior who fought in the ranks of Alexander the Great, "was when these animals took up the armed soldiers with their trunks and delivered them up to their governors on their backs." Elephants also played a central role in the ritual life of old Siam, bearing the king at the head of stately royal processions and solemnly marching in the ordination ceremonies of Buddhist monks.

Siamese army on the march.

More commonly, however, domesticated elephants were used as Asia's primary means of transportation and heavy labor. For over seven centuries, these intelligent four-legged tractors earned their keep by hauling people and goods through what was then densely forested terrain. However, travel on elephant back was something of an acquired taste. As Carl Bock, one of the many European naturalists who visited Thailand during the late nineteenth century, described it: "The sensation is something like that of being rocked—not too gently, and with a circular movement—in a huge cradle. The pace is slow, and this mode of locomotion altogether tedious, though, when the country is open, there is an advantage to the fine view to be had from a height of ten to eleven feet or more from the ground."

Up until the end of the nineteenth century, a lush green canopy covered as much as 90 percent of Thailand. This tropical forest was home to about three hundred thousand elephants, a third of them domesticated and holding down essential jobs. Today, forests cover less than 20 percent of the land. Thailand's remaining wild elephants—their ranks diminished to a mere fifteen hundred—are boxed into several dozen scattered national parks where, despite their endangered species status, they are stalked by ivory poachers and hunted by starving villagers for their meat. When elephants stray outside their cramped confines in search of food, local farmers defend their crops from these roaming gleaners with gunfire, poison, and burning torches. The stakes are high for the poverty-stricken villagers: a herd of hungry elephants can silently devour an entire rice field in a single night. At times, the struggle for survival between desperate farmers and dispossessed elephants can escalate into an extraordinary battle of wits. There have been several accounts of elephants using mud or clay to plug up

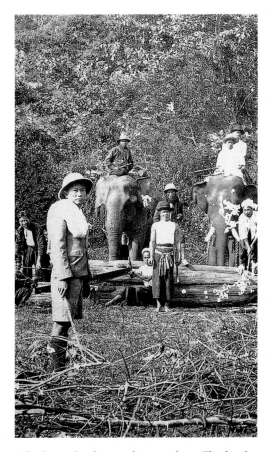

Elephants hauling teak in northern Thailand.

THE ELEPHANT IN THAILAND: THE LAST 150 YEARS

1850s

Last use of elephants in warfare with Burma. Human population is five to six million; estimated elephant population is one hundred thousand. One male in twenty-five worked as a mahout.

1884

In northern Thailand over twenty thousand elephants are employed in transport.

1900

Thailand, still over 90 percent forested, has over one hundred thousand domesticated elephants.

1905–09

Teak trade peaks; a yearly average of 122,000 cubic meters of teak are exported.

1921

Wild Elephant Protection Act makes all wild elephants property of the government. The intent is to conserve elephants for logging and ceremony.

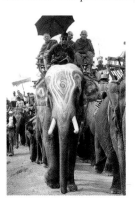

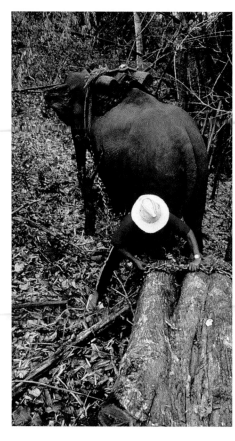

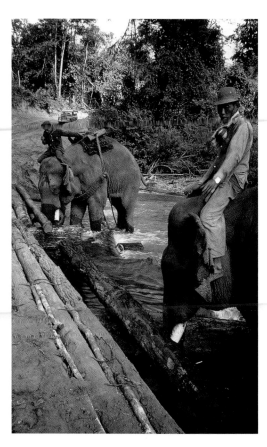

ABOVE LEFT: *A twenty-five-year-old female in northern Thailand is outfitted with a harness to facilitate the dragging of cargo.*

ABOVE RIGHT: *Elephants are used outside of Chiang Mai to carry or roll logs onto a makeshift bridge.*

the wooden bells that wary farmers sometimes hang around their necks, and then silently stealing into cultivated banana groves at night. There they quietly gorge themselves on ripe bananas and tender leaves, while the farmer and his family sleep peacefully in a hut a few hundred yards away.

Paradoxically, it was largely through the diligent labor of thousands of domesticated elephants that Thailand's forest cover—the natural habitat of their species—was systematically demolished. This process began in the mid-nineteenth century, when the economically ambitious King Mongkut signed treaties with a number of European powers, leading to a huge increase in trade between Thailand and the West. Among the nation's most coveted commodities was teak, a hard wood found in abundance in the forests of the northern region. Strong, surefooted, and keenly responsive, elephants provided much-needed muscle power for dragging heavy logs through the thick, roadless forests.

The training of logging elephants usually began between the ages of three and five, when calves were enrolled in special training schools where they would meet

their mahouts. Over the next five or six years the elephants were taught to respond to over forty verbal commands ranging from simple instructions to crouch down or step forward to more complex tasks, such as walking in single file or in pairs, dragging and piling logs, or gently nudging felled trees down muddy slopes leading to the nearest river. Despite their bulky appearance, elephants are extremely agile at negotiating the thick undergrowth and steep, slippery terrain of the rain forest. Their feet are cushioned by sensitive pads of shock-absorbing tissue, and they walk almost noiselessly and with exceptional grace, propelling themselves forward in smooth, rhythmic strides. Strapped into a harness, a healthy bull is capable of dragging a load of two tons or more—nearly half his own weight.

The early years of the twentieth century were boom times for Thailand's timber industry; by 1904 over one hundred thousand logs were being tied into sturdy rafts and floated downriver to Bangkok's buzzing sawmills annually. Over the years these figures began to decline dramatically as Thailand's forests were systematically plundered for precious "green gold." Thousands of trees were felled each year, yet there was almost no new planting. At the same time the population of Thailand was growing rapidly, and large areas of forest in the northeast were clearcut and planted with rice, the main staple of the Thai diet. Although environmentalists repeatedly issued grim warnings about the disastrous effects of clear-cutting, these protests were drowned out by the triumphant roar of a booming economy. Finally, it was public outrage at a large-scale logging-related disaster in November 1989 that provoked the government to act. In the southern province of Nakhon Si Thammarat, a fierce three-day tropical storm set off massive landslides and mudflows on denuded land, destroying villages and killing hundreds of people. Faced with an ecological scandal, the government officially banned all logging in Thailand in 1990, saving what remained of Thailand's forests but leaving about three thousand domesticated elephants and their mahouts suddenly out of work.

While this new law may have scored Bangkok bureaucrats points with environmental groups, it had little effect on the day-to-day plunder of Thailand's upcountry forests. With teak prices driven higher than ever by the ban, a massive underground network of illegal logging operations sprang into action overnight. "A few weeks after the ban," one villager observed, "the forest almost exploded with the roaring sound of chain saws." Much like Thailand's other illicit enterprises—the drug trade and prostitution—the business of illegal logging is rife with violence, treachery, and corruption. Log poachers protect their clandestine operations from police interference with an impressive arsenal of evasive equipment, including souped-up trucks, spotlights to blind pursuing forestry officials, nails scattered on the highways, high-tech electronic gear for eavesdropping on police communications, and, naturally, large bribes to officials monitoring checkpoints. For the estimated fifteen hundred elephants who toil in this illegal industry, the working conditions are treacherous—and often deadly.

1940s

World War II brings new technology, particularly the introduction of machines for hauling and dragging logs. Modernization destroys elephants' habitat: forest and lowlands lost, along with a precipitous fall in paying work.

1950

Thailand has 13,397 domesticated elephants.

1960–65

Wild Elephant Protection Act has little impact except slight increase in the fee to capture a wild elephant. Thailand is 53 percent forested, with 11,192 domesticated elephants.

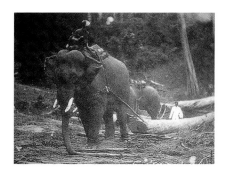

1986

Thailand is 29 percent forested, with 4,633 domesticated elephants.

1989

A three-day tropical storm causes mudflows, flooding, and landslides, leaving 236 people dead and 305 missing. Citizens blame this on "illegal and unwise logging."

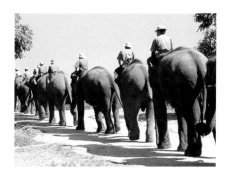

1990

Logging is banned in Thailand.

THE ELEPHANT TRUNK

The natural agility and versatility of the elephant's trunk makes it extremely well-suited to the world of art. The trunk, which can function as equal parts arm, hand, nose, snorkel, storage jar, and semaphore flag, is one of the most useful features of the animal kingdom.

It can weigh up to three hundred pounds. It can hold two and a half gallons of water. It comprises nearly 150,000 separate muscles. (The entire human body, by comparison, has only 639 muscles.) The trunk's four external muscle groups—the top and sides, the bottom, and the pair on both sides of the base—allow the elephant to raise (the maxillo-labialis), twist (the nasalis), and lower (the pars rimana) the appendage; the naso-labialis helps move the upper lip. The functions of the internal muscles are more specialized: the septum nasi helps dilate and constrict the elephant's nostrils, as does the rectal nasi, which helps twist the trunk as well. Thousands of muscle fascicles radiate from each nostril, permitting it to perform such delicate tasks.

OTHER USES

An extraordinary sense of smell: The elephant's sense of smell is superb, and while the trunk usually hangs near the elephant's feet, in times of danger the elephant may raise its trunk and use it as a sort of periscope, seeking clues in the air. When meeting a new friend, it will run its trunk all over that friend's body like a vacuum cleaner sucking in clues from every part of its companion's anatomy.

Siphon: After sucking the water into the trunk—the quantity it holds is proportionate to the size of the elephant—it can either deposit the fluid into its mouth for drinking (a thirsty adult has been known to drink almost sixty gallons in five minutes), or spray the water onto its back to wash or cool off. This task looks extremely casual and random, given how carelessly it's performed. Similarly, trunks are used to place dirt or grass onto the elephants' backs, to protect against the sun or insects.

Lifting: An Asian elephant's trunk can carry hundreds of pounds of whatever it chooses: a log, a barbell, a group of small children. In doing so, the elephant will either use the trunk to wrap around and lift the object, or it might choose to push or scoop the load, especially in the case of a particularly heavy log, which can just as easily be rolled.

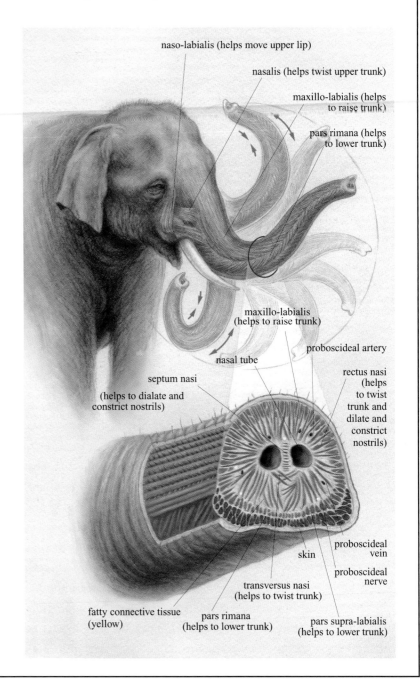

naso-labialis (helps move upper lip)

nasalis (helps twist upper trunk)

maxillo-labialis (helps to raise trunk)

pars rimana (helps to lower trunk)

maxillo-labialis (helps to raise trunk)

proboscideal artery

nasal tube

rectus nasi (helps to twist trunk and dilate and constrict nostrils)

septum nasi (helps to dialate and constrict nostrils)

proboscideal vein

skin

proboscideal nerve

transversus nasi (helps to twist trunk)

fatty connective tissue (yellow)

pars rimana (helps to lower trunk)

pars supra-labialis (helps to lower trunk)

Elephants are commonly fed bananas spiked with amphetamines, then brutally prodded with knives and spears to keep them working at breakneck speed through the night. Pushed far beyond their normal capacity, these overworked animals suffer from internal bleeding, extreme fatigue, and an enormously increased susceptibility to disease. Tired and bleary-eyed, elephants sometimes tumble to their deaths down rocky slopes or end up badly crippled by logs that skid out of control. Other elephants get hooked on amphetamines, lose their appetites, and wither down to walking skeletons; if their supply is cut off, they simply lie down to die. The luckiest workers in this sordid business are the ones who get caught and temporarily impounded at a special field clinic and holding facility in the north. There ailing elephants are gently eased out of their amphetamine addictions, poked with two-foot-long syringes of antibiotics to treat infected wounds, and nursed back to health from a general state of debilitating exhaustion. "For hundreds of years men treated elephants as friends," the clinic's resident veterinarian told a recent visitor. "Now people treat an elephant like a car. If it breaks down, they get rid of it and find a new one."

Another—and somewhat less perilous—option for many unemployed elephants and their mahouts has been to pursue a second career in show business, capitalizing on their looks, talent, and unfailing ability to charm human audiences. With tourism now surpassing agriculture as Thailand's biggest money-making industry, it's not a bad way to go. Although Thailand has no real circus tradition, elephants are quick studies and, with a little training, they can usually master a few simple tricks—enough to scrape up work as exotic entertainers. About three hundred elephants are currently employed in fixed-venue shows, most within driving distance of Bangkok or at tropical tourist meccas like Phuket, a beach-lined island in the south. Cheered on by the inevitable crowds of European tourists, elephants kick soccer balls, stand on buckets, play harmonicas, dance to Michael Jackson songs, and curtsy daintily when handed a banana by a camera-toting spectator. A number of luxury hotels at seaside resorts employ baby elephants—usually one- to two-year-olds—to greet guests in the lobby and frolic adorably in the sand. But like most child stars, these show business ingenues have a limited

shelf life. Generally, when they reach the age of three, they are sold or otherwise disposed of, and expediently replaced with another sweeter, younger thing. Sadly, many of these young performers—weaned too early from their mothers and lacking vital nutrients and enzymes—die before they reach adulthood.

In an effort to keep up with the changing times, Thailand's government-run Young Elephant Training School in the northern province of Lampang—once the country's premier academy for elephants hoping to break into the logging racket—quietly re-created itself as the Thai Elephant Conservation Center, a tourist venue dedicated to raising elephant awareness and keeping their artists-in-residence healthy and well-fed. The forty or so elephants who live at the camp with their mahouts pitch in by performing in twenty-minute shows twice daily. Following the current trend toward "ecotourism," the Center has the elephants obediently lifting and rolling logs in a lackluster demonstration of their now obsolete skills, staged for audiences of foreign tourists and Thai schoolchildren. For a few extra baht, visitors can climb onto a howdah (a benchlike saddle tied to the animal's back) and enjoy a brief "jungle trek" through a replanted patch of teak forest surrounding the camp.

At other locales, such as the historic city of Ayutthaya—Thailand's former capital—elephants carry tourists amid ancient architectural ruins, plodding through arduous eight-hour shifts under the hot sun. In the north, adventurous foreigners can hire an elephant to trek through roadless forests up to the secluded villages of the opium-smoking hill tribes who occupy the backwoods of Thailand's notorious Golden Triangle. Like old-time vaudevillians, many elephants and mahout pairs routinely travel the countryside—either on foot or loaded into ten-wheeled trucks—following the seasonal tides of tourism from one venue to another. The highlight of the year for these itinerant entertainers is the annual Elephant Fair and Roundup held each November in the northeastern town of Surin. Every year hundreds of elephants from all over Thailand converge on this sleepy town to participate in a massive spectacle recalling the past glories of the noble beasts. Draped in red and yellow silk, elephants march in monumental formations across the dusty open-air stadium like a single multilegged organism, restaging the colorful pageantry of ancient royal processions. They charge into simulated battle accompanied by throbbing drums and bottle rockets that fill the air with clouds of pink and green

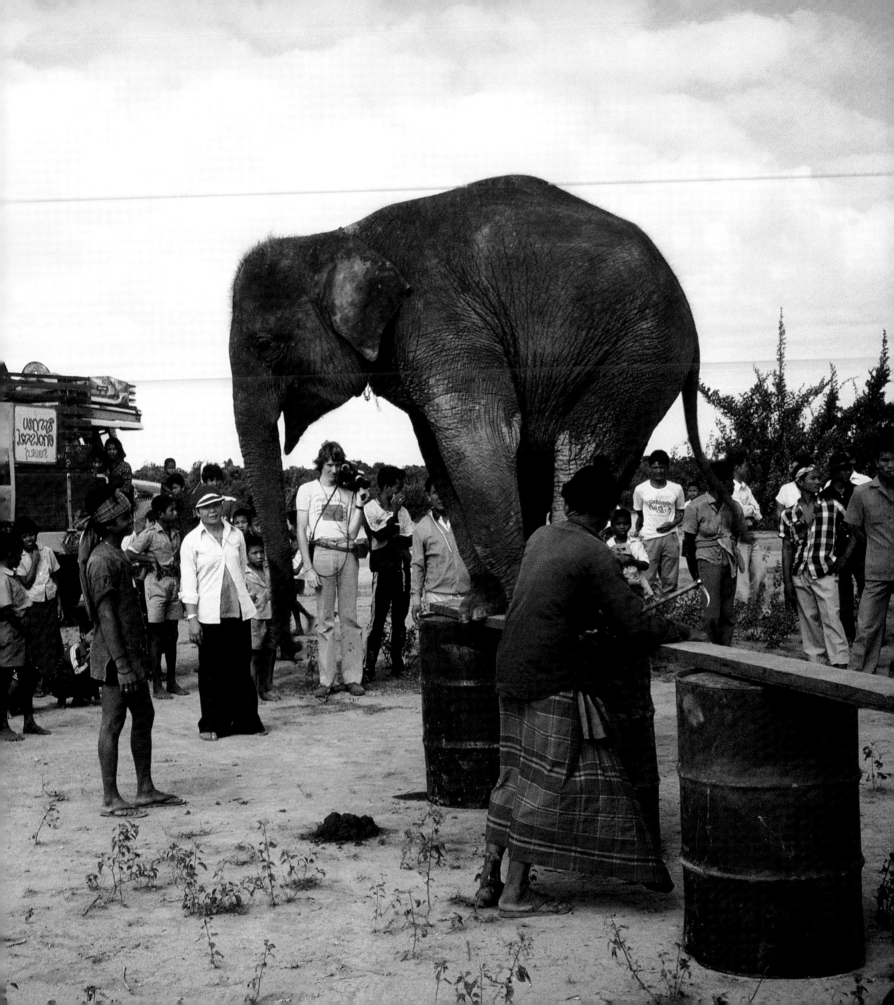

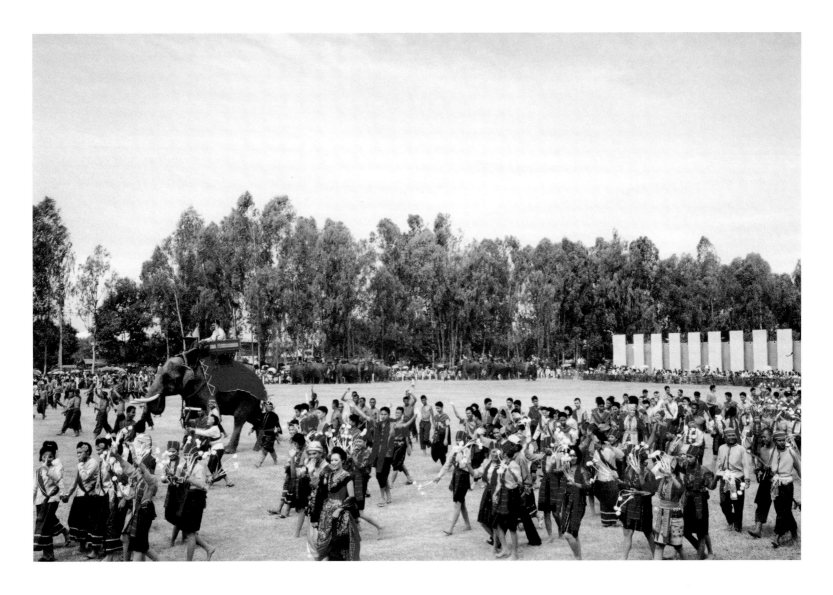

smoke. There's also a talent show, a soccer match, and an obviously rigged game of tug-of-war between an elephant and fifty young Thai army conscripts. (The elephant invariably wins.) After the show, mahouts pick up a few extra baht by selling fruit and rides to the milling hordes of tourists longing for closer contact with these colorful gladiators.

As the week-long festivities draw to a close, the mahouts prepare to leave this dreamlike evocation of old Siam to return to the often nightmarish realities of modern Thailand. The first stop for many of the elephants is Bangkok, where in the last few years they have joined the ranks of other urban vagabonds struggling to eke out a meager living on the margins of Thai society. Bangkok, Thailand's capital city and home to over eight million people, is a modern megalopolis of elephantine proportions. The Thai call it Krung Thep, or "City of Angels," and like its American counterpart, Los Angeles, Bangkok is plagued by chronic pollution, traffic jams at all hours of the day and night, squalid slums, and unbearable, unrelenting heat. Thailand has two basic seasons: hot

ABOVE: *Simulated battle at the Surin Elephant Roundup, November 1998.*

FACING PAGE: *An elephant performs in a traveling show in Surin.*

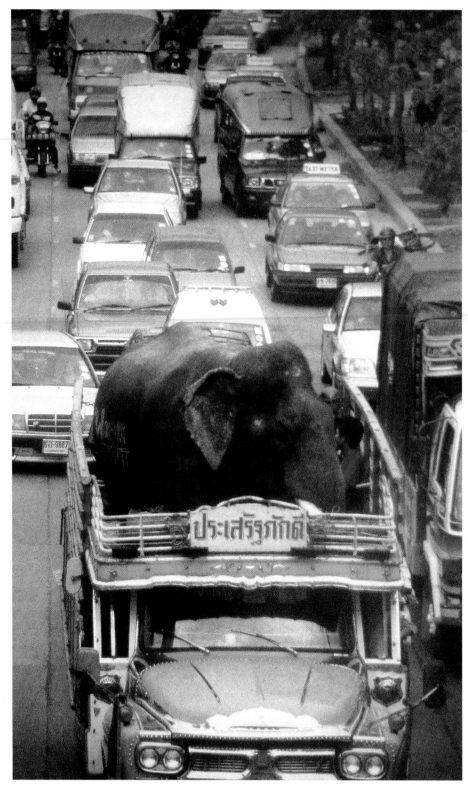

ABOVE: *Elephants are trucked back and forth across the countryside in search of new performance venues.*

FACING PAGE : *Elephants dodge traffic in the streets of Bangkok.*

and wet, and hot and dry. During the wet season, from June through October, monsoon winds blow in from the southwest, and rainfall can average between sixty and one hundred inches, depending on the region; during the dry season, temperatures can easily soar to 104 degrees Fahrenheit in the daytime, dropping only a few degrees at night, with humidity levels hovering at around 70 percent.

Today this city of angels is renowned for its decadent nightlife. In the lurid red-light districts of Patpong Road and "Soi Cowboy," American servicemen and sunburned European tourists mingle with young Thai women who have escaped the brutal poverty of the provinces for the glittering but dubious promises of Bangkok's thriving sex industry. Recently, these provincial newcomers have been joined by dozens of jobless elephants—often hailing from the same parched regions—who wander the city streets begging for change and selling fruit and trinkets for a few baht to curious tourists and well-to-do Thai. More and more often, foreign revelers on Patpong Road may look up from their Mai-Tais to see an elephant lumbering down a narrow alleyway like a large gray cloud, led by a mahout toting a basket filled with bunches of bananas, slices of watermelon, or bundled stalks of sugarcane. For forty baht (about one American dollar), these amused onlookers can purchase a few pieces of fruit from the mahout and offer them back to his sad-eyed companion. The routine, repeated hundreds of times a night, rarely varies: the elephant delicately grasps the treat with the tip of its trunk and tosses it into its mouth; then, raising its trunk in an elephant salute, it issues a quick bow by way of thanks. The elephant and mahout move off into the night, cautiously edging their way through the choking throng of cars, overcrowded buses, zigzagging motorcycles, and snorting three-wheeled tuk-tuks.

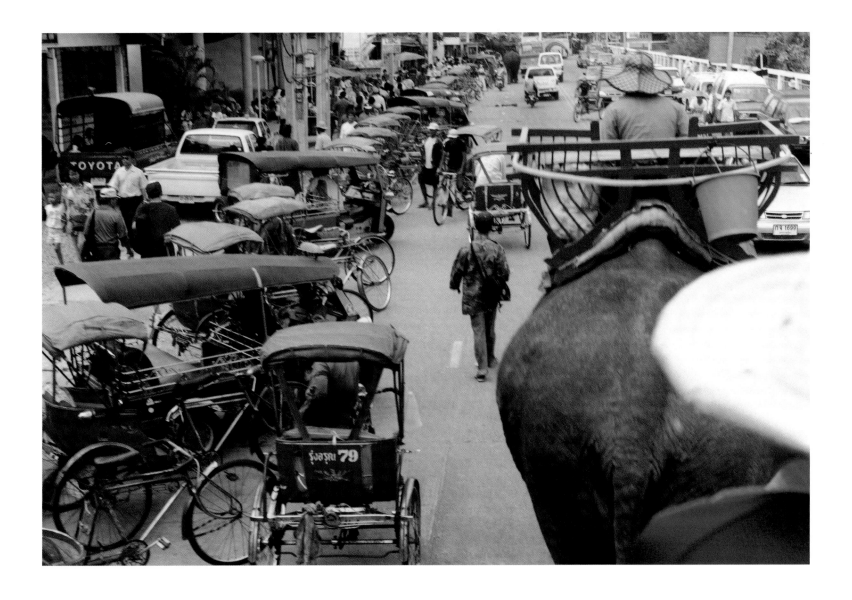

Images of elephants are everywhere in Bangkok. The first sight that greets tourists in the terminal of Bangkok's international airport is a large, smiling, cartoonish figure of an elephant—Chai-yo, the official mascot of the 1998 Asian games. Two massive bronze elephants stand guard at the throne hall of the Grand Palace, while sumptuously stylized elephant figures march, prance, and sometimes fly through the scores of mural paintings that brighten the walls of the city's palaces, temples, and museums. Elephants are featured on coins, in royal and official emblems, on postage stamps and billboards, and in countless commercial logos. Their images can be found on note cards, cuff links, T-shirts, silk ties, chopsticks, pocket-knives, opium pipes, cigarette packages, and bottles of beer. Every souvenir store in Thailand offers a dizzying array of elephant figurines rendered in every imaginable material, from gold-plated teak to candy-coated coconut.

But for the fifty or so living breathing elephants who nervously roam the city's overcrowded streets at any given time, daily life is a grim struggle. By day, they endure the brutal heat and pollution to trudge from one end of the city to another, pausing on the steps of Buddhist temples or at the entrances to glittering new department stores. There they often capitalize on the Thai belief that walking three times clockwise under the belly of an elephant will bring good luck, fertility, and, for pregnant women, a safe delivery. Among the

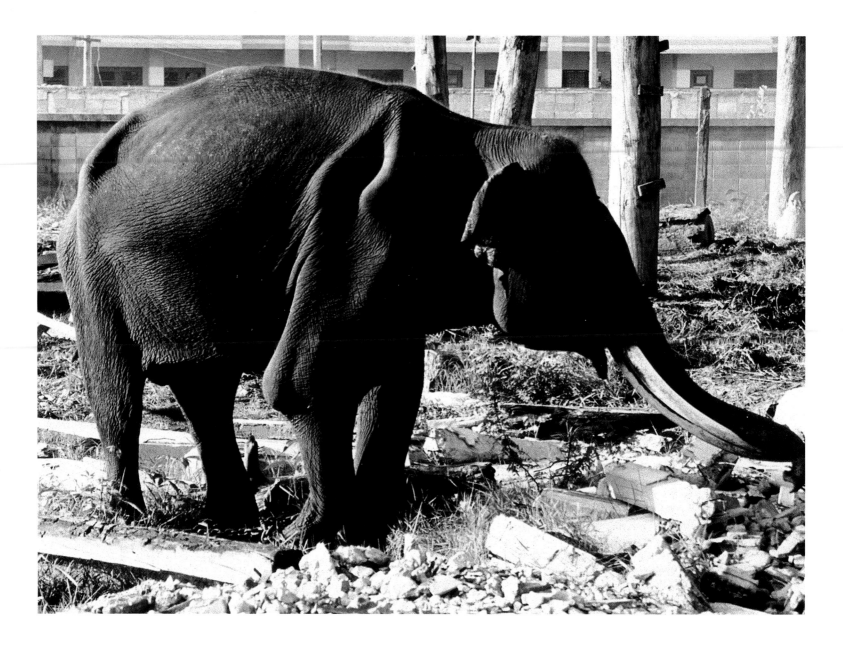

most anachronistic sights in present-day Bangkok is that of an elegantly dressed pregnant woman nervously ducking under an elephant on a busy shopping street as she casually passes a handful of change to the attending mahout. By night, the elephants gather in weed-infested abandoned lots under elevated highways where they try to catch a few hours of sleep amidst the blazing lights and incessant rumbling of the traffic overhead. In 1994 the Bangkok Municipal Authority, besieged by public complaints and bad press, officially banned elephants from the city limits. But this edict—though well-intentioned—is extremely difficult to enforce. Mahouts must pay a fine of

An elephant scavenges for food near an abandoned pencil factory in Bangkok.

five hundred baht (about twenty-five dollars) if they are caught with their elephants on the streets of Bangkok. Sometimes, as the officer is writing up the ticket, the exhausted elephant will casually rest his hindquarters on the police car idling nearby, crushing the metal frame with his five-ton heft. And hauling these massive urban nomads into the station is out of the question: they wouldn't fit through the front door. Generally, the weary mahout will hand over his day's earnings

to pay the fine, and then quietly lead his elephant to a neighboring district.

Yet there is one elephant bull who makes his home in the center of Bangkok unharassed by the municipal authorities: his name is Phra Savet Adulyadej Pahon, which translates roughly as "offering to the gods." Phra Savet belongs to Thailand's King Bhumibol Adulyadej, and lives in quiet luxury in his own pagoda-style stable within the royal compound. Although he is the highest ranking of eleven royal "white elephants," he is not white but a dusty pinkish gray. At fifty years old, he stands eight feet tall at the shoulder, with long curved tusks that cross at the tips (right over left—a highly auspicious sign in traditional Thai elephant lore). His eyes are light blue and ringed with amber. Alone in his austere and meticulously clean pavilion, Phra Savet lives a life of enforced leisure, much like the other members of the royal household.

The former flag of Siam.

By law, every white elephant found in Thailand must be presented to the king. Most so-called white elephants are not true albinos but are, as Thai elephant experts insist, "genetically different" from their more plebeian cousins. The proper term for "white elephant" in Thai is *chang samkhan,* which translates more accurately as "important" or "illustrious" elephant. When a likely candidate to these elite ranks is discovered, experts are immediately called in to examine the elephant for certain distinguishing characteristics. These include: white or pink genitals and toenails, tawny brown hair that is transparent when held up to light, pleasant-smelling droppings, and a mellifluous snore. Within each of these rather arcane specifications, there are further and ever more subtle shades of meaning. For example, as one expert has noted, "an elephant whose snoring is like the blowing of a conch shell is auspicious, while one that snores like a crying baby is merely lucky."

The white elephant has long been associated with royal wealth and power in Thailand. Like many aspects of Thai culture, this symbol has its roots in Buddhist belief. As legend has it, Buddha's mother, Queen Maya, conceived him shortly after dreaming that a white elephant approached her, bearing a white lotus blossom in his silvery trunk. The future Buddha in elephant form uttered a long, drawn-out cry, bowed three times, then gently struck Maya's side and entered her womb.

Until the early years of the twentieth century, Thailand's national flag bore the image of a white elephant set against a scarlet background, reinforcing Siam's romantic reputation as the Land of the White Elephant. In the late nineteenth century, word of these rare, magnificent creatures spread throughout the West, prompting P. T. Barnum—always on the lookout for exotic specimens—to cough up a small fortune for a white elephant captured in Burma, which he proudly presented to European and American audiences. However, the attraction proved to be something of a bust, since—like most white elephants—this one was not at all white. Barnum apparently had a hard time disposing of this ill-fated animal, giving rise to common meaning of the phrase "white elephant": a rare or valuable possession that proves too expensive and burdensome to maintain.

In this sense, present-day Thailand is overrun by white elephants. Today an elephant can be purchased for about $6,000—less than the price of a new car—but these colossal creatures are notoriously costly to maintain: every day a mature elephant can consume as much as five hundred pounds of food, washed down with fifty gallons of water. Add to this the cost of medical care and transportation, and you have on your hands a five-ton problem in dire need of a solution.

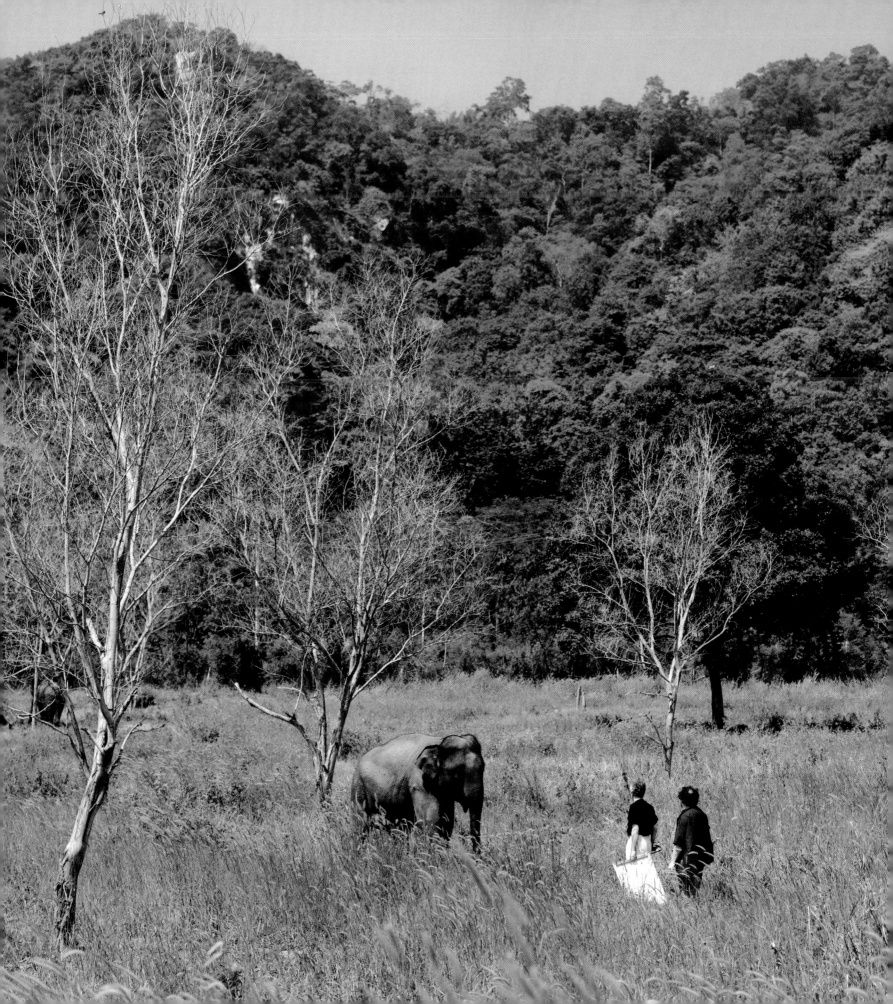

III.

A JOURNEY OF EPIC SCOPE, INCLUSIVE OF LOVE, ADVENTURE, AND THEMES BIG AND SMALL

After a grueling twenty-four-hour flight, the plane touches down at Bangkok's International Airport at just after midnight. Komar and Melamid step out of the air-conditioned terminal into the brutally frank heat of Bangkok in midsummer. "What a weather!" Melamid beams, stretching out his arms as though trying to embrace the heat itself, taking it all in—the humidity, the busy parking lot, the distant lights of downtown Bangkok, the apprehensive-looking Thai driver who is busily loading their luggage into the white Chevy van that will ferry them to their hotel.

During the hour-long ride into town, Komar and Melamid stare

Komar and Melamid recruit a new student in northern Thailand.

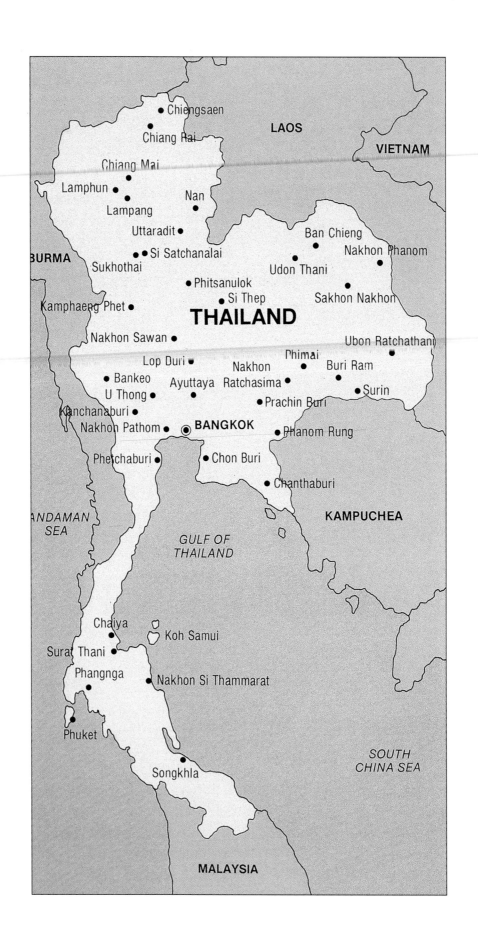

out the van windows, transfixed by the chaotic suburban sprawl of greater Bangkok. Signs of Asia's recent boom-and-bust economy are everywhere. In the early 1980s speculators sent up hundreds of postmodern-style skyscrapers in and around the city, creating a seemingly endless sprawl of glass-and-steel towers topped with gleaming plaster simulations of Greek temple facades. Today many of these high-rises remain skeletal and half-built, abandoned next to towering cranes in the aftermath of Asia's devastating economic crash of 1987. The city, once striding forward on an optimistic trajectory into the future, seems frozen in its tracks: miles of elevated highways float sixty feet above street level, only to end abruptly in midair. On the streets below, crowds of pedestrians squeeze through narrow walkways, surrounded by the ubiquitous open markets, food stalls, and merchants hawking cheap designer knockoffs—faux Chanel handbags and Cartier watches imported from Hong Kong via Singapore.

In an effort to avoid the heavy traffic that clogs the city's main thoroughfares, the driver veers off onto a small side street that runs alongside a narrow canal. Bangkok, long known to Europeans as the "Venice of the East," was once permeated by hundreds of canals, most of which have now been paved over. The few that remain are like open sewers, lined with flimsy shacks that appear to be built out of corrugated cardboard and pieces of string.

They take it all in, and then Melamid says what he seems to often say at seemingly inappropriate times—when faced with sights that are at first blush ugly, or tacky, or run-down, or overcrowded, or pathetic and depressing:

"It is all so beautiful!"

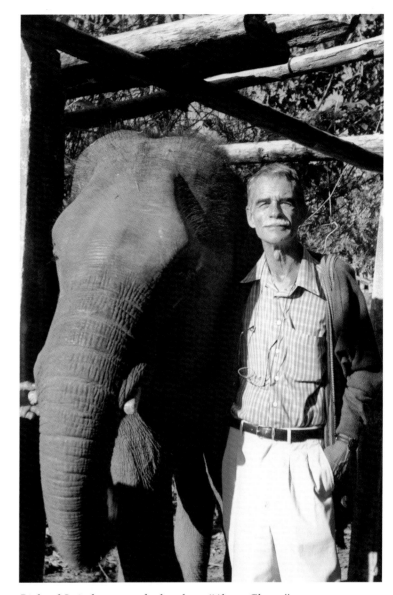

Richard Lair, known to the locals as "Aharn Chang" (Professor Elephant).

The next day, spirits are high, even though there are far too many people crammed into the van and at 9 A.M. it's already over a hundred degrees. There is one feeble air conditioner in the van, but it's performing with noticeable indifference. Intimidated by Thailand's tropical climate, Komar has brought along a "personal air conditioner" that he bought through a mail-order catalog. It's a black plastic box, about the size of a shoebox, that straps around the chest, with a small fan pointing upward toward the chin. He seems fairly smug about having it at first, but as the trip wears on, it's obvious that it's doing about as much good as the car's pretend air conditioner. The entourage is on its way to the Elephant Nature Park, a privately owned elephant camp near Chiang Mai. Today Komar and Melamid and their crew are investigating this camp and over the course of a few weeks they will investigate others in order to gauge the talent of the elephants at each and the quality of the care provided to the animals. The hope is to find one, two, or perhaps three suitable camps in Thailand, ideally spread among the country's varied regions, at which elephant art academies can be established.

THE ART OF MAHOUTSHIP

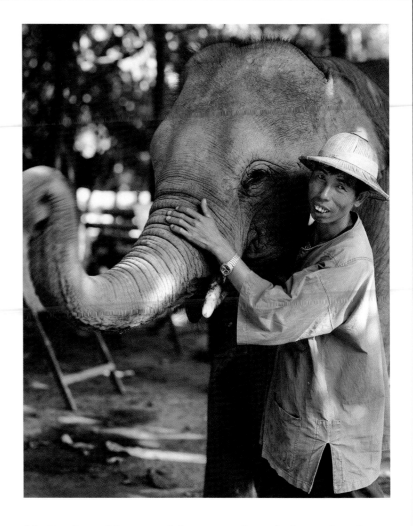

The neologism "mahoutship" is intended to be the exact equivalent of horsemanship. The word implies that not only does the rider possess great physical skill, he also has extensive technical knowledge and even a powerful spiritual or magical component. "Mahoutship" is a badly needed word because a disastrous decline in the quality of mahouts in nearly every country forces much discussion of a loss of capability. Mahoutship implies superb athletic ability.

Today's mahouts, unlike their elephants, receive no respect or appreciation from the larger society. Economically, nearly all mahouts are disadvantaged and many are genuinely downtrodden. Hired mahouts with no natural or culturally inculcated affection for elephants all too often see their elephant as the cause of their woes. Outright cruelty is rare but indifference is rife, and indifference leads to unhealthy, poorly nourished elephants.

The easiest group of keepers to accurately characterize is the mahout-owners: anywhere in Asia their elephants will be well treated, or at least treated as well as possible. The elephant is carefully tended not only because it represents much of the family's wealth but also because family ownership is by its very nature self-policing.

Hired mahouts are the next easiest class of keeper to generalize. Wherever hired mahouts are found there is likely to be significant abuse, particularly where there is poor supervision from owners. Sloth is endemic, and many hired mahouts are too lazy or too resentful to spend the large amount of time and energy needed to ensure that elephants are properly fed and watered. Most hired mahouts work under some sort of incentive system so they will tend to overwork the elephant.

Non-mahout owners fall into two primary subclasses, traditional owners and nouveau riche owners. Traditional owners are families that for endless generations kept, bought, sold, hired, and rented out elephants. Usually of high social class, traditional owners are well versed in elephants and usually quite

kind to them. Nouveau riche owners buy elephants for what to them is pocket change. Sometimes purely status-hungry, sometimes kindhearted, nouveau riche owners nearly always spell trouble for elephants because inexperienced owners invariably lack the expertise needed to supervise their hired mahouts.

Mahoutship in Thailand is entering a crisis. Until twenty or even ten years ago in northern Thailand, the traditional path to becoming a full-fledged mahout was very long and difficult, with most of the work occurring far off in the forest, perhaps two or three days' march from the nearest village. Today even the most inaccessible logging sites in Thailand are invariably within a few hours' walk from a good road. A whole body of absolutely irreplaceable knowledge is being lost as the older mahouts sit quietly, highly respected but not sought out for their knowledge. Uneducated country boys with no prior elephant experience seek to become mahouts as a tempting alternative to unrewarding work in the rice fields. Given a shortage of ma-

houts, they often become full mahouts far younger than in the old days. Although often brave, the young mahouts of today almost universally lack the massive knowledge of earlier generations. To informed observers, the decline in mahoutship is appalling and—in terms of the future—frightening.

KUI

The most famous elephant catchers in Thailand are certainly the Kui ("human beings" or "the people"). Around 1970 there were just over one hundred thousand Kui in Thailand. The elephant-keeping Kui, a small portion of the total, make their home in two provinces of northeastern Thailand and the adjoining northern parts of Cambodia. The Kui were until recently masters of mela-shikar, catching elephants both near home and in Cambodia. They preferred to hunt in flat, relatively open areas which favored their technique of slipping the noose on a hind foot. Many of the elephants noosed would have been fairly young, confused, exhausted, and thus relatively easy to catch.

The Kui are victims of a well-documented environmental decline. Four or five decades ago the land of the Kui was perhaps the single place on earth most closely resembling east Africa's savannahs with a great diversity of large mammals surviving today. In 1961 some 33.7 percent of the land area of the two "elephant Kui" provinces was forest, but by 1982 that number had declined to 8 percent. The loss of forest severely impacted on domesticated as well as wild elephants. The environ-mental decline has brought a parallel deterioration in traditional culture.

KAREN

The Karen are a "hill tribe" found in Thailand and Myanmar with a total population of approximately 2,500,000 people, about 200,000 living in northern Thailand. The Karen in Thailand keep elephants along hundreds of kilometers of the mountainous border with Myanmar. Rarely venturing down from the hills, in the past most Karen elephants worked in transport and general village tasks; the last century of working at teak logging was atypical.

The Karen have two unusual attitudes in their relationship with elephants. First, the Karen seem to be more genuinely kind toward elephants than are most other elephant-keeping peoples. Second, as opposed to the clear preference shown for bulls in many cultures, the Karen generally prefer cows and there are never aspersions of a mahout being less virile because he raised a cow rather than a bull. Owning an elephant brings great prestige to a Karen, even conveying a special title. Relatively few elephant-keeping Karen become master mahouts. On the Thai side of the border, making a legal living with elephants has become very difficult since the 1989 logging ban. The degree of involvement of Karen mahouts and elephants in illegal logging is unknown but certainly some must work in that shadowy trade.

—**Adapted from Richard Lair,**
Gone Astray: The Care and
Management of the Asian
Elephant in Captivity.

The chief arbiter of the quality of the camps is Richard Lair, a thin man in his late fifties, dressed in khaki and sitting in the van's front seat. By all accounts, Lair, an American expatriate who has lived in Thailand for the past twenty years, is the premier elephant expert in the region. Knowledgeable in elephant lore, care, and, in particular, the history and plight of domesticated elephants, Lair consults with most of the country's camps and is the author of the bible of the field, *Gone Astray: The Care and Management of the Asian Elephant in Domesticity,* a sort of textbook sanctioned by the United Nations and considered definitive on the subject. Lair is helping to discern which camps might be appropriate, according to the following criteria:

CARE OF ELEPHANTS

Everything from elephant diet to their daily regimen is evaluated. The quality of care at the camps in Thailand, unfortunately, varies wildly. Some camps are run by elephant experts, versed in and sensitive to the delicate needs of the elephants, while many are operated by business people and hucksters, trying to make a few baht off animals they have purchased on the open market. Elephants frequently die without proper care.

QUALITY OF MAHOUTS

Again, great variation in quality (see sidebar, page 36). While in some regions mahoutship has been a tradition for thousands of years—and great pride is taken in the profession—in other locations the mahouts are young, poorly trained, and often abusive. The best mahouts know the elephants intuitively and do not need to employ cruel methods to provoke desired behaviors.

GOALS OF ELEPHANT CAMP

Many camps are primarily entertainment-oriented. At these operations, the elephants not only give rides to tourists, but they often are forced to do tricks, like dunking basketballs and dancing to disco music. Goals of conservation at these venues scarcely exist, and when elephants are too old or otherwise unable to perform, they are discarded. Komar and Melamid, with Lair's help, are seeking camps that strive first and foremost to provide better lives for the elephants.

After the hour's drive through the sweltering heat the van descends into a wide green valley and suddenly there are elephants everywhere below the road, in the camp, moving slowly, deliberately, huge and gray like earthbound clouds. The group disembarks in the gravel parking lot, next to a number of cars and tour buses. They are directed to a viewing area under a large thatched roof where about fifty German and American tourists are sitting on wooden bleachers. In front of them is a large oval staging area where, at the moment, there is a small elephant, perhaps three years old, balancing its heft on top of a bucket. When the elephant steps down, it drops on one knee, raises its trunk, and toots. The audience coos and applauds. The show continues, running through a standard range of tricks. There is the basketball dunking, the popular soccer ball kicking trick, a routine where the elephant steals the mahout's hat and pretends to eat it, and, as a finale, the disco dancing, in which the elephant jiggles its whole body to the sound of the Bee Gees. At the trick's conclusion, the crowd applauds vigorously.

"You know how they do that one?" Lair says under his breath. "They're conditioned to respond to the music that way—for months, every time the music starts, the mahout jams a steel hook into the elephant's rump. The jabbing causes the elephant to shake its hindquarters—to dance. Finally, after months of this, the elephant automatically dances when it hears the music. It's brutal. Simply brutal."

Lair is not enthusiastic about this camp thus far. But while he is among the staunchest supporters of the rights of elephants to live out their lives in the wild, unmolested by their human neighbors, he is also a realist. He knows that with such a limited amount of wild forest available, most elephants, whether they are born into captivity or not, are destined to come into contact—and most likely perform some sort of work—with humans. "The only viable alternative for elephants today is tourism," he explains. "It's not a bad life if the operation is run well. The animals are in a natural setting and they get plenty to eat." And so he monitors the care of domesticated elephants and issues advice to mahouts and camp operators—all while realizing that often the best that can be done for the animals is to improve their lives in small degrees, one tiny battle at a time. And he believes that if elephants learn how to paint, they might earn enough in just a few hours a day to support themselves and their trainers, allowing

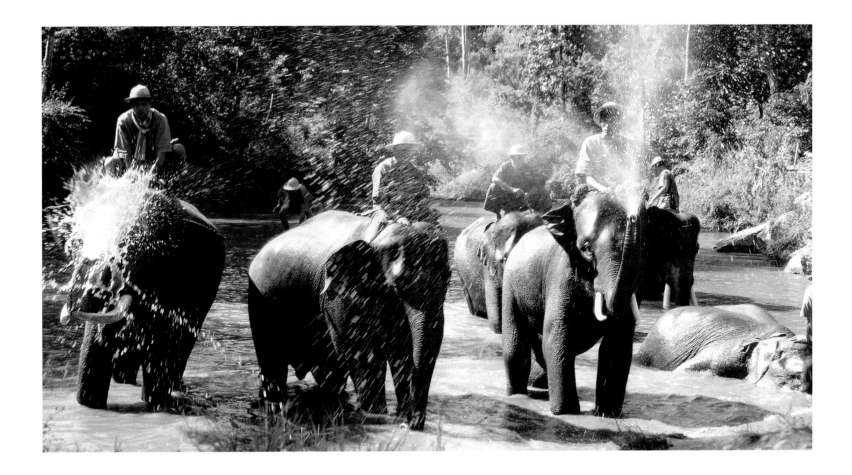

them to devote the rest of their time to gentler pursuits—like frolicking, eating, and sleeping.

After the tourist show, the group of elephants is led to a small pen alongside a river and under a high thatched roof. There three young calves have been chained to a post with art materials—canvas, brushes, paint poured into cups—arranged before them. Although Komar and Melamid have painted with elephants before, and have spent a good deal of time in their company, they are continually amazed by the animals. They embrace them with their big Russian hugs, vigorously stroking their wrinkly skin—leathery and dry to the touch but surprisingly warm and lined with bristly, whiskerlike hairs. The elephants seem equally intrigued by the pungent smells and robust cackling of their new acquaintances. They investigate the artists with their ceaselessly mobile wet-ended trunks—gingerly exploring, fondling, and then, their curiosity satisfied, exhaling through two tubelike nostrils a warm whoosh of moist air smelling of wet hay.

"Look at these beautiful ladies!" Komar roars.

The art students of Lampang wash up after their first lesson.

"Are you ready to create art?" asks Melamid. When the elephants do not answer, Melamid shakes his head. "It is not clear if they are ready."

People have written about the soulfulness of elephants, but nothing really prepares one for how intelligent, how remarkably human they seem. At first they are the animals one sees in zoos and circuses—huge, slow, gray, the big ears, that trunk—simple: elephants. Then, soon after, they take on more personality, become the creatures one sees in animated films—cute, smart, cuddly. But then, finally, after one has met and interacted with maybe ten or fifteen of them for extended periods of time, they become something else. Because of their incredible, cautious grace, and their bizarre, oversized burlap sack of skin, and their eyes, which though distant seeming are strangely hopeful and happy, and particularly because of the position of their heads in relation to their shoulders, hunched

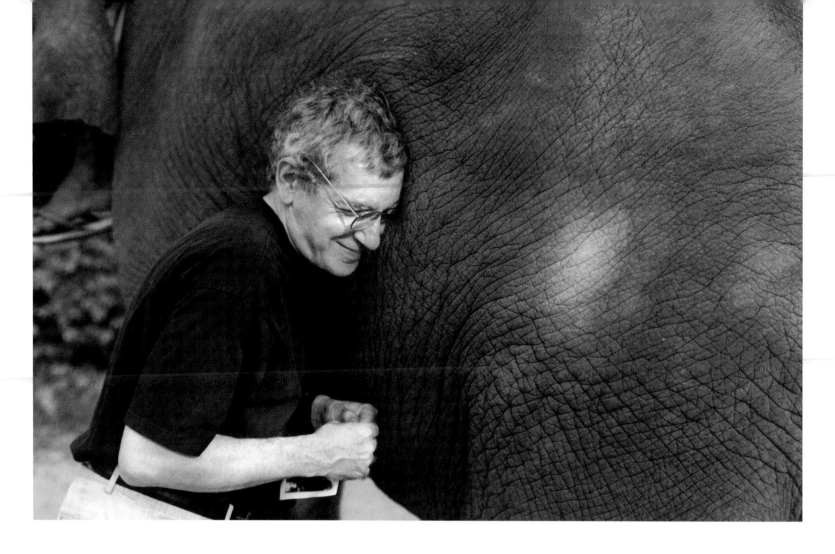

Melamid tests his strength.

over as they appear, seeming burdened by the weight of existence, they come to seem eerily emotional, oddly human.

And just about everything about elephants mirrors humans. They carry their children for longer than any other mammal, they reach maturity at the same age, and their lifespan is almost precisely equal to ours. ("The life span is very unfortunate," Melamid jokes. "Because then they will have to study art for a very long time.") And thus it seems fitting that they would be the animals demonstrating, in the blistering heat in the middle of an almost-jungle, that animals can create art.

Komar and Melamid cautiously approach the painting area, followed by their entourage and a cameraman intent on recording for posterity this first attempt to paint with elephants in Thailand.

But the question remains: will these elephants paint?

Twenty minutes later, Melamid is staring into the eyes of an elephant, even though thus far, things are not at all going according to plan. He smiles weakly at the elephant, and walks over to another. When this elephant drops the brush, Melamid picks it up from the dusty ground and gives it back. The elephant, trained to perform a variety of circus tricks, confuses Melamid's gestures with some sort of prompting, and so hands the brush back to Melamid, bows to him on one knee, lifts its trunk, and toots an elephantine thank you.

A few feet away, an elephant is trying to eat his brush. Another elephant knocks over a cup full of paint. All three elephants are restless, fidgety, annoyed. They shake their heads, pace back and forth, and, clearly confused, continue with the bowing and tooting. Though they are holding the brushes given to them—by curling their trunks around the long wooden handles—and are making marks on the canvas, as artists, they are clearly uninspired. They throw the brushes, they try to put

them on their heads. What painting the elephants actually are doing is essentially being done by their trainers—young men in blue uniforms—who are crouched at the elephants' feet, barking staccato commands in Thai—Chawa! Chawa! Chawa!—while moving the trunks around the canvas themselves, as if painting with a big hose.

The whole thing is kind of disheartening. Under a furious sun, the young elephants are trying to please their mahouts, the mahouts are trying to please Komar and Melamid and their entourage, but nothing much is happening, and spirits are beginning to flag.

Now the elephants are hungry—with their unsettling, wet-ended trunks they're fondling anyone within reach, looking for bananas. One of the mahouts pushes a bunch of tiny bananas into his elephant's mouth, and then pulls his trunk back toward the paper. The elephant emits a piercing squeak.

"What does it mean?" Komar asks.

"That means, 'Don't bother me. I'm eating,'" explains the camp owner.

Melamid watches the bedlam, hands on hips. Komar wipes sweat from his brow. They do not appear to be worried.

"No problem," Komar says. "This is just first lesson!"

The next day, Komar and Melamid have acknowledged that the first camp was a bust. The care of the elephants was adequate, but there were many disagreeable aspects of the operation, not the least of which was the fact that the elephants were chained to a post while they painted. So today the group is on their way to another elephant camp, about an hour north of Chiang Mai, where today they will meet a different group of elephants, at a much larger camp, the Thai Elephant Conservation Center at Lampang. This camp, Lair explains, is run by the Forest Industry Organization, a government agency

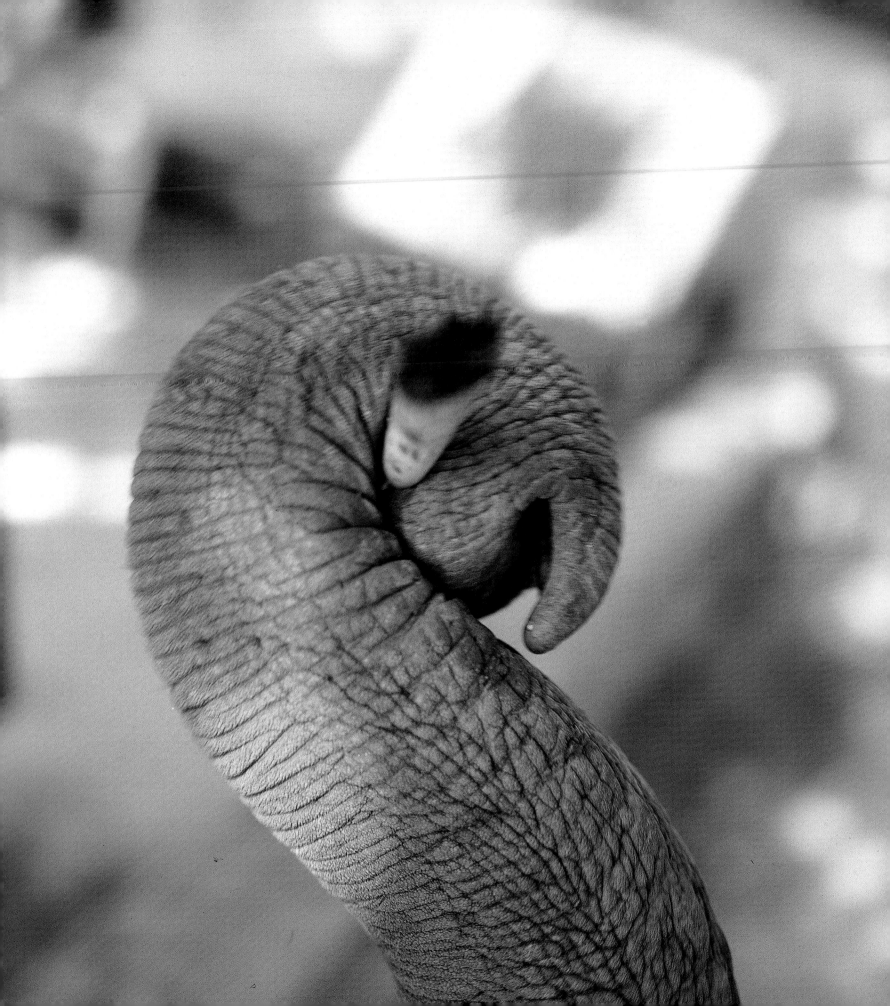

THE TOOLS

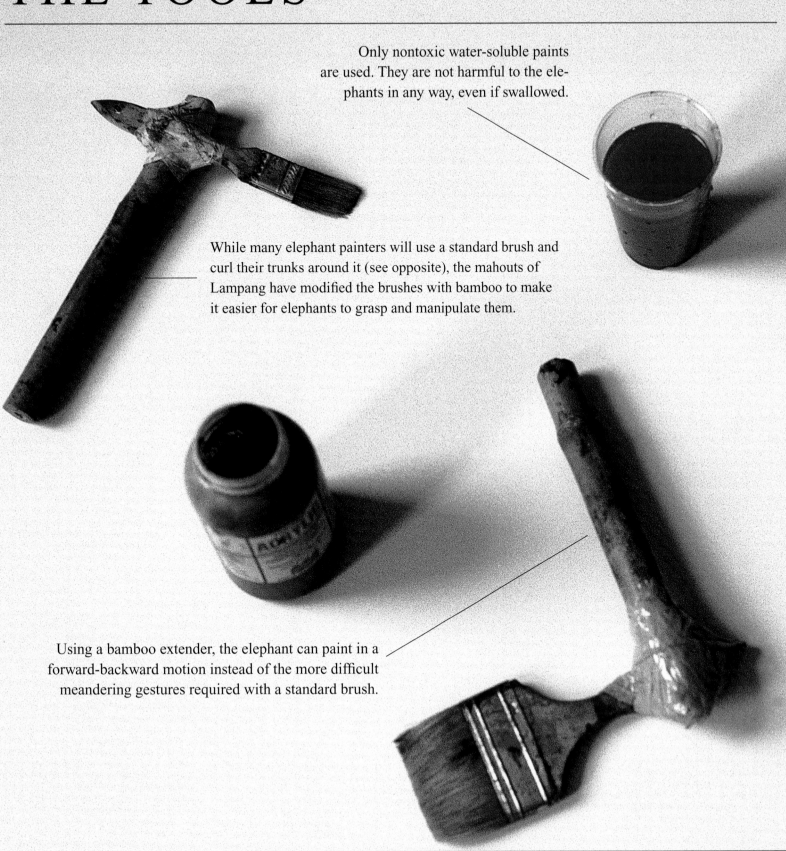

Only nontoxic water-soluble paints are used. They are not harmful to the elephants in any way, even if swallowed.

While many elephant painters will use a standard brush and curl their trunks around it (see opposite), the mahouts of Lampang have modified the brushes with bamboo to make it easier for elephants to grasp and manipulate them.

Using a bamboo extender, the elephant can paint in a forward-backward motion instead of the more difficult meandering gestures required with a standard brush.

that also helps to support an adjacent clinic which treats severely injured and ill elephants. Originally established to train young elephants for logging, the camp now serves as a sanctuary devoted to the humane care and treatment of domesticated elephants.

The van lets its passengers out near a shady holding pen where a huge female elephant hovers protectively over her shy three-month-old calf. The pair, the group is informed, was recently rescued from a dangerous illegal logging operation near the Myanmar border, where—exhausted, over-worked, and nearly skeletal—they had been left to die. Lair walks over to a group of mahouts eating lunch near the entrance to the camp. He has known most of them for years, and they laugh uproariously at a series of jokes Lair rattles off in perfectly idiomatic Thai. The mahouts at the TECC tend to be older, in their thirties and forties. Most have been tending elephants since childhood, and as a result they are both highly skilled and astutely sensitive to the moods and behavior of their animals.

Komar and Melamid's group helps the mahouts to prepare for the day's lesson. The mahouts arrange the elephants, six of them, in a roughly oval area, under a group of trees. The paper, luminous in the dappled sunlight, is clipped to boards set before each elephant and liquid acrylic colors are squeezed into plastic containers set at their feet. An assortment of brushes is provided for each elephant, with water nearby for cleaning.

When they paint, ideally it works like this: the mahout, crouching on the ground at the elephant's feet, dips the brush into whatever color he sees fit. He gives the brush to the elephant and maneuvers the trunk, now grasping the paint-soaked brush so that it meets the canvas. He then guides the trunk around the canvas in slow, circular movements, giving the elephant a feel for the action desired. The hope is that, after some practice and verbal encouragement, the elephant will get the hang of it, and will begin to move the brush around independently—will begin, in other words, to paint. When the session is over—in about an hour and a half—their efforts will be amply rewarded with towering piles of sugarcane and fruit.

The canvases are propped up on easels beneath a cluster of trees; the sunlight traces a mottled pattern on their surfaces. Expectations are high. Indeed, here everything is different. The mahouts are older, more experienced and easygoing. There are no chains around the elephants' legs, and these mahouts do not bark impatient commands. Instead, they coo encouragement. "Jam-way, jam-way," they say, over and over. "Re-

Students at work at the Lampang Elephant Art Academy.

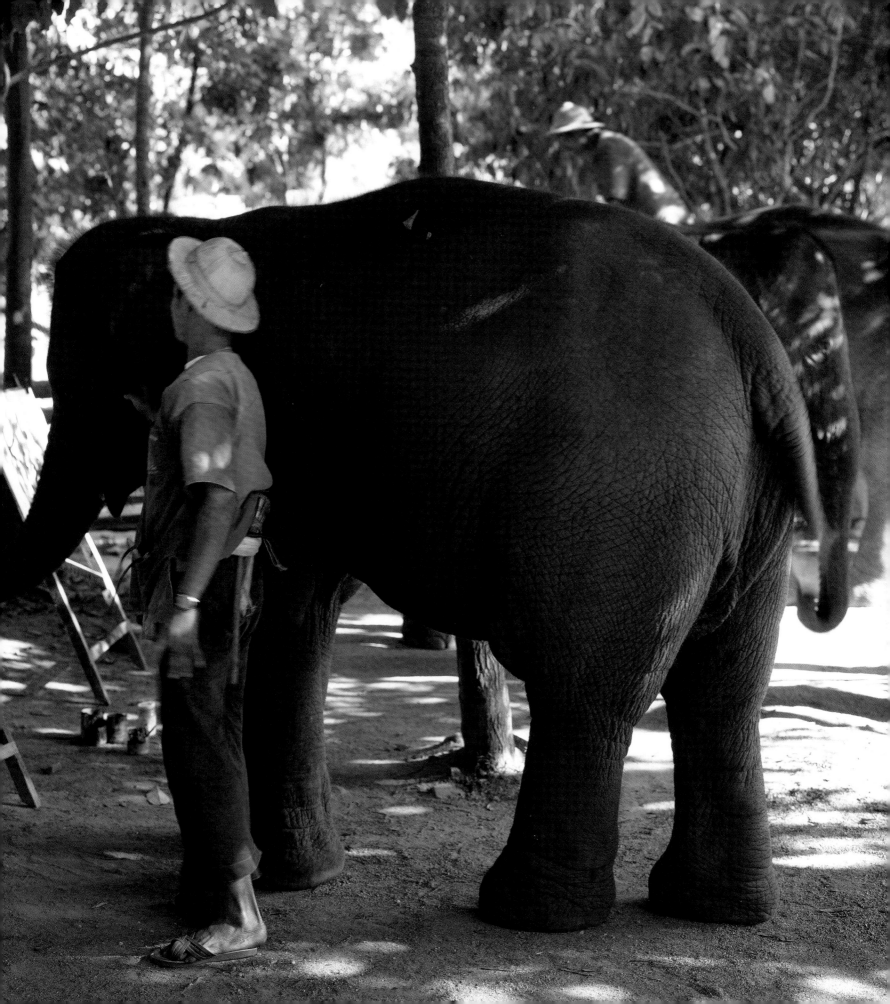

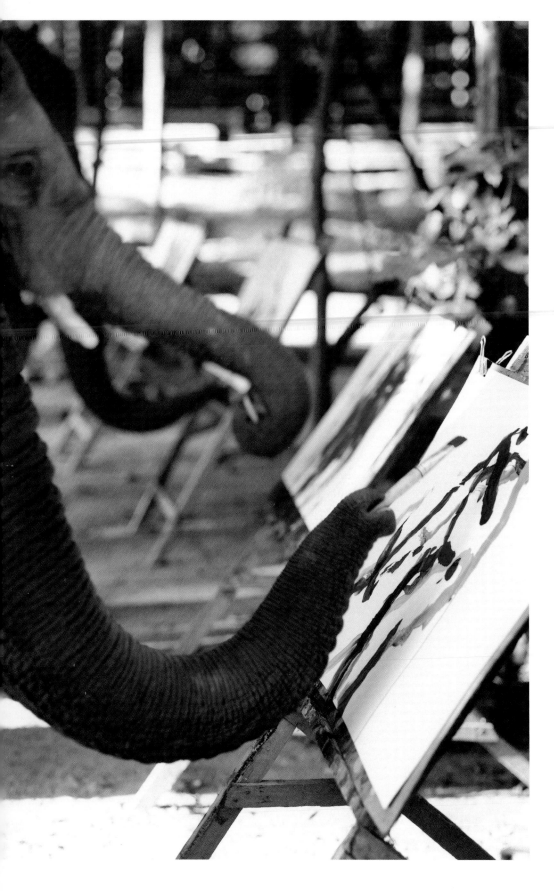

member, remember." (In sharp contrast to yesterday's mahouts, who were yelling "Quickly! Quickly!")

With everything in place, Melamid gives a signal, the mahouts begin to give commands, and the elephants start painting. The brushes are flying, filling the bright white canvases with color, bold streaks and twisty worms of brilliant acrylic pigment. With six elephants painting, the action is fast, hard to follow. But what's happening is remarkable. They really are painting! And in half a dozen different ways, each filling its canvas with entirely different marks, entirely different styles. One elephant swings the brush backward and forward with broad sweeping strokes, covering the canvas with heavy tectonic lines, like Franz Kline. Another twists and turns the brush to create an open web of loose lyrical arabesques—something like the paintings Brice Marden made with a paintbrush tied to a tree branch. Another lets the brush slither around drunkenly, as if hypnotized by the rhythmic motion—the marks of a young Phillip Guston. Incredibly, these elephants who have never painted before are soon doing it on their own, with a minimum of prodding from their mahouts and no stops for bananas—in other words, with no obvious reward serving as motivation, and no use of coercion, the elephants are indisputably creating art.

"It looks like a school already," announces Melamid gleefully.

The paintings are completed at a furious pace. Five minutes, and the mahout removes the canvas, setting it aside to dry in the sun, while the elephant starts on the next one. After half an hour there are almost thirty finished paintings spread all over the dusty grounds.

An academy-style art class at Lampang.

The mahouts' color preferences show, as some guide the elephants to darker palettes, others to brighter and more varied combinations. In a sense, of course, the mahouts, too, are learning to paint. Most of them have no art background; indeed, before Komar and Melamid's visit, none among them had ever seen abstract art, a genre that the Thai didn't have a word for until ten years ago. This journey of art-making is a first for both animal and trainer. Komar and Melamid's interest in the collaborative spirit of art has seemingly reached an apex.

"You see," notes Komar, while watching the action, "I collaborate with Alex, and we collaborate with mahouts, and mahouts collaborate with elephants. It is beautiful way to make art. Then viewer of art is last collaborator. They decide what art means to them."

After forty-five minutes or so the mahouts and elephants take a break. The elephants are given sugarcane as a treat for their hard work, the results of which are splayed all around them, drying in the noontime sun: about fifty paintings, bursting with raw energy, colors bright and uncomplicated, markings that are the pure two-dimensional incarnation of anima, pure id.

A small crowd of tourists who have come to see the logging demonstrations has congregated around the painting area, pointing curiously at the canvases laid out on the ground.

"Is this, like, some kind of performance art?" asks a young man in black shorts and a black T-shirt, as he drops a bulging backpack at his feet.

Melamid hesitates. "Well . . . what do you think?"

The young man glances at his companion, a young woman also dressed in black, clutching a clear plastic Hello Kitty handbag.

"I don't know," he ventures. "I mean, it seems like some kind of sixties-style Happening, you know, like that guy Yves Klein who hired a couple of chicks to smear themselves with blue paint and use their bodies as paintbrushes on the gallery floor."

"Hmm." Melamid looks pensive.

"Or, like, a few summers ago I was in Berlin when Christo wrapped the Reichstag with that tinfoily stuff. It was a real scene, man. People hanging out on the lawn with guitars talking about the future of Germany and how it's the first time it's been reunited since Hitler and shit. Who are you guys anyway? Did I see you on MTV?"

"No, that was those other guys," the young woman says. "Gilbert and George, I think. This is cooler. It's like, how do we decide who gets to be an artist and who doesn't? Who gets to say what's good art and what's not? Like, when Marcel Duchamp tried to put a urinal in an art gallery and there was this huge scandal but now it's in, like, the Museum of Modern Art and everyone's, like, 'Isn't this great?'"

"Maybe you're right," says Melamid. "There's certainly a very good chance that you're right. But then again, maybe you're wrong."

Meanwhile, Emery has spotted a middle-aged couple from Michigan lingering nearby and, recognizing them as the sort of people the Asian Elephant Art and Conservation Project hopes will buy the artwork, asks them if they would consider purchasing such a painting. Hypothetically, of course.

"Oh sure," the woman says, holding up one of the paintings. "It looks like something you'd buy in a gallery."

Her husband looks annoyed. As they turn to leave, he leans over and whispers to her, still within earshot of the group: "Well, it looks to me like some kind of a hoax."

"Of course it's all a hoax!" says Melamid, later, at dinner. "But all art is a hoax. Like the idea of three-dimensionality in paintings, the creation of illusion. 'It's a window! No, it's a painting! Oh my God, what a master!'"

The whole entourage is outdoors, at a long table in a riverside restaurant in Chiang Mai, and there is much talk about the success of the day's trip to Lampang, and about its implications.

"Every art movement starts as a joke or a sham and then becomes a serious occupation or a revelation. Like Impressionism—Edouard Manet's *Olympia* was a parody, a caricature of Titian's *Venus*. It was a funny picture. But then it became a great work of art. Maybe it was human stupidity. Don't forget, all stupidity is serious. Jesus never once smiled in the Scriptures."

First of all, there is confidence all around that the Thai Elephant Conservation Center, with its healthy elephants, superb facilities, and skilled mahouts, would be an ideal location for the flagship elephant art school. Then there is the issue of just what happened. A group of elephants, six of them at one

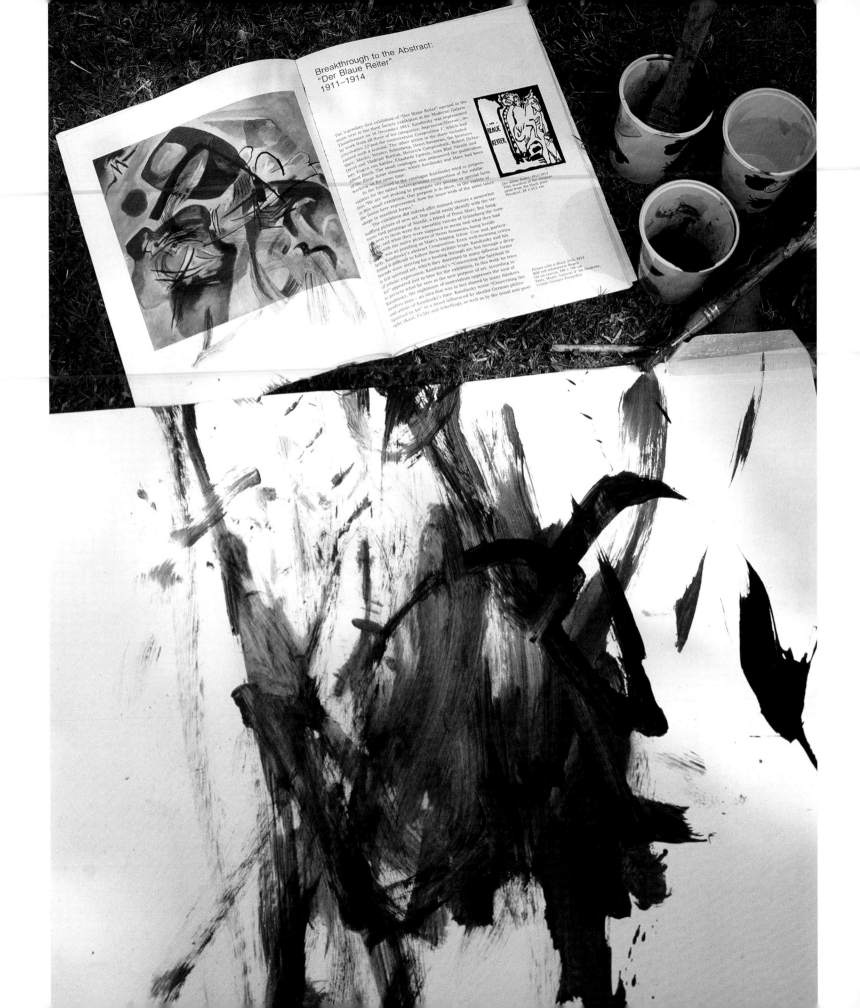

Breakthrough to the Abstract:
"Der Blaue Reiter"
1911–1914

The legendary first exhibition of "Der Blaue Reiter" opened in the room next to the third Society exhibition at the Moderne Galerie Thannhauser on 18 December 1911. Kandinsky was represented by work from all three of his categories: *Impression-Moscow, Improvisation 22* and the controversial *Composition V*, which had caused such a scandal. The other artists in the show included Marc, Macke, Münter, Schönberg, Henri Rousseau, the brothers David and Vladimir Burliuk, Heinrich Campendonk, Robert Delaunay, Eugen von Kahler, Elisabeth Epstein, Jean Bloé Niestlé and Albert Bloch. The small catalogue also announced the publication of the *Blaue Reiter* almanac, which Kandinsky and Marc had been working on for some time.

In the foreword to the catalogue Kandinsky tried to prepare visitors for the rather heterogeneous composition of the exhibition – "We are not seeking to propagate any precise or special form in this small exhibition. Our purpose is to show, in the variety of the form here represented, how the inner wish of the artist takes shape in manifold forms."

The exhibition did indeed offer stunned visitors a somewhat baffling picture of new art. One could easily identify with the virtuoso bird paintings of Niestlé, a friend of Franz Marc. But hanging next to them were the unearthly visions of Schönberg the composer and what they were supposed to mean and what they had to do with the naïve pictures of Henri Rousseau, hung beside the puzzling picture of new art. One could easily identify with the virtuoso bird paintings of Niestlé, a friend of Franz Marc. But hanging next to them were the unearthly visions of Schönberg the composer and what they were supposed to mean and what they had to do with the naïve pictures of Henri Rousseau, hung beside the puzzling Kandinsky's abstract *Composition*. Even well-meaning critics found it difficult to follow these stylistic leaps. Kandinsky and his friends were striving for a healing through art, but through a deep felt spiritual art, which they discerned in many different forms of artistic expression. Kandinsky's "Concerning the Spiritual in Art" appeared just in time for the exhibition. In this work he tries to present what he sees as the new purpose of art. According to Kandinsky, the nightmare of materialism oppresses the soul of modern man – an idea that was in fact shared by many thinkers and artists of Kandinsky's time. Kandinsky wrote "Concerning the Spiritual in Art" in a mood influenced by idealist German philosophy (Kant, Fichte and Schelling), as well as by the usual anti-posi-

57

Der Blaue Reiter, 1911/1912
Title woodcut of the almanac print from the black plate
Woodcut, 28 x 21.2 cm

Picture with a Black Arch, 1912
Bild mit schwarzem Bogen
Oil on canvas, 188 x 196 cm
Paris, Musée National d'Art Moderne,
Centre Georges Pompidou

time, created art that could very easily be mistaken for work created by human artists. In three-quarters of an hour, they produced fifty paintings singing with color and emotion.

Big plans are made.

Komar and Melamid want to "flood the world" with elephant art. They want to make it available to people all over the world, to first sell it all over Thailand, have it in all the hotels, sold in every shop. And that would be just the beginning. Though the Thai Elephant Art Center would start modestly, with three to five elephants on a smallish parcel of land, there would soon be room for dozens of elephants, elephant experts, an educational center, a veterinary facility, a gift shop, an on-site gallery! And then other centers to aid elephants and their trainers—in Nepal, South India, Laos, Vietnam, Malaysia, and Indonesia.

Melamid is asked if the elephants really know what they're doing when they create paintings, if they understand that they're making art. He shrugs.

"We don't know either what we are doing when we make art, so why should they? We think we understand, we use words like 'because'—a painting is good because the artist had a certain feeling or idea, because he somehow turned that idea into an image—but really we have very little idea what we mean by that. What is art about? We use words like genius, brilliant, spirit, but we don't know what these things mean, either."

One thing that everyone can be sure about, though, is that the elephants' paintings are stunning in their resemblance to the work of the Abstract Expressionists. And this is fitting, of course, as that movement attempted to strip painting down to its essentials, to a purity of color and mark-making for its own sake, to an unfiltered, action-oriented process that had little use for precision or careful deliberation.

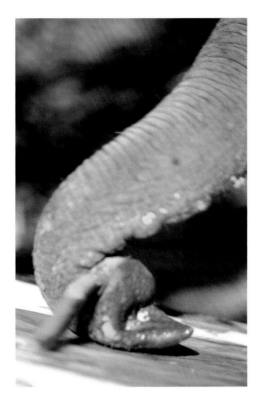 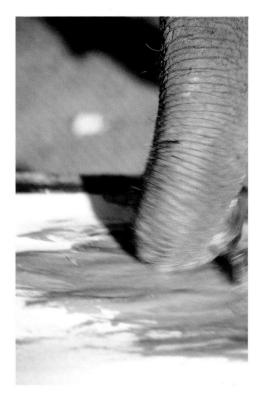

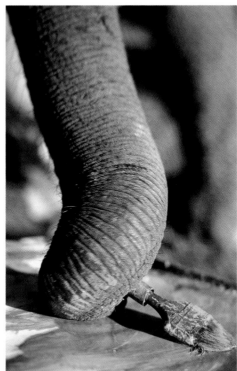 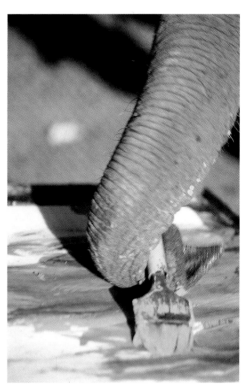

ABOVE: *Juthanam at work, step by step.*

FACING PAGE: *The elephants of Lampang absorb the lessons of the Russian modernist master, Vasily Kandinsky.*

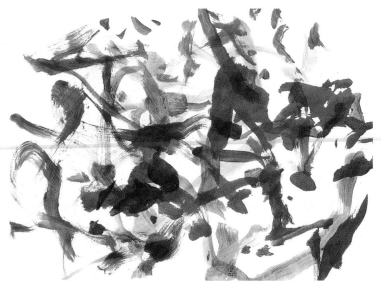

Lukkang, Untitled, *1998, acrylic on paper.*

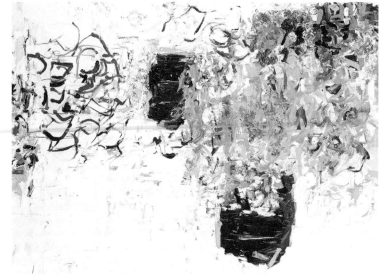

Joan Mitchell, Sunflower III, *1969, oil on canvas.*

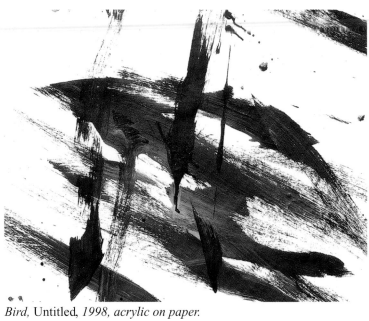

Bird, Untitled, *1998, acrylic on paper.*

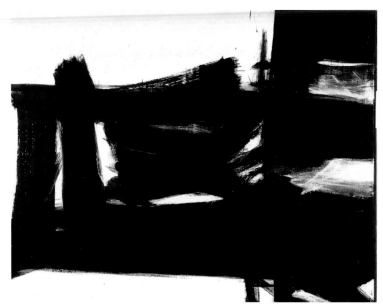

Franz Kline, Meryon, *1960–61.*

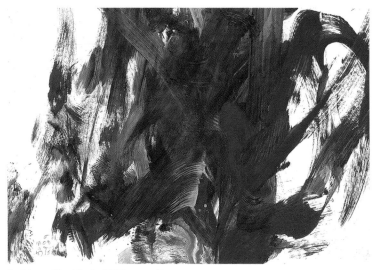

Lukkop, Untitled, *1998, acrylic on paper.*

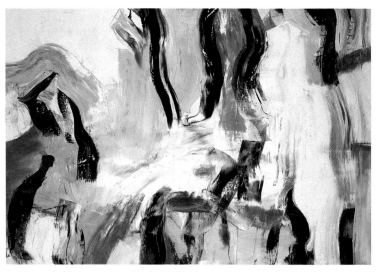

Willem de Kooning, Untitled V, *1981, oil on canvas.*

"I painted abstract paintings for a year in my early twenties," notes Melamid. "And it's a really great occupation because you really don't know what you're doing. But something is right, something moves your hand around a canvas, like an external force."

What mattered with the Abstract Expressionists was the most direct transference of the artist's will, his or her muscle and sweat and energy, to the canvas. For Willem de Kooning, it meant a vaguely representational sort of art, where a portrait of a woman became a frenzied, swirling picture of anger and confusion—the woman at its core hardly recognizable. For Jackson Pollock, it meant going even further, eschewing even the touching of brush to canvas in favor of simply dripping and throwing the paint upon the canvas, not stretched but simply laid out on the floor.

"Abstract Expressionism is elephant painting," Melamid says. "Both are totally mindless occupations. Pollock, when he discovered drip painting, did he think about it? Even when I paint a realist painting, do I really think about what I'm doing as I'm doing it? If you think about it, it shows, and it's not good. Elephants are really the best Abstract Expressionists—they don't think too much."

And now these elephants, halfway around the world, have picked up the mantle. They, too, toss paint onto the canvas. They, too, reduce art-making to pure anima. They, too, paint with a canvas at their feet, and create without any intellectual second-guessing.

"It's not the intention of the artist that matters," says Melamid. "It's the later interpretation of their intention that matters. There are a lot of people who paint without an extensive knowledge of art history. Outsider artists don't know their place in art history, but does it matter? We're as good as we're judged to be—or as bad."

Komar has been nodding. He leans over to make a point.

"Some people believe that piece of art is like a radio station, and the viewer is like a radio that receives these waves. I believe it's different: we are the radio station and we project onto the work of art our thoughts, our knowledge. Let's take an example: even if we do not know the name and life story of the creator of the Venus de Milo, we still bring to it what we know about goddess of love, about ancient Greek and Roman art,

about incident of vandalism that robbed the goddess of love of her arms, et cetera."

"Yes," says Melamid. "That is why the story of the elephants is so important. This is not just about the paintings made by elephants. It is about the fact that elephants are painting."

Komar leans forward again.

"And who is to say these animals are not artists?"

Early the next morning, the group is back in the van and headed for Surin, a province in the northeastern corner of Thailand, next to the Cambodian border. Pittaya Homkalitat, an elephant field expert with close ties to the region, has joined the group as a guide for this leg of the trip. An avid photographer and composer who writes songs about elephants and handicapped people based on traditional Thai melodies, Homkalitat is slender and soft-spoken, his voice lilting and melodic. His English, though passable, is a little rough at the edges. As Melamid regales the van's sleepy passengers with a caffeine-fueled monologue about his latest brainchild, Light and Shadow Therapy, a "healing, preventic, and holistic therapy" that involves "lumen massages" and "light infusions" administered by a trained technician (none other than Melamid) in a white lab coat wielding an array of flashlights, candles, and laser beams, Pittaya looks more and more confused.

"I think I understand about seventy percent of what you say," he admits sheepishly.

"Seventy percent is too much," says Melamid. "Thirty percent would be better."

On either side of the bumpy two-lane dirt highway is an endless flat expanse of rice fields, pinkish gold and green, dotted with shade trees and the occasional water buffalo wallowing in shallow muddy pools by the side of the road. The lush forest and grasslands that once covered the region were clearcut in the 1960s to make way for the rice paddies, and the villagers' flimsy wooden shacks are propped up on stilts to protect them from the annual floods. It's harvest time, and in the distance, farmers in broad cone-shaped hats chop at the slender stalks with long, arching blades. Then they tie the glasslike stalks into bundles and carry them through the fields

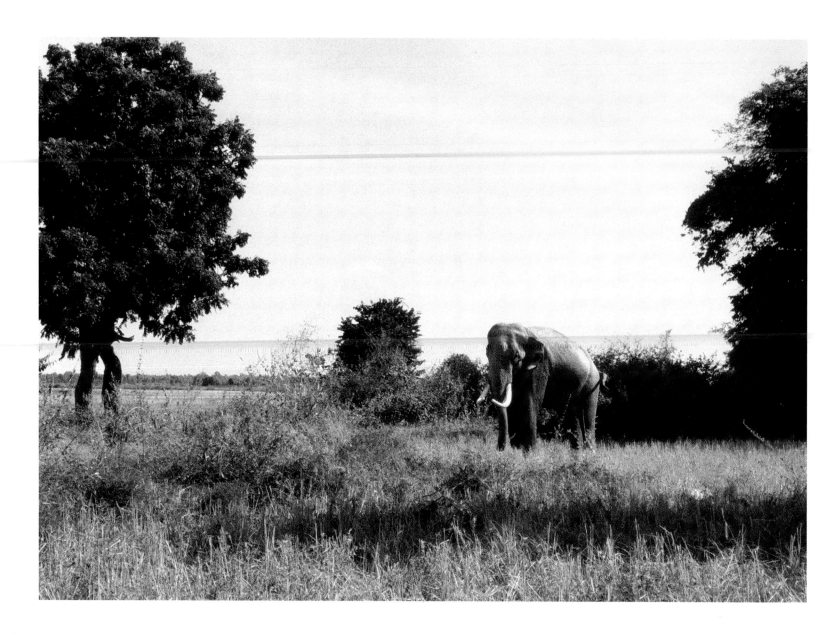

The male tusker who killed a foreigner last year.

on sticks balanced on their shoulders like scales. The sky here is big, the air smells sweet.

Komar is still lugging around his personal air conditioner, sweating profusely under the added burden. He has given up on it.

"Pull over," he commands the driver. When the van stops at a gas station, he gets out, walks determinedly to the side of the building, and kicks the device onto a pile of trash. He returns to the van unburdened.

"I put my faith in technology," he says, settling into his seat. "It was biggest disappointment of my life."

On the way into town, the van stops at the ranch-style house of the village "Big Man." He's a descendant of the Suay people, an ancient tribe indigenous to the northeast region who have hunted and domesticated elephants for centuries. Homkalitat introduces the artists to the Big Man, who is actually a very small man in his late sixties with a feathery beard and dark rheumy eyes. There's a lot of bowing and polite genuflection. Pittaya quickly explains their mission in Surin, and the Big Man generously agrees to round up a few young elephants early the next morning. "Mai phen rai," he says—no

problem. Meanwhile, the rest of the entourage has collapsed on the smooth dark wood floor of the Big Man's front porch, lazily sipping green tea and snapping pictures. Zinovy Zinik, a BBC correspondent and Melamid's oldest friend from Moscow who has come along to cover the event, wanders off to record the braying of water buffalos in the front yard with his obscenely large BBC microphone. The humpbacked beasts sniff at the microphone; once they determine it's not food, they quietly return to their grazing.

Later that afternoon, the artists and their entourage check into the biggest hotel in downtown Surin—a gleaming white neoclassical building, the tallest in town. The rooms, however, are small and windowless, their walls covered with rancid yellow fake wood paneling. To compensate for the lack of a view, one wall of each room is plastered with a garish mural-sized photograph of an exotic landscape: rolling fields of red poppies, a blue ocean and white sand, palm trees against an azure sky.

Tired and thirsty, the group adjourns to the hotel lounge, where young Thai women in white thigh-high boots dance on stage before a magenta and yellow sunburst, lip-synching to Bon Jovi songs. After each number, they cruise around the tables and sit with the customers; Melamid beams at them, wide-eyed with admiration: "What a woo-mon!" he crows at each in turn.

Komar, Melamid, and Zinik share a bottle of Thai rice whiskey, an innocuous-looking clear liquid that tastes something like turpentine mixed with sugar. For Russians, Zinik explains, glass in hand, drinking is more than a recreational pursuit, for vodka is the very spirit from which Russian spirituality is derived. "Russians consume all kinds of drinks under different cir-

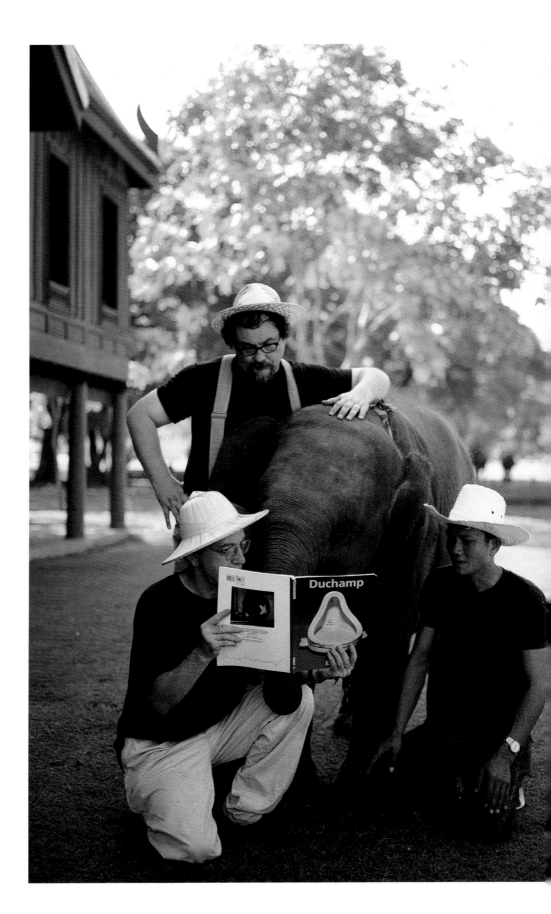

A young pupil learns about his artistic forebear Marcel Duchamp.

The lovely chanteuses of Surin.

cumstances," he continues. "Jesus turned water into wine, but we turn any kind of wine into vodka. We drink sherry and Pernod and Cuban rum—and even this dreck—but we drink them all as though they were just different types of vodka with exotic labels on the bottle."

And with this, Komar, Melamid, and Zinik—three exiled Russian-Jewish dissidents and childhood friends—solemnly raise their glasses and drink to Mother Russia.

The next morning, pale and bleary-eyed, Komar and Melamid and their entourage are on the road before dawn. After a brief courtesy call with the Big Man, everyone climbs back into the van, which carries them a few miles down the dusty two-lane road and then stops. There is nothing but yellow rice fields and blue sky as far as the eye can see. Supplies are unloaded and hauled out into the middle of the field. There's a large tusker chained to a tree a few hundred yards away. "Don't get too close to him," Homkalitat warns the group. Why? "He killed a farang [a Westerner] last year. A tourist from Europe—gored him to death."

And then, seemingly out of nowhere, three young elephants appear with their mahouts. The mahouts here are in their teens and still attend the local high school. They wear baseball caps and bandannas on their heads; their T-shirts bear English slogans like "Captain America" and "Red Bull." One of them proudly sports a black T-shirt printed with high-kitsch renderings of the faces of *Titanic* stars Leonardo di Caprio and Kate Winslet that look like they could be painted on black velvet.

The painting lesson begins at 7:30 A.M. Komar and Melamid stand with the elephants and mahouts in the middle of a dry rice paddy. Tiny red ants crawl up their ankles and under their black socks, happily gorging themselves on the exotic taste of Russian blood. The sun hangs low in a cloudless sky; the air is relatively cool. The elephants, fresh from their baths, seem to be in a good mood, rumbling and squeaking and swinging their trunks in anticipation of a taste of the sugarcane piled in a nearby basket. Komar clips some fresh sheets of paper onto the particle boards and begins squeezing acrylic paints into small plastic containers laid out on the ground.

The mahouts look a little apprehensive. None of them has ever set foot in an art museum, they don't know anything about painting, they've never done it themselves.

"What color should I use?" one of them asks Emery in Thai.

"Whatever you like," she tells him. "This is a collaboration between you and your elephant."

"Okay," he says, mustering his confidence. "I feel like something really intense today." He dips the brush in industrial orange.

Komar and Melamid step back and let the mahouts take over. Tong Chai, a five-year-old

The first lesson at the Surin Elephant Art Academy.

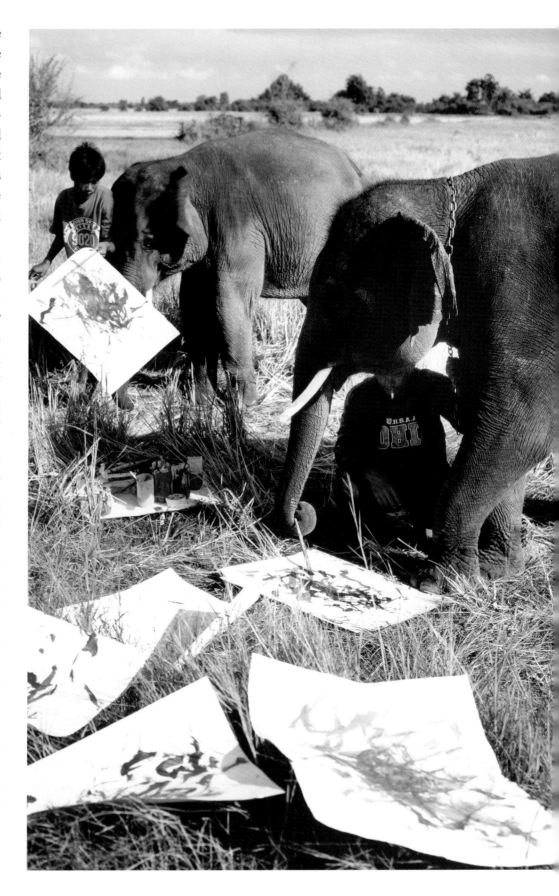

DR. IGOR'S EXPERIMENT

"**W**hen we were in art school," Melamid says in the van one day, "the most important thing was to have a 'good sense of color.' My parents—they were intellectuals—weren't so happy that I was on this track of being an artist. I was always a terrible student and they were afraid I didn't really have any talent. So they came to the school to talk to my teachers, to ask them if I wouldn't be better off learning a trade, like making belt buckles or fixing radios, something useful. But my teachers told them, 'Don't worry, he has a good sense of color,' and they went home happy."

"Yes. Is very important," says Komar. "But how do we know about elephant sense of color? We can't ask them. Maybe we should make experiment. Dr. Igor?"

Dr. Igor Galinka, seated in the front of the van, looks vaguely annoyed. He wasn't planning on a working vacation, but he is, after all, a man of science.

"All right," he sighs. "I can set up a test, but the results won't be conclusive. We don't have the proper facilities out in the field—there are too many variables, and we can't bring the elephants into a laboratory. But I'll give it a try."

When the van arrives back at the rice field for the afternoon session, the elephants are already there, waiting in the shade.

"Get me some bananas," Dr. Igor says, "and some paint."

Working quickly, he pulls seven bananas off the bunch, and paints each a different color: red, orange, yellow, green, blue, purple, black.

He lays them out in a row on a makeshift table and calls for his first test subject. The mahouts lead Bok Bak, the youngest of the three elephants, over to Dr. Igor's field laboratory.

"Now don't give him any cues," Dr. Igor instructs them. "Just let the elephant pick whichever color banana he likes."

Bok Bak approaches the neat row of rainbow-colored bananas. He tentatively sniffs at the yellow banana, fingers it with the tip of his trunk, then backs away in confusion. There's something wrong here, something very wrong, but . . . what the hell. Bok Bak picks up the orange banana and tosses it in his mouth, then quickly moves down the line, devouring the rest of the bananas one by one—black, purple, blue, green, yellow, red.

"So, Dr. Igor, what does it prove?" Komar asks.

"Well," he says with the accumulated authority of a medical degree and two Ph.D.s. "The elephant clearly went for the more brightly colored bananas at the beginning. It's not necessarily the yellow, but more likely the brightness of the color that attracted his eye. Tone or hue—we don't really know which is more important to elephants at this stage. Or maybe it was the smell of the pigment—that's another hypothesis. But at this point, I would have to say, in my professional opinion, and in the absence of other supporting data, that the experiment proves absolutely nothing."

"Thank you, Dr. Igor," Melamid says solemnly. "Thank you for the scientific perspective."

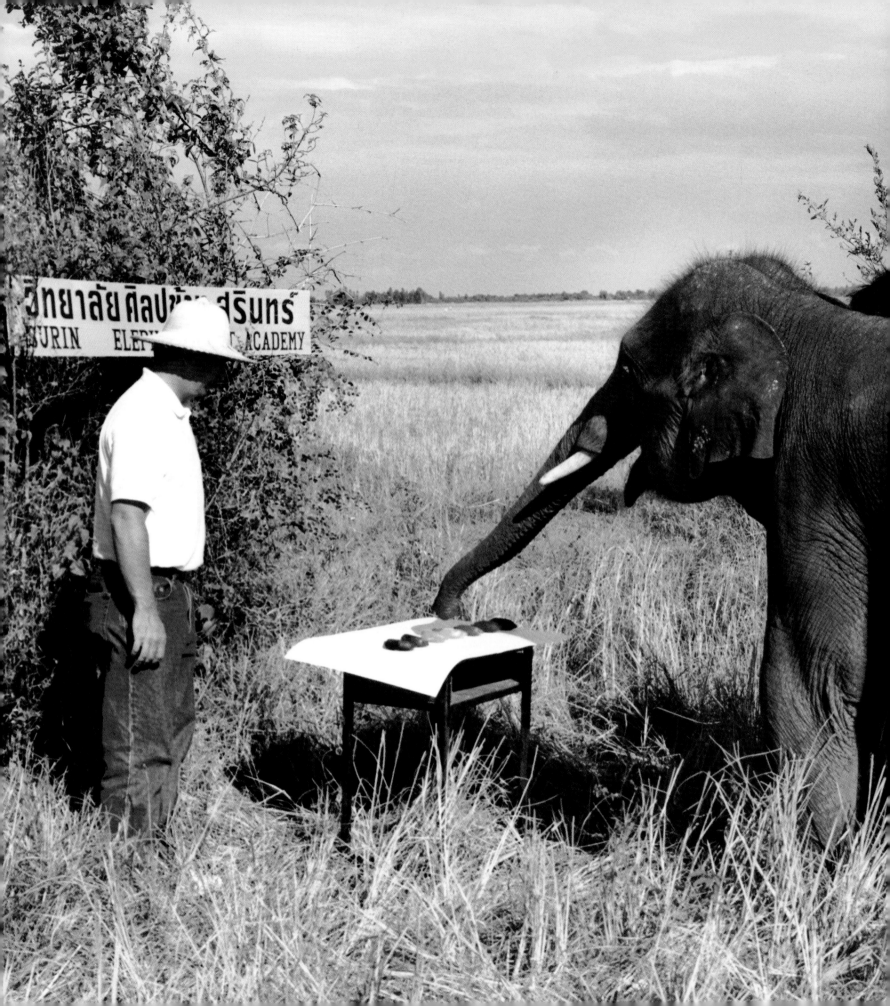

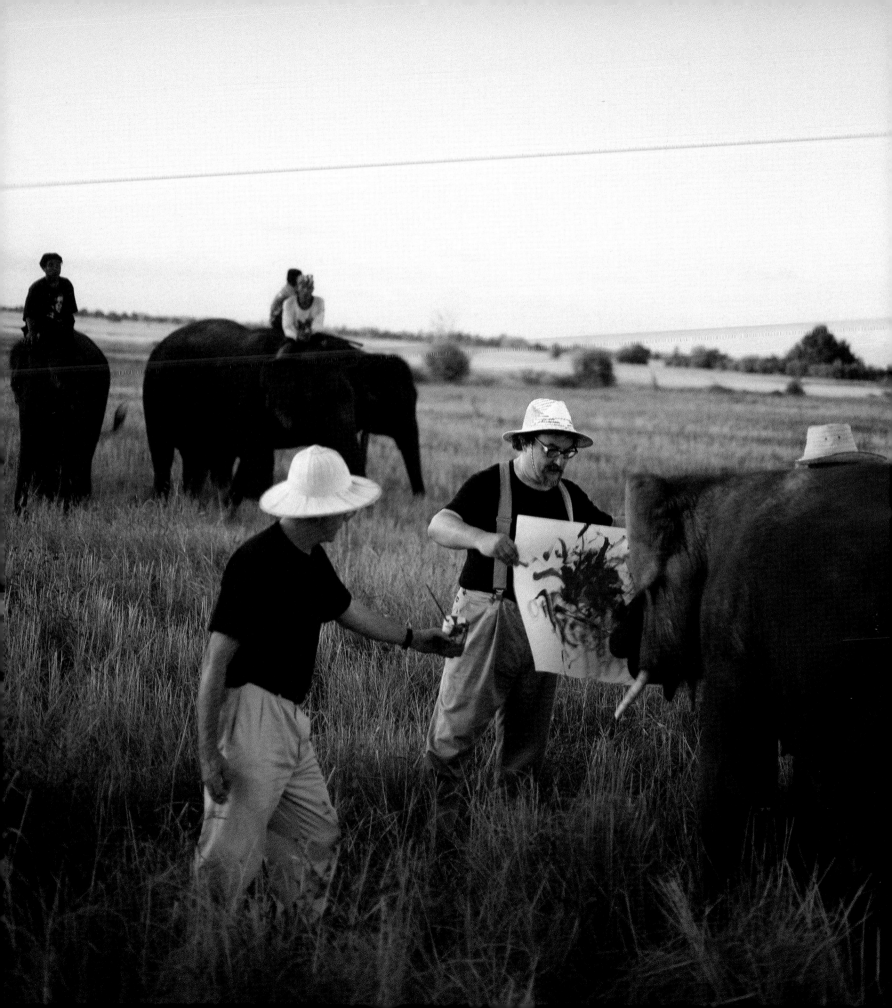

male, picks up the brush with the tip of his trunk and tentatively places it in his mouth. Crouching at his feet, Bratip, his fourteen-year-old mahout, gently guides his trunk back toward the paper. "Euuughhha, euuuughhha," he says by way of encouragement. Tong Chai swishes his tail, flaps his ears, and casually tosses the paintbrush to the ground.

"Gep! Gep!" ("Pick it up!"), the mahout commands. Tong Chai stretches out his trunk to retrieve the brush, and delicately touches it to the paper at his feet. He hesitates a moment, as his breath rushes out the end of his trunk with a soft whooshing sound. Then, holding his trunk straight, he takes a step backward, slowly dragging the paint-loaded brush across the paper, leaving behind a brilliant streak of cobalt blue. "Geng mark!" ("Well done!") Bratip says, smiling with satisfaction.

ABOVE: *Melamid prowls an indoor food market in Bangkok.*

FACING PAGE: *Komar and Melamid discuss the day's work with one of their students in Surin.*

The elephants are catching on. Brushes fly in a focused flurry of activity as the elephants fill sheet after sheet of blank paper with loopy, calligraphic streaks of color. As each painting is completed, Emery carefully lays it out to dry in the sun a few yards away from the elephants. Red ants swarm across their shimmering surfaces, drowning in the liquidy pigment.

With the first lesson successfully completed, the group breaks for lunch. Seated beneath a rickety straw lean-to, they chew on skinny chickens cooked on an open grill and swat at the large black flies that swarm around the table. For dessert, they

LEFT: *Stir-fried elephant dung beetles, a northern Thai delicacy.*

FOLLOWING PAGES: *Komar and Melamid at the end of a successful day in Surin.*

are treated to durian, a melonlike fruit with the pungent odor of an open sewer. Nearby, an old woman in a colorful silk sarong sits in the shade chewing betel nut, her lips and her few remaining teeth stained with the bitter red juice. After lunch, Pittaya drives the group to an open-air market. They wander through row upon row of stalls selling stir-fried insects, huge slabs of bloody, fly-covered meat, caged birds, rabbits, dogs, and guinea pigs, and, most spectacularly, two hairless buffalo fetuses laid out next to a floppy white placenta. The fetuses, says the vendor, are so tender you can chew right through the bone. "Like veal," Lair comments, "taken to its logical extreme." And then the food machismo begins. Lair buys a plastic sack of deep-fried salted bamboo larvae—insect fetuses, essentially, that taste a little like potato sticks if you close your eyes. In the adolescent spirit of gross-out one-upmanship Melamid proffers a handful of stir-fried elephant dung beetles, cracking open the enormous insect's brittle carapace to reveal a tiny knot of white flesh that tastes vaguely like smoked crab. The group ambles back to the van to find one of the filmmakers regurgitating the delicacy.

"Ha," says Melamid, looking at the splattered food on the sidewalk, multicolored, splayed out like an array of paint thrown on a canvas. "Not bad."

As the sun sets, Komar and Melamid return to the makeshift camp and bid the elephants farewell. "Another day, another art school," Melamid sighs. Back at the hotel, the group convenes for another marathon planning session. How much should the paintings sell for? Fifteen dollars seems like a lot in Thailand, but it's small change in New York, where the real collectors are. Should they be thinking about merchandising—images of elephant paintings on T-shirts, coffee mugs, wallpaper? Someone has a brother with connections at Barneys—maybe a line of children's clothing? And yet, despite hours of discussion, analysis, and rehashing, nobody really seems to have a handle on why or how this is all happening, where it will lead, what it all means, except to agree that—for whatever reasons—at least for the moment the Asian Elephant Art and Conservation Project appears to be unstoppable.

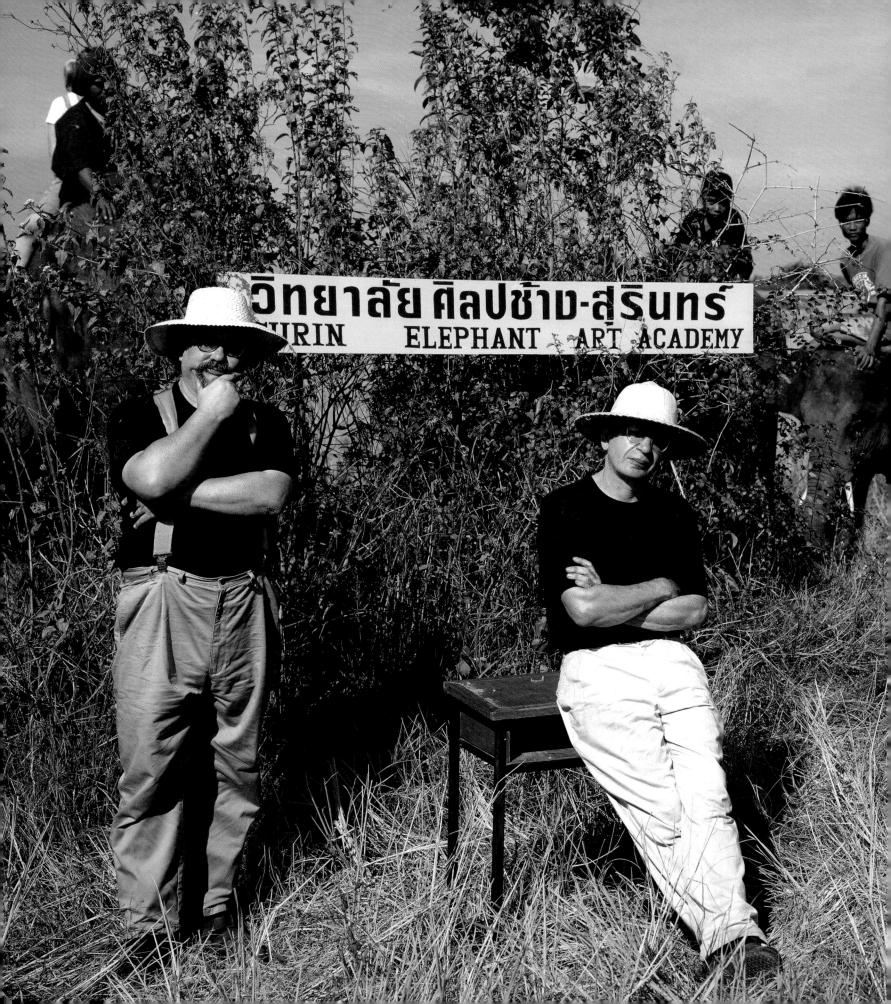

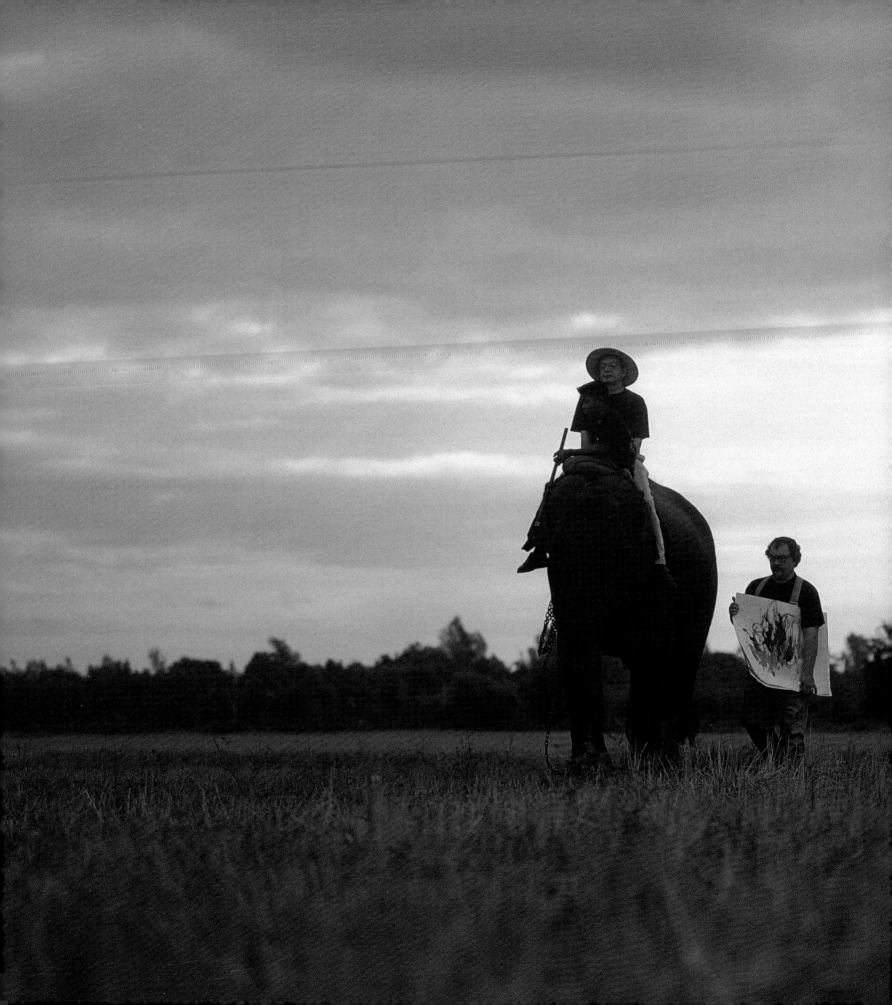

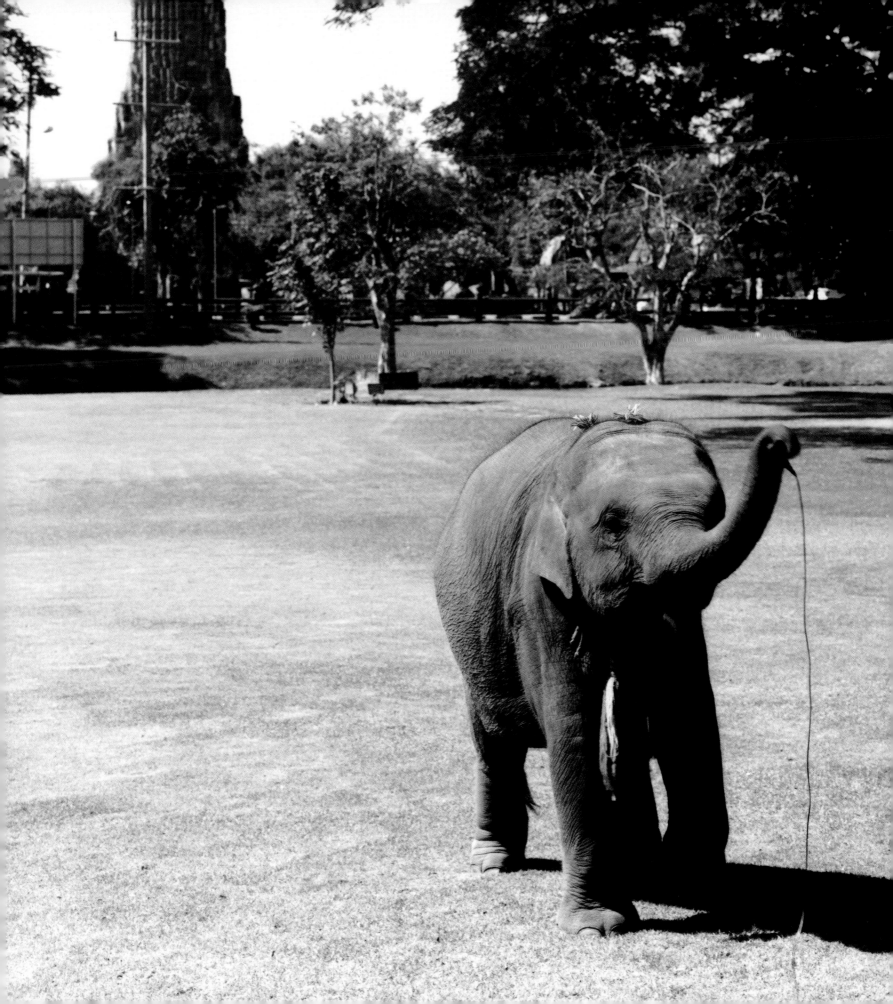

IV.

IDEAS LIKE VIRUSES; ARTISTS AS STARS

"The idea of ideas is the most mysterious thing," Melamid says in the van, to no one in particular. "How do ideas spread? You say something and people get it; then they pass it on to someone else. Elephant art is like a virus that we're trying to release into the world. And like it or not, it's turning out to be very contagious."

The van pulls up to a small dock on the banks of the Chao Praya river, where a renovated teak rice barge waits to carry the group eighty kilometers upriver from Bangkok. Komar and Melamid and their entourage are on their way to yet another privately owned elephant camp, where they expect to start yet another school in the historic city of Ayutthaya, just a day trip away from Bangkok.

A photographic self-portrait by promising young elephant artist Nom Chok.

The trip is being sponsored by the Magic Eyes Chao Praya Barge Program, an environmental nonprofit that operates the barge as a hands-on floating classroom for Thai schoolchildren. Their motto: "Teaching environmental literacy to today's students and tomorrow's leaders." Today, though, things are a little different. There are no schoolchildren, and Komar and Melamid are here to talk about elephant art to a motley group of drifters and expatriates who saw the ad for the overnight trip in the local newspaper, and who have been joined by journalists from the *Bangkok Post* and the *Baltimore Sun,* and a BBC news film crew. As the barge chugs out of the harbor, the passengers are instructed to remove their shoes and take a seat on the pillows scattered across the polished wood deck. A barefoot, sunburned, thirtyish man in a peach polo shirt and puca-bead necklace stands, smiling, at one end of the deck.

"Hi. I'm Robert Steele, your cruise director," he shouts over the ship's churning motors. "Welcome to the Magic Eyes barge. Before we get started with our program, I'd like us to try a little ice-breaker so we can all get to know each other first. What we're going to do is arrange ourselves in a circle according to our birth dates, January to December. But the catch is, you're not allowed to speak. It's an exercise we use to help highlight the importance of nonverbal communication in the global community."

The group rises, and after much milling about and frantic gesturing and finger-counting, settles back down in a loose oval. As each person in turn divulges his or her date of birth— February 7, September 12, July 14—it quickly becomes clear to everyone involved that the global community might want to hire a translator.

"Okay, guys, pretty good job," Steele says. "Now we'll try something we call the name game. Each person introduces himself—or herself, as the case may be. But pay attention, because the trick is that you have to remember them all and repeat them back in the same order. Let's start with our guests of honor."

Melamid rolls his eyes and tugs at his sock.

"Hi, I'm Alex Melamid and I'm an artist from New Jersey."

"Hello, I'm Zinovy Zinik and I need a drink."

"Hi, I'm Alex Melamid and I need a drink too."

"It's not your turn, Alex. Come on, let's keep this thing going."

"Hello, my name is Dr. Igor and I am needy."

"Hello, I am Vitaly Komar and I also need drink."

Steele's mouth tightens into a mirthless smile. "Ha ha, very funny. You bunch of unhealthy, cynical bastards."

Komar and Melamid look up, eyes wide with surprise.

"Just kidding," he adds.

The barge arrives in Ayutthaya at noon. A fleet of tuk-tuks meets the group at the dock and whisks them to the camp where they are graciously received by a small army of Thai bureaucrats, including the vice governor of Ayutthaya, the local director of the Thailand Tourism Authority, and the camp's owner and assistant manager. The man from the Tourism Authority presses a local Thai-language newspaper into their hands. On the front page is a color photograph of a painting elephant, with the caption: "An elephant named Boon Tien from the elephant camp in Chiang Mai uses his trunk to paint for a Hollywood film crew, who will go back to show the world the talent of Thai elephants."

Close enough.

Thirty-three kings of various Siamese dynasties reigned in Ayutthaya before it was conquered by the Burmese in 1767. Formerly the royal capital of Siam, the city is now famous for the grand Khmer-style ruins that dominate its center. Tall phallic spires and crumbling pillars of saffron-colored brick are scattered around an overgrown grassy area, like hoary relics of the kingdom's bygone glory. The Ayutthaya Elephant Camp sits on the northwest edge of the ruins. The ten or so elephants in residence here earn their keep giving seven-minute rides around the ruins, at two hundred baht a head. They work from 8 A.M. to 5 P.M. seven days a week—a grueling schedule that doesn't leave much time for other, more refined pursuits. The camp is owned by Sompast Meepan, a wealthy Thai businessman with rough pockmarked skin and a pragmatic entrepreneurial streak who peppers his conversation with casual references to his swelling bank accounts and the eighteen or so houses he maintains for his family. When he first got wind of

Bird looks to the past for inspiration.

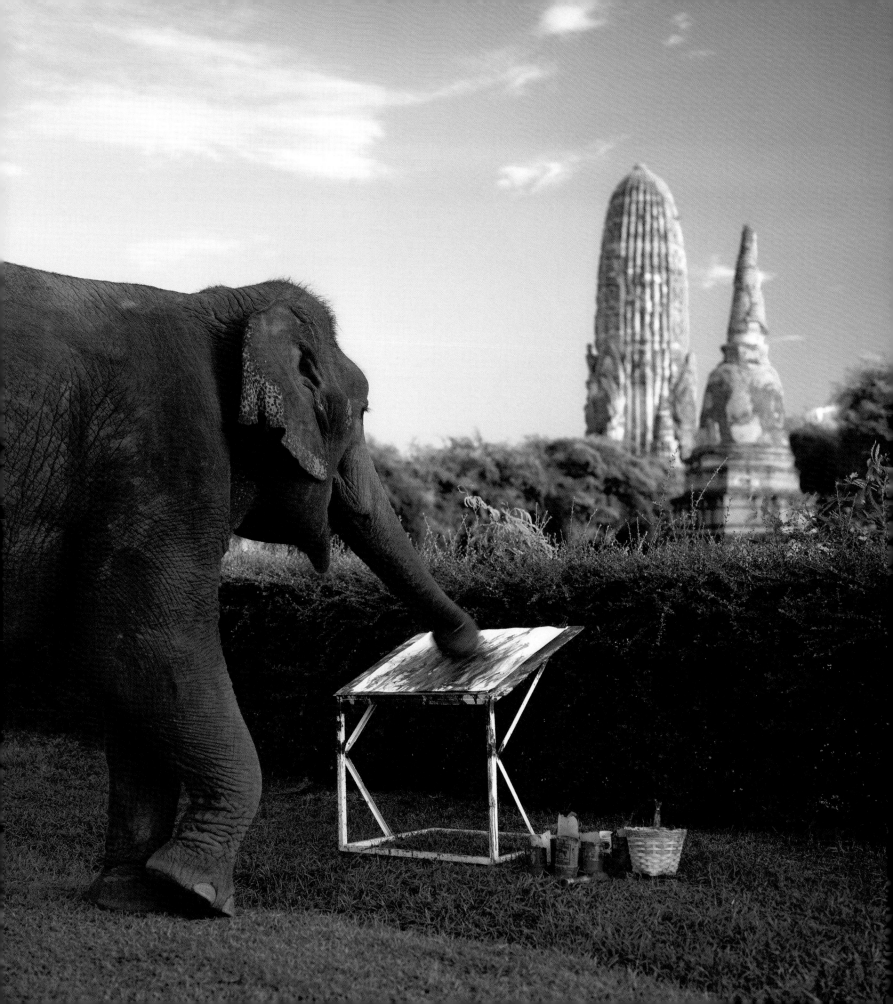

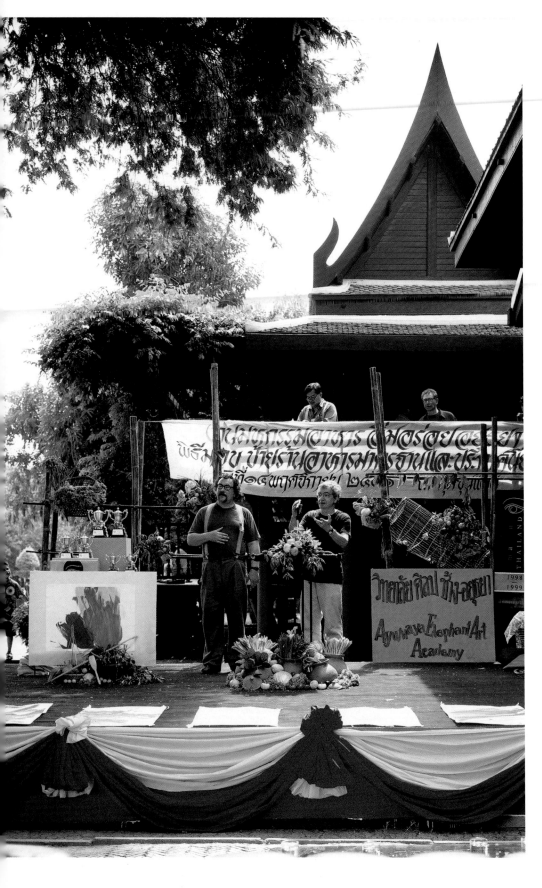

elephant painting at other camps in Thailand, Meepan quickly recognized its tremendous publicity-garnering potential. Within hours, the elephants of Ayutthaya were equipped with paints and brushes, and the mahouts began nudging their trunks toward blank canvases propped up on easels and barking commands. And soon enough, the elephants caught on. As Melamid had predicted, the idea of elephant painting was spreading through the humid air of Thailand like a virus.

Komar and Melamid are briskly escorted onto a dais draped with red, yellow, and magenta curtains. Mangos, melons, and pink orchids are piled before the podium, and traditional Thai music blares from speakers suspended above the stage. They step up to the podium and survey the crowd. Hundreds of people are milling about on a large, well-manicured lawn: there are several busloads of Thai and Japanese tourists with cameras in hand, reporters from every major newspaper in Thailand, three television news crews, journalists from the BBC, Reuters, and the Associated Press. The elephants are decked out in their Sunday best, draped in silk hung with red and gold tassels, adorned with ribbons and bells. The mahouts wear matching red and gold costumes.

All eyes and all cameras are trained on three elephants as they stand before their easels, blank canvases in front of them, waiting for their cues to start painting. The largest of the three, a ten-year-old bull named Bird, is having trouble restraining himself. He picks up a brush, presses it to the canvas, and begins swinging his trunk in great sweeping movements, forward and back, as if painting a fence. His paintings—with their broad straight strokes of black, dark blue, forest

LEFT: *Komar and Melamid address the masses at Ayutthaya.*

FACING PAGE: *Bird and Gam Lai Phet collaborate on a massive canvas at the Ayutthaya Elephant Art Academy.*

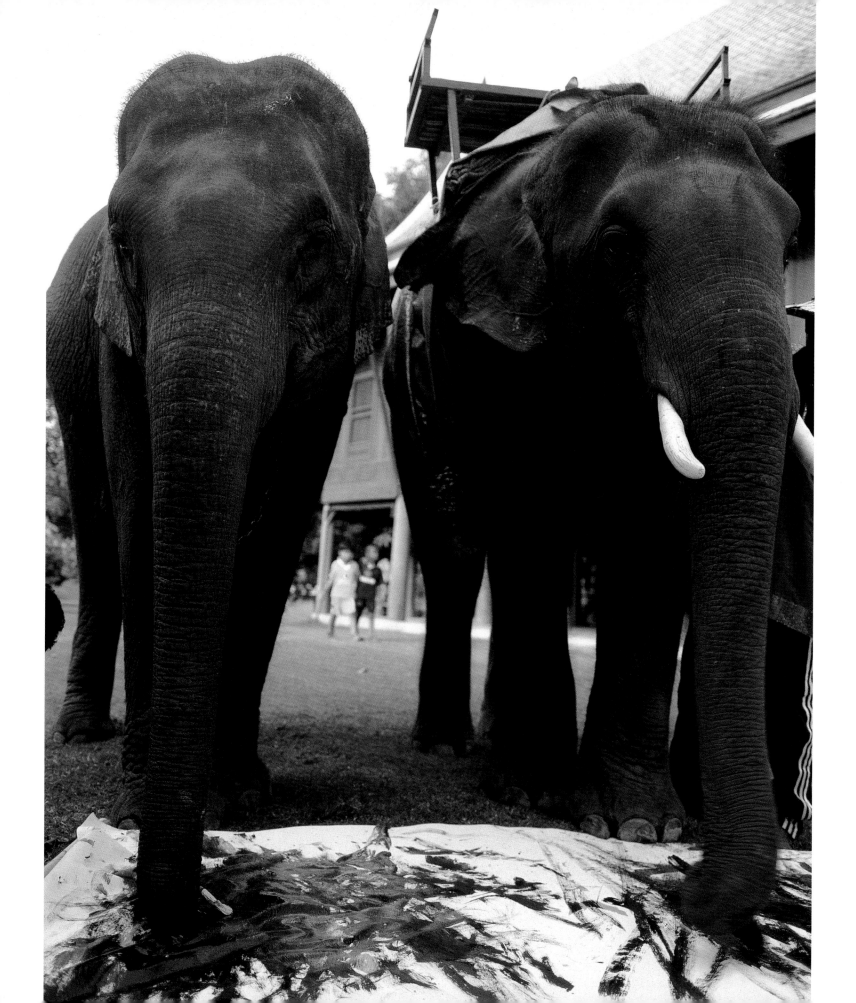

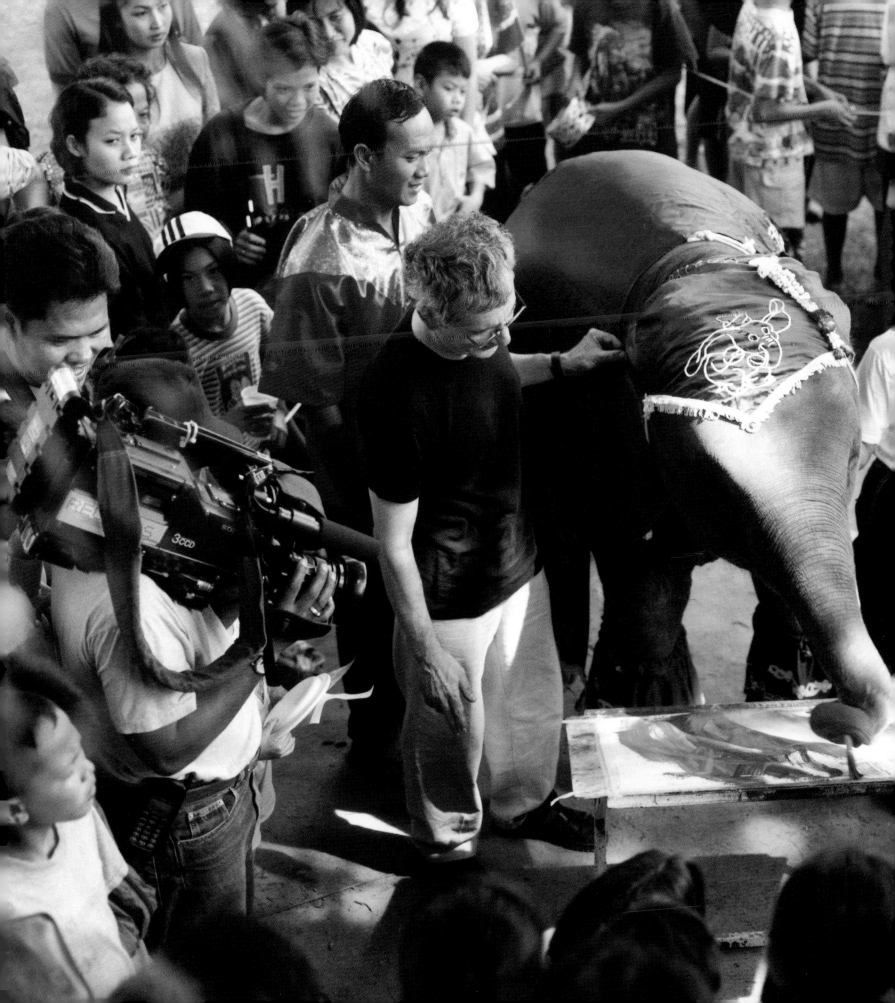

green—look a lot like the work of noted Abstract Expressionist Franz Kline. Bird is reckless, impulsive. The night before, he had managed to sneak into the storeroom and cleverly pried open one of the jars of paint that had been put aside for today's session. He couldn't find a brush, so he improvised, dipping his trunk into the jar and smearing the buildings and wooden corrals of the camp with sloppy streaks of cobalt blue. The paint is water-soluble, and in the morning the camp workers washed the buildings clean. Bird, still with swaths of blue paint all over his body, got off with a light slap on the trunk.

"Now this," Melamid says while patting Bird's side, "is a true artist!"

Next to Bird stands Gam Lai Phet, a nine-year-old female with long legs and a sturdy, athletic build. Her favorite activities, Meepan says, are football and tug-of-war. She grasps the brush with the tip of her trunk and begins thwacking the canvas hard and rhythmically, as if she's beating a drum. Her gestures are violent and vigorous and full of contained rage. This is real Action Painting—a pure, uninhibited engagement with the materials, a direct translation of emotion into visual form—not a picture, as the critic Harold Rosenberg once said of Abstract Expressionist painting, but an event.

But the real show-stopper in this Happening-like performance is Nom Chok, the two-and-a-half-year-old enfant terrible of the elephant art world. Nom Chok, born at the camp to a mother who died during childbirth, made his first painting by dipping his trunk into a jar of paint and blowing forcefully onto the canvas, leaving behind a loose splatter of pigment eerily reminiscent of Pollock's first drip paintings. He soon graduated to broad housepainting brushes, which he wields with a childlike exuberance, covering the entire surface of the canvas, edge to edge, with a dark, murky blend of colors. There's a compulsive quality to his process—he won't stop painting until every last bit of white has been obliterated.

With the crowd watching, the elephants paint furiously, side by side. At first, many of the spectators are skeptical, nudging each other and scoffing audibly. But once the elephants begin, all watchers become believers. They are enthralled; they ooh and aah as the brushes go to and fro—these elephants all

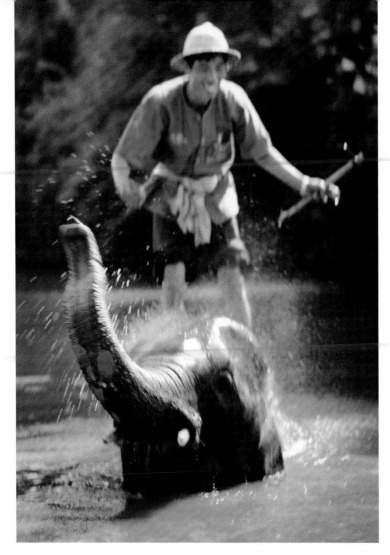

Elephants and mahouts wash up after their morning lesson.

paint in a forward-backward motion and with much more gusto than the elephants at Lampang or Surin. Here the canvases are struck with great force, making a loud *thwack!* sound with every stroke. The painting is an almost violent act, so consumed with passion are these elephant painters. Indeed, Bird even has a trademark habit—much like a rock star's breaking of his guitar—of dropping his brush after every fifth stroke. He will brush forward, then back, then forward, back, forward and when the stroke is finished, he lets go of the brush, sending it into the crowd, a different spectator tagged each time. And the elephants, perhaps more so here than at the other camps—even Lampang—seem to be having fun. Almost too much fun.

The Thai word *sanuk* means fun, and in Thailand anything worth doing—any kind of work—should have an ele-

ment of sanuk, otherwise it automatically becomes drudgery. This general attitude of loopy playfulness explains, at least in part, the success of elephant painting here: playing with paints and brushes is fun for the elephants, fun for the mahouts, fun for the Thai onlookers who stop to gawk at this latest innovation imported from the West. When asked what they think of elephant painting, the mahouts inevitably smile and answer simply, "Sanuk."

When the group finishes the painting session, the crowd roars its approval. Then the mahouts lead the paint-splattered elephants to a small pond for their baths. The mahouts stand on their necks and scrub the paint off their trunks, while the elephants splash and bob like oversized infants. Meanwhile, a long snaking line has formed to buy the new paintings At five hundred baht each, they're priced to move.

"These elephants are stars," says Melamid. "Truly, they are stars of the art world." He pauses, watching a woman push another out of the way to get to the paintings. "This is good, of course, but part of me is thinking, 'My God, what have we done?'"

The group returns to Bangkok, triumphant. In the hotel bar, the conversation centers on what's next for the project. Emery has it all figured out. After they get back from Thailand, there will be a series of events in the United States to raise money and generate interest. First there will be an exhibit of elephant art in Seattle, then a benefit auction in Philadelphia, strategically planned to coincide with the Republican National Convention. Then a "star-studded" fundraising gala in Los Angeles, for which the project has been trying to contact Goldie Hawn and Tippi Hedren, both of whom, they have heard, have a strong interest in elephants. After that, discussions are under way for exhibits in New York, Tokyo, Cologne, Sydney, and, almost definitely, Jerusalem. There is talk of expanding the scope of the school to encompass a research center. In addition to the three schools planned in Thailand—at Lampang, Ayutthaya, and Surin—there is talk of schools in Sri Lanka, India, and Bali. There is much talk of raising more money. Someone has an idea: Disney. Should they be calling Disney? That new animal theme park they're planning seems like a cinch.

Bangkok's concrete jungle.

The whole of Thailand suddenly seems taken with Komar and Melamid and their project. A day after their Ayutthaya session, footage is broadcast on every nightly newscast, and pictures from the visit grace two of the country's largest newspapers. All of which makes for perfect timing—the project has rolled into Bangkok looking for money. They immediately begin a series of bizarre meetings with Bangkok's A-list, get-togethers that make their work in the jungle, teaching giant animals to create art, seem positively normal by comparison. The meetings are uniformly excruciatingly long and meandering, and more often than not about stroking the host's ego than about the business at hand. Komar and Melamid are clearly bored to tears. "The painting is fun," says Melamid. "These meetings . . . not so fun."

Still, as professional artists navigating the New York art world, they know that a successful artist needs first and foremost to be able to meet and charm the sort of people who will,

in the end, make their work possible: rich people. The group is on the way to the Bangkok Hilton, to meet with its owner, Bilaibhan Sampatisiri.

"This is when experiment most mirrors human art world," says Komar, again sweating profusely without his personal air conditioner. "It is mostly about—what is word?—smoozing?"

"No, no, no!" Melamid corrects him. "Schmooooozing," he says, drawing out the *o*'s for ten seconds or more.

"Schmooooozing," Komar repeats.

"You should know that by now," Melamid scolds.

"If we knew it better," Komar notes, "we would be sitting on pile of gold—not teaching animals to hold brushes."

"Good point," says Melamid. Then he giggles wildly.

When introduced to Westerners, Bilaibhan Sampatisiri tells them, "You can call me Peg." People asking her for favors call her Khun Peg ("khun" is the gender-neutral Thai equivalent of the respectful "sir" or "madam"), and that's how Komar and Melamid address her. Her background is ethnic Chinese, but her family has deep and powerful roots in Thai society—her father was Thailand's former minister of finance. Khun Peg is rather heavyset, with large features and a round face. A lot of things about her are big: she wears big roundish silver glasses and on the middle finger of her left hand she wears a ring with a diamond so large it looks fake. She owns and manages the Hilton International Hotel in Bangkok, and in her role as a hotelier she's personable, verging on gushy, funny at times, with a tendency to laugh appreciatively at her own jokes. She's also highly status-conscious, and peppers her conversation with desperately casual references to the countless minor celebrities, ambassadors, members of various royal families, and other international A-listers who make up her social circle. (She intimates, "I'm about to see Her Royal Highness for dinner tonight, as a matter of fact.")

Komar and Melamid sit with Khun Peg in the palatial lobby of the Hilton, surrounded by fountains and huge planters sprouting birds of paradise, with floor-to-ceiling windows that look out on a pool and a lavish garden. She looks elegant in a cream-colored suit accessorized with a large silver-bead necklace; Komar and Melamid are wearing black T-shirts and paint-splattered khakis. They sip jasmine tea and make their pitch: they want her to sponsor an exhibition of elephant paintings in her hotel lobby, with a gala reception, and then to help them place the elephant paintings in her hotel and others. With her endorsement, surely the other hotels in the region will follow suit. And with so many hotels buying and displaying the elephant paintings, they will be well on their way to Elephant Easy Street.

"At least art will serve some purpose," offers Melamid, "because art has never served a purpose before."

Luckily, Khun Peg is a self-proclaimed animal lover. She has adopted a ten-year-old female elephant who resides at a camp in the north; she refers to her as "my daughter." She tells them about her fund-raising work with countless charities. "I'm always in the business of getting money," she says, "one way or another."

Conversation veers to other subjects, from where Peg's human daughter is at college—like most of Thailand's wealthy,

she sends her children to college in the United States—to Komar and Melamid's possible upcoming trip to Tibet.

"No, no," Khun Peg says, wagging a finger, "Tibet is so passé. You must go to Bhutan." Melamid looks confused.

"Do they have elephants in Bhutan?"

"I don't think so. But they have the best asparagus in the world. Very few people know this. If you're ever in Bhutan, you must try the asparagus. I'm going there with my mother in September. She's dear friends with the Queen Mother."

A string quartet seated beneath a Thai-style gazebo strikes up a concerto by Berlioz. Peg wants to know how she can be assured that the paintings are genuine.

"We will have a guarantee," says Melamid. "An official stamp!"

"And how do I know which ones are the good ones?"

"We will tell you," Melamid answers with the utmost gravity. "Because we are famous artists from New York. We will determine for everyone what is good and what is bad. The art will come with only the best pedigree."

"Yes," agrees Komar with great seriousness. "We will tell you what to like."

Peg seems satisfied. The meeting ends with plans to show the artwork the following spring, about five months hence, with the Princess Galiyani (the older sister of Thailand's King Bhumibol) almost definitely in attendance.

Nearly all of the Bangkok meetings are similarly successful. Because the Thai are rather star-struck by the presence of the renowned Russian duo and their large and bizarre international entourage, and because elephants occupy such a sacred place in Thai culture, the aims of the Asian Elephant Art and Conservation Project are an easy sell.

And with each success, Melamid's plans become larger, his ideas more ambitious. In a meeting with a U.N. representative—an impossibly debonair Thai man whose accent is distinctly British and whose English is better than any of theirs—he brings up the notion of starting a school for mahouts, to ensure that all elephant handlers have the proper training. In another meeting, with the head of a wildlife conservation project, Melamid veers from the elephant art to possibly opening a center where scientists might study the brain functions of elephants, their thoughts and emotions. The rest of the entourage is repeatedly left in the dust of Melamid's runaway

imagination, with Emery attempting to hold the meetings to-gether, to bring the subject back to immediate and practical concerns. But Melamid is restless in the meetings and after-ward. In the van traveling from meeting to meeting, he discusses plans in the works to collaborate with a geneticist in order to make artistically enhanced animals, and ways to begin healing people through the use of art.

Richard Lair, for one, is starting to get confused.

"It's so hard to tell when you're being satirical," he says.

"I don't know myself!" Melamid answers.

"Ah," responds Lair, intrigued, "the plot thickens."

The next night is the group's last in Bangkok. The stay in Thailand's metropolis has been wildly successful, and it's only fitting that the stay be capped off with a rous-ing sort of entertainment. And for that there is Kamala.

Kamala is the owner of the Siam City Hotel, the glassy be-hemoth where Komar and Melamid and their entourage have been staying, largely at her expense—she has given the group drastically reduced room rates. And now, on the last night, she will treat them again. She has summoned the group to the small nightclub off the main lobby. Inside, the look is art deco and the stage is set. A piano player, bassist, and drummer stand at the ready as two attendants usher the group into a row of chairs a few feet from the stage's front lip. Drinks are ordered and served as the tension mounts. Then she enters. Kamala, a stout woman in her mid-fifties, in a full-length blue sequined gown.

"Welcome, welcome," she says, as the piano keys are tin-kled. "It's so good to have you all here, such an honor to have such distinguished guests."

Komar's expression is one of shock. Melamid is amused.

"I'm sort of an artist myself," she continues. "Yes, I dab-ble a bit, you might say. And I did my time in your hometown, that toddlin' town...."

Melamid's eyes are popping out of his head.

"But enough of my yakkin'," she says. "It's time for a song." And then the inevitable happens: "New York, New York." It is a passionate and determined version. It ends with Kamala's feet stomping on the stage. Everyone claps. Komar and Melamid order more drinks.

"This next one goes out to the elephants," Kamala says

Kamala Sukosol in a command performance at the Siam City Hotel, Bangkok.

before launching into "It Had to Be You," a rendition that also ends with stomping.

Things have gotten weird. An hour later, after versions of "Crazy," "Hava Nagila," and "La Vie en Rose," the show is over and everyone is in the elevator, stunned into silence.

"How do these things begin?" Melamid asks. "We have this idea, and we paint with elephants; then, suddenly, we are being sung Edith Piaf by a Thai hotel owner in Bangkok. What is happening?"

For a moment, Komar is lost in his own thoughts. Then he clears his throat. "I tell you what happened. We have started the Doomsday machine."

LAMPANG

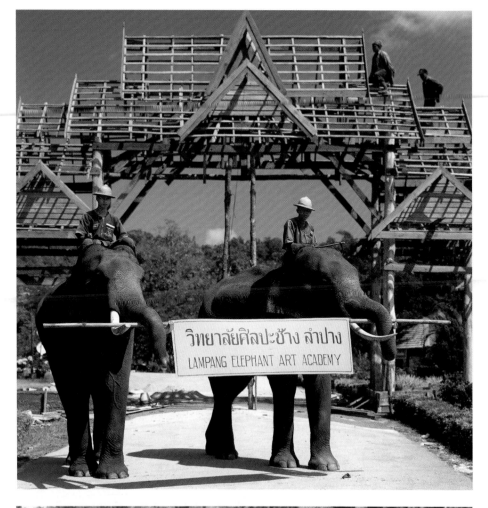

At the northern tip of Thailand near Chiang Mai, the Thai Elephant Conservation Center in Lampang is the most developed of the three camps. A government-supported sanctuary in protected teak forests, the Lampang camp was established to train elephants in logging, until Thailand banned the practice in 1989. Today, logging in Thailand is largely confined to the underworld economy; illegal operations exist in the northern forests, on the border with Myanmar, operated by organized criminal networks. And the camp in Lampang has been restructured to function as an educational, ecological center.

Here, mahouts and elephants play a somewhat dignified role. Rather than eight-hour workdays, the elephants perform two brief shows a day, leaving their remaining hours to more ingrained hobbies like swimming and foraging in the teak forests. Standard fare in Thai elephant-camp performance art might incorporate animals trained to dribble soccer balls and play harmonicas; here, they paint vibrant abstract canvases that sell to tourists and nearby hotels for 300 baht—roughly $12—each.

The mahouts at Lampang tend to be somewhat older than at the other two camps. Juthanam (nicknamed "Phratida"), a five-year-old female, is accompanied by a thirty-one-year-old mahout, Preeda Phundish ("Ning"); Boon Yang ("Lukkop"), a four-year-old male, has a forty-two-year-old mahout named Boon Tiam; and the six-year-old female Nawaporn ("Lukkang") has a twenty-year-old mahout, Sontaya Wawong ("Berm").

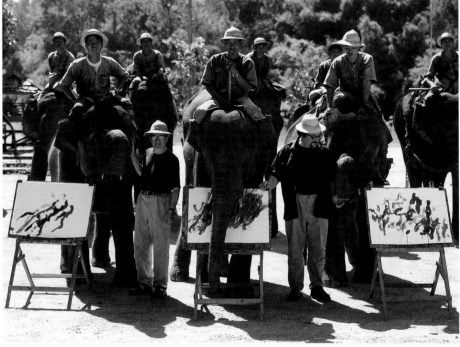

Three of Lampang's star pupils display their work.

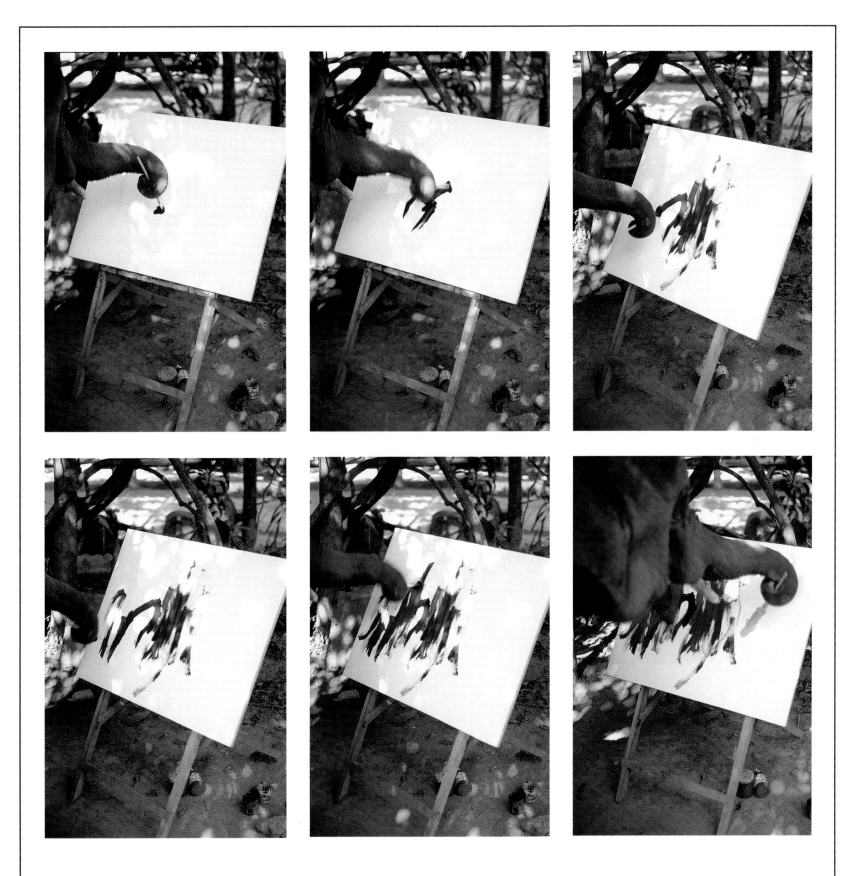

Lukkop, step by step.

ARTISTS' PROFILES

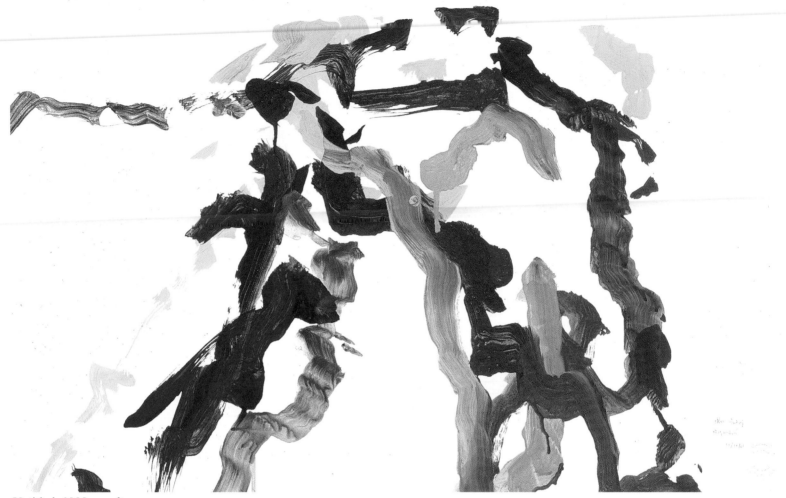

Untitled, *1998, acrylic on paper.*

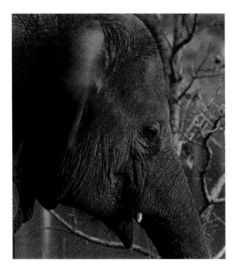

ARTIST: Juthanam
NICKNAME: Phratida
AGE: 5
MAHOUT: Preeda Phundish ("Ning"), age 31
SCHOOL: Lampang
NOTE:
• The exceptionally vibrant colors indicate a certain optimism as well as the mahout's attention to keeping the brushes clean.
• The hesitant, wormlike lines indicate a painting style more deliberate and ponderous, making use of the upper trunk muscles, as opposed to the more wristlike lower muscles.
• Composition evokes the mountains of northern Thailand, pointing to Juthanam's possible transition from abstraction to representation.

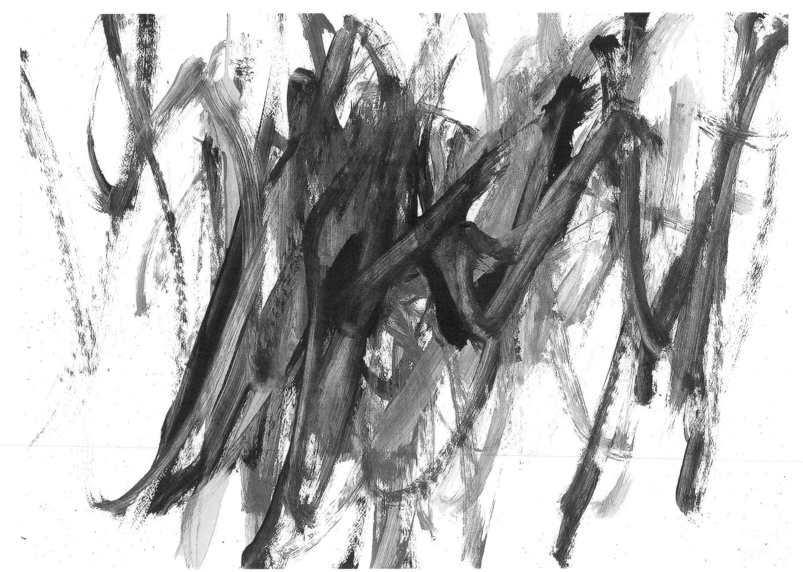

Untitled, *1998, acrylic on paper.*

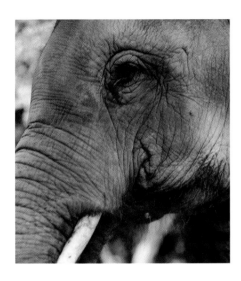

ARTIST: Boon Yang
NICKNAME: Lukkop
AGE: 4
MAHOUT: Boon Tiam, age 42
SCHOOL: Lampang
NOTE:
• Lukkop uses a primary color–based palette characteristic of the Lampang school, while his lyrical, carefree brushstrokes suggest a hearty joie de vivre.
• At the same time, there is a certain intensity to his work. The marks are made quickly but not without some force, a touch of angst, perhaps.
• The composition evokes both the long reeds of the rice fields and the density of the jungle.

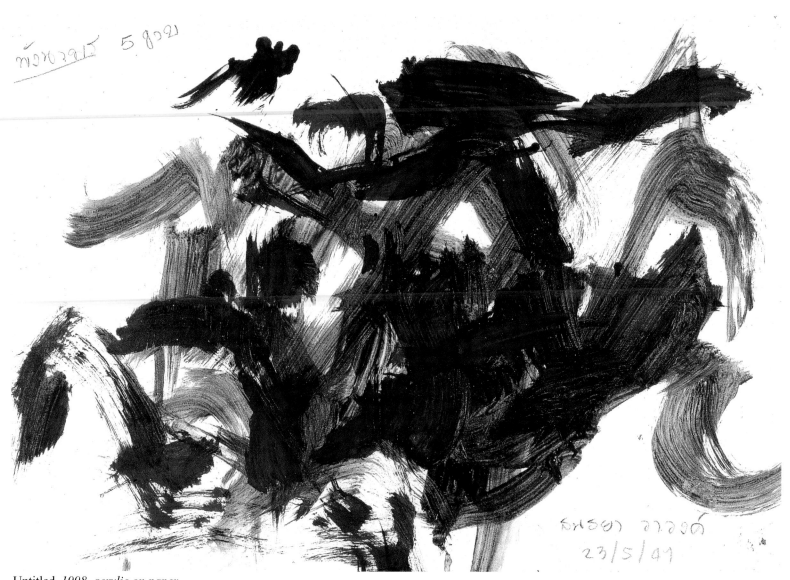

ทั้งหวาดไร 5 ข้อๆ

อหรอา ภาวงด์
23/5/01

Untitled, *1998, acrylic on paper.*

ARTIST: Nawaporn
NICKNAME: Lukkang
AGE: 6
MAHOUT: Sontaya Wawong ("Berm"), age 20
SCHOOL: Lampang
NOTE:

- Secondary colors are produced through on-canvas mixing. The overall effect is one of extraordinary harmony of hue.
- Unlike many elephant painters whose marks are fairly consistent—left to right or top to bottom—Lukkang's brushstrokes come from every conceivable direction, indicating a restless and expansive nature.
- The concentration of marks in the picture's center points to Lukkang's no-nonsense approach, her seriousness of intent. This is a picture from an artist at full stride.

IMPRESSIONISTS AT LAMPANG

It's late afternoon at the Lampang Elephant Art Academy and the students are straggling back from their leisurely midday meal in the cool, shady forest, still chewing their last mouthfuls of leaves and bamboo stalks. Their paintings from the morning session have been laid out to dry on the dirt floor of their open-air classroom—glowing rectangles embellished with brilliant streaks and splashes of color scattered among giant footprints in the grayish-brown dust. Komar stands in the center of the enclosure, hands in his pockets, staring down at the paintings and frowning slightly. The elephants have clearly mastered the technical fundamentals; they can now grasp the paintbrushes easily in their trunks, they can produce a variety of different types of markings, and the work looks good—exceptionally good for first-year art students with no previous training. But there's a problem: all of the paintings, all of these vibrant, multicolored abstract improvisations, are beginning to look alike.

At this early stage in the learning process, it is the mahouts who are choosing the colors, and to these young men—most of whom have never set foot inside an art museum—the language of painterly abstraction is as foreign and unintelligible as the heavily accented English of their Russian guides. Lacking confidence but eager to please, the mahouts have developed a radically democratic method of choosing colors: in each painting, they systematically cycle through all the hues laid out before them—first red, then yellow, then blue, then black—resulting in a cluster of canvases that, while pretty, lack a certain rigor, a certain decisiveness.

But Komar and Melamid are not discouraged—obviously, it's time for these talented students to progress to the next stage in their training. They're ready to make the leap from unstructured abstract improvisation to the representational depiction of the world around them; they're ready to attempt to translate the sensory richness of visual experience into color and form. And what better place to begin than with what Komar and Melamid have scientifically determined to be the world's favorite subject for painting: the bucolic landscape.

Two of the academy's young star pupils—Lukkop (male, age 4) and Lukkang (female, age 6)—are led over to a couple of easels set up at the edge of a small but picturesque tree-lined pond. The sun is beginning to set, bathing the scene in a soft, atmospheric light. As the elephants impatiently sniff at the paints, Komar speaks to the mahouts through a translator. "The point of this exercise," he tells them, "is simply to paint what is in front of your eyes. If you see green on the trees, use the green. If some of the leaves are turning yellow, add a little yellow. If the sky is blue, then blue." The mahouts nod, the elephants swing their trunks, and the experiment begins.

Shifting her gaze back and forth between the landscape and the canvas, Lukkang renders the scene as a densely scumbled thicket of green, accented with bright notes of yellow, red, and blue; Lukkop attacks the canvas with bold vertical strokes of yellow and dark green, conjuring an image of the tall grasses that grow along the shore. "Beautiful!" Melamid crows. "It's their best work yet. They're like Monet and Renoir painting side by side in the south of France. En plein air! No sketching, just light and color! Color and light!"

Elephant Impressionism? It may sound far-fetched, but these intelligent animals may naturally possess the kind of untutored visual innocence that the Impressionist painters tried to cultivate themselves. Monet wanted, above all, to translate his immediate visual sensations directly into pigment, to strip away his preconceptions about how things are supposed to look, to circumvent the intellect and paint directly from the eye. "When you go out to paint," he advised a young art student in 1889, "try to forget what object you have before you—a tree, a house, a field, or whatever. Merely think, here is a little square of blue, here an oblong of pink, here a streak of yellow, and paint it just as it looks to you, the exact color and shape, until it gives you your own naïve impression of the scene before you." The landscape paintings produced at Lampang may provide the first, tentative answers to the tantalizing question: What does the world look like through the eyes of an elephant?

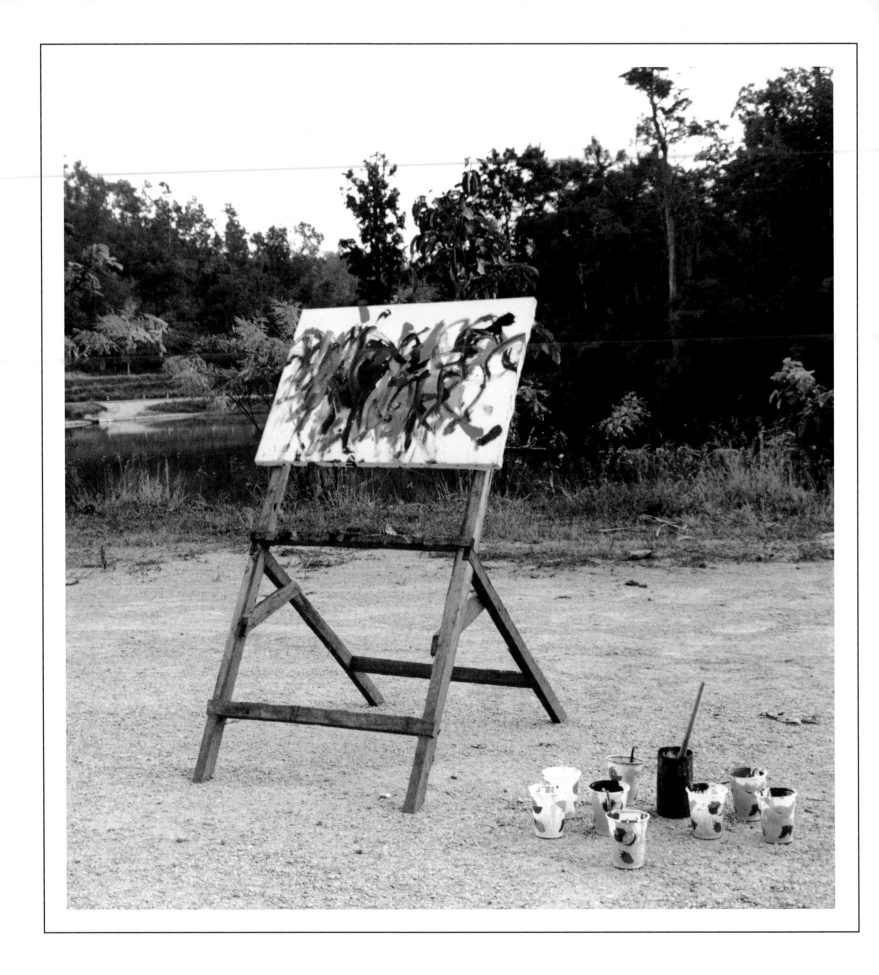

AYUTTHAYA

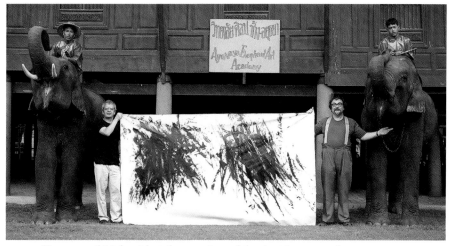

Ayutthaya was Thailand's capital city until Bangkok, forty miles away, assumed that role during the twentieth century. Located on the banks of the Chao Praya River in a tropical agricultural region that produces rice, melon, pineapple, and sugarcane, the town is an easy day trip from the teeming metropolis. Today it's known mostly as a popular attraction among Western visitors for its enthralling, ornate ruins of temples and palaces. That's a chief reason for the location of the Ayutthaya Elephant Camp, a somewhat diversified commercial venture that attracts tourists not only for elephant paintings but also for rides among the ruins; the elephants, working as cheap-labor transportation, are bedecked in elaborate silk costumes.

Although a lack of shade can make the animals' eight-hour shift punishing in this hot, humid climate, those elephants who are permitted to retire before they grow too old for such stressful labor tend to live longer in captivity than they might in the wild.

The Ayutthaya Elephant Camp was established in the early 1990s by a wealthy local real estate developer and elephant enthusiast, employing mahouts who largely hail from the province of Surin. The mahouts' elephants either arrived with them or have been relocated from defunct logging ventures nearby.

Elephants at the Ayutthaya camp include Gam Lai Phet, a nine-year-old female (her mahout is Dong); Bird, a ten-year-old male with a mahout named Nimit; and a two-year-old male, Nom Chok, whose thirty-eight-year-old mahout, Ded, is twice as old as his human colleagues. From the Ayutthaya school, elephants and mahouts prefer darker, cooler colors—deep violet, black, forest green—applied with broad, vigorous brushstrokes that sweep across the canvas from one edge to the other.

ABOVE: *Komar and Melamid at the opening of the Ayutthaya academy.*

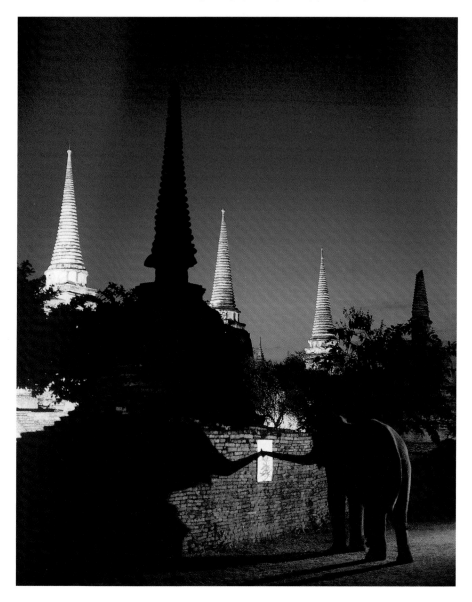

BOTTOM: *Bird paints the ruins by moonlight.*

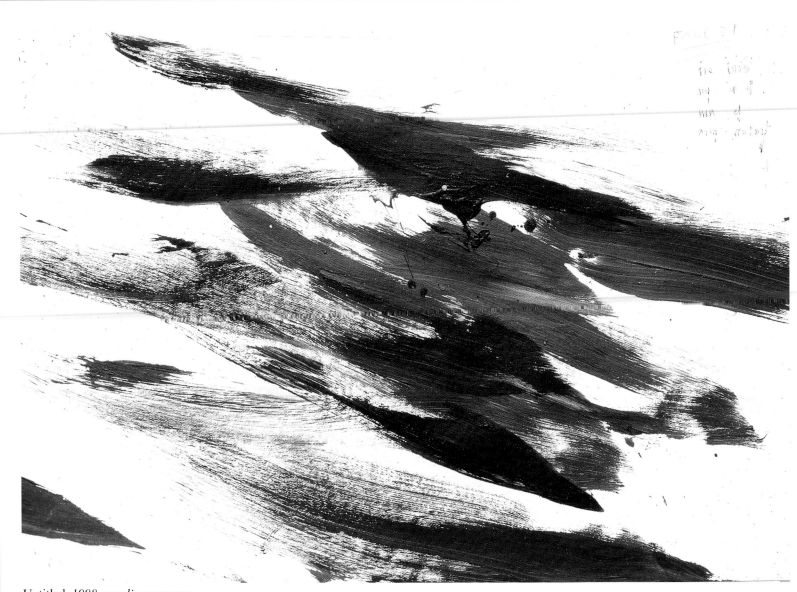

Untitled, *1998, acrylic on paper.*

ARTIST: Bird
AGE: 10
MAHOUT: Nimit Kerdkarn, age 19
SCHOOL: Ayutthaya
NOTE:

• Bird approaches the blank canvas with a potent combination of exhilaration and fury, swinging his trunk forward and back in broad, sweeping strokes. Like many elephant artists, Bird was born into a family of timber workers, and his working class roots seem to impart a brute physicality to his painting style.

• Bird's broad, tectonic strokes of black, dark blue, and forest green have drawn frequent comparisons to the work of Abstract Expressionist Franz Kline.

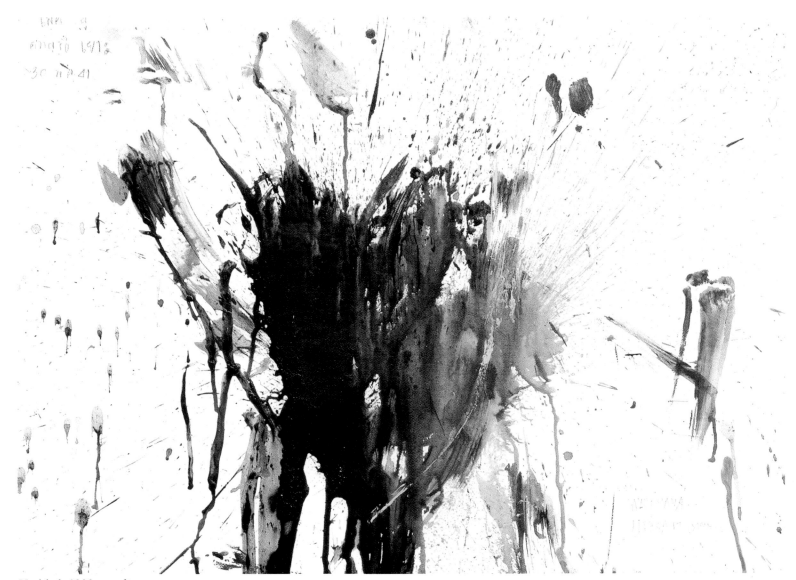

Untitled, *1998, acrylic on paper.*

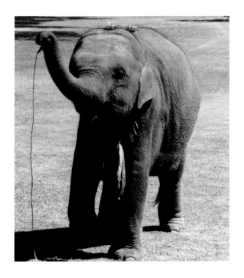

ARTIST: Nom Chok
AGE: 2
MAHOUT: Ded Chaiyaphum, age 38
SCHOOL: Ayutthaya
NOTE:

- Nom Chok wields the brush with a childlike exuberance, covering the surface of the paper from edge to edge.
- He generally favors deep murky tones, mixed on the surface with an obvious pleasure in the creamy viscosity of the paint.
- At the precocious age of two, Nom Chok has been lauded as the "enfant terrible" of the elephant art world.

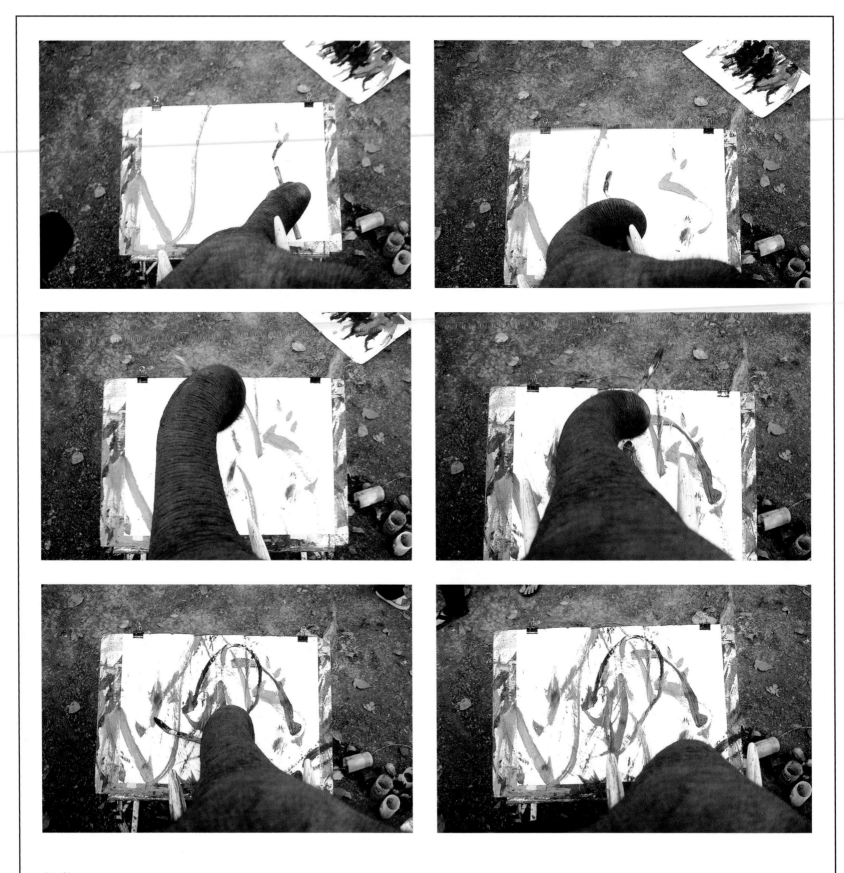

Bird's-eye view.

SURIN

S urin, just north of the Phanom Dongrak Mountains and the Cambodian border in eastern Thailand, is Thailand's poorest province, its once-abundant teak forests clear-cut throughout the twentieth century and particularly since the 1970s. The flat landscape that remains is prone to frequent droughts and is chiefly used today to harvest silk and rice.

Surin is also Thailand's traditional elephant province, the indigenous Suay people having captured and domesticated the animals for use in the logging trade. Fewer than two thousand wild elephants remain in Thailand, but they are nevertheless celebrated here in an annual festival each November, the Surin Elephant Roundup.

The local elephant-painting school is the least sophisticated of the three; lacking any formal infrastructure, the camp is based in a rice field and overseen by Pittaya Homkalitat. The Thai elephant expert set it up with local mahouts, the boys and young men who train the elephants on an individual, teacher-to-pupil basis. The camp is associated with the Elephant Foundation of Thailand; its mahouts attend the school after their own high school classes every day. Elephants include the six-year-old female Noi Na; Tong Chai, a five-year-old male; and Bok Bak, a three-year-old male. The primary consumer audience for the elephants' artwork is comprised of Thai and foreign tourists. While the elephant paintings from every school tend to be vibrant and abstract works, the art from Surin has a subtle, atmospheric style characterized by cool greens and earth tones reflecting the subdued palette of the landscape's watery rice fields.

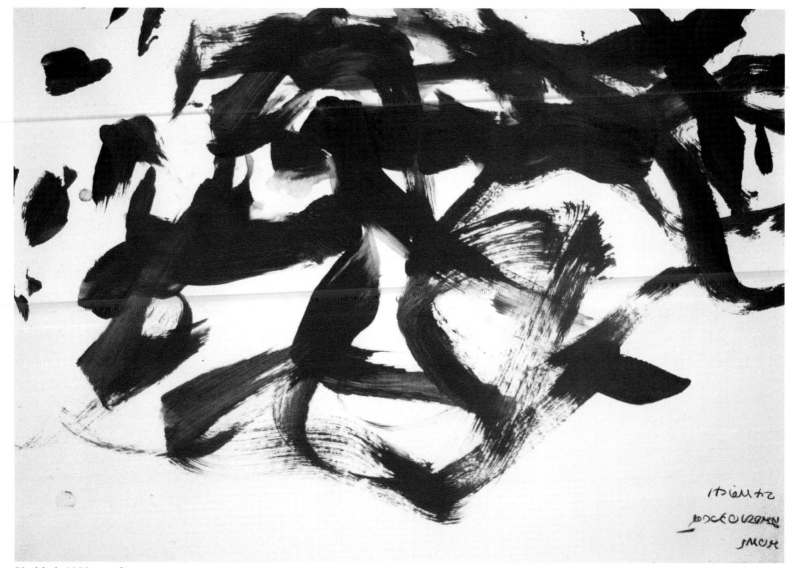

Untitled, *1998, acrylic on paper.*

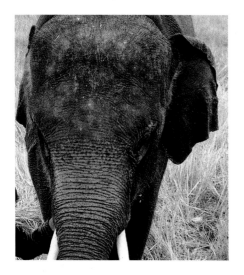

ARTIST: Bok Bak
AGE: 3
MAHOUT: Boon Pienthang, age 12
SCHOOL: Surin
NOTE:
• Remarkable coverage and lushness of paint.
• While the mahout has started with primary colors, Bok Bak moves to secondary hues by mixing the colors on-canvas.
• Bok Bak's fluidity of brushwork sets him apart. Moving beyond the careless slapping common to some elephants and the slow, wandering mark-making common to others, Bok Bak's sinuous S-style marks signal a masterful handling of pigment.

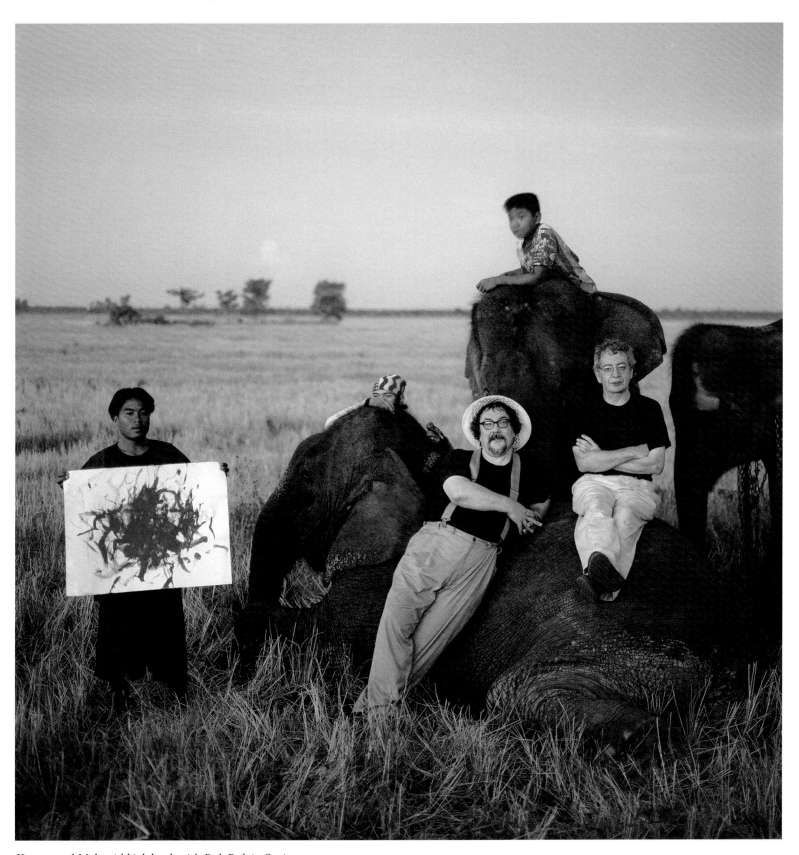

Komar and Melamid kick back with Bok Bak in Surin.

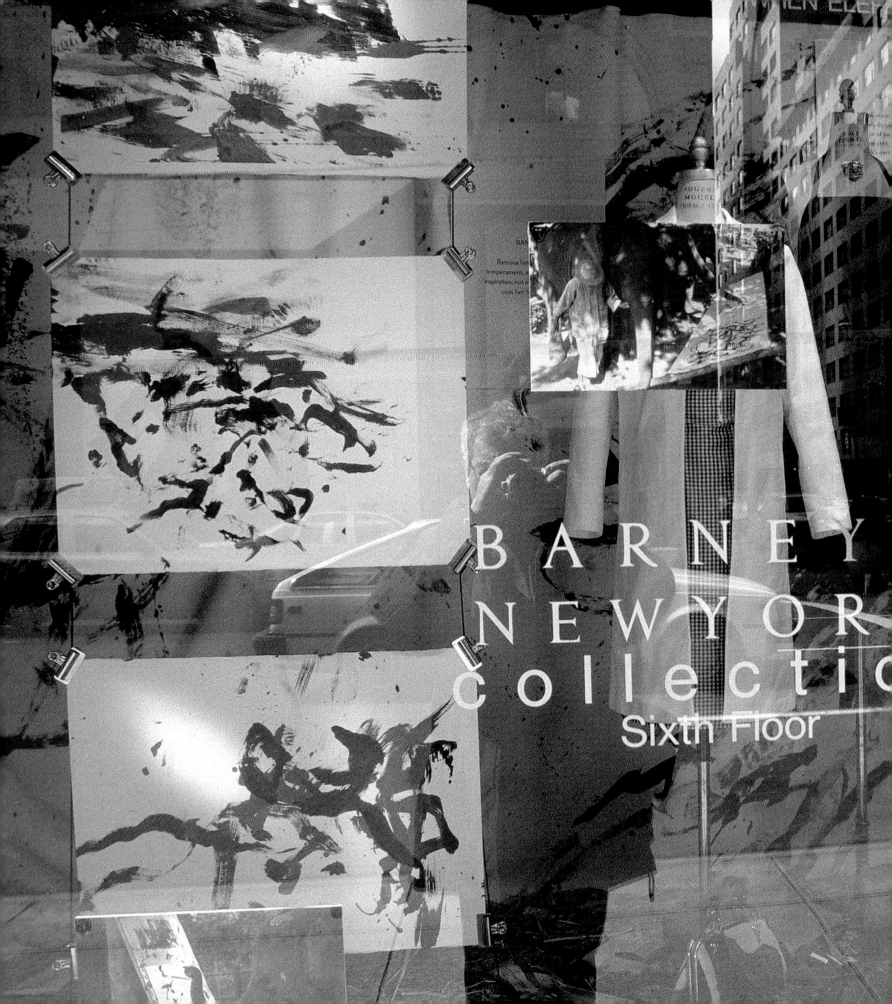

V.

CIRCUS MAXIMUS

The floor of Komar and Melamid's Tribeca studio is littered with paintings. Vibrant squiggles and streaks of blue, gold, green, red, and black seem to writhe and pulsate across the bright white rectangles while, here and there, bits of brown dirt and glistening elephant snot cling to the surfaces like clues to the works' unorthodox origins. Melamid darts around the room, shuffling through the paintings like giant playing cards, arranging them in loose piles according to the school at which they were made—Surin next to a rickety wooden easel, Lampang beneath the large windows that look out on Canal Street, Ayutthaya in front of the black vinyl couch where Komar is currently stretched out, snoring softly, still jet-lagged from the twenty-two-hour flight the day before.

At first glance, the paintings—hundreds of them, all colorful, abstract, bursting with energy—look pretty much alike. But as

Elephant painting window display at Barneys, New York
Madison Avenue store.

Melamid groups them by region, certain similarities, certain family resemblances, begin to assert themselves. Each pile has its own distinctive "look," its own unique visual idiom, its own vocabulary of brushstrokes and colors and forms. Amazingly, and probably unconsciously, the elephants and mahouts have somehow developed and refined three clearly distinct regional styles. The paintings made in Lampang tend to be lyrical and expressive, with fluid, sinuous brushstrokes and a palette of bold, clear primary colors. The elephants of Ayutthaya, on the other hand, prefer darker, cooler colors like deep violet, black, and forest green, which they apply with broad, vigorous brushstrokes that sweep across the canvas from edge to edge. In the paintings from Surin the brushwork is loose, rhythmic, and gestural, with colors tending toward the cool greens and earth tones enlivened by dabs of bright orange and red.

With Emery's help, Melamid is trying to select thirty of the finest works to be framed and shipped back to Bangkok, where they will be featured in a gala exhibition and benefit at the Hilton Hotel scheduled for November. Her Royal Highness the Princess Galiyani has accepted the invitation, and at the opening Komar and Melamid will officially present her with a painting made by her own adopted elephant, Juthanam, one of the stars of the Lampang school.

Emery picks up a painting covered with fluid swirls of magenta and midnight blue. "We definitely have to include this one," she says, holding it up by two corners.

"Fine," says Melamid. "But why is that one better than any of these others? What makes that one good?"

"Well, the colors are really nice, the way they're blended together on the paper."

"So blended colors are good?"

"Not always. But in this case, they're good."

"But how do you know?"

Emery rolls her eyes. "I don't know, Alex. The ghost of Clement Greenberg whispered it in my ear."

"Be careful. He's been known to bite."

Komar and Melamid arrive in Bangkok in the middle of a steamy afternoon in late November. They drop their bags off in their rooms—deluxe executive suites this time around—and make their way down to a large vault-like hall just off the hotel's main lobby. Technicians in blue jumpsuits are busy hanging lights and installing temporary walls around the perimeter of the room; there is a podium, a massive sound system, and a large chair resting on a raised pedestal like a throne. Khun Peg welcomes the artists with open arms and passes on warm greetings from the Queen Mother of Bhutan, who regrets that she will not be able to attend this evening's event, since it unfortunately coincides with her country's royal asparagus festivities.

"Now let's get down to business," says Khun Peg, stepping down from the pedestal where she has been carefully straightening the pleated yellow dust ruffle that hangs down from the bottom of the chair meant for the princess to sit on a few hours hence.

Drawing on a seemingly limitless store of knowledge about the manners and mores of the ruling elite, Khun Peg instructs the artists in the proper forms of genuflection that must be observed when offering a gift to the princess. First and foremost: never turn your back on the royal personage. All gifts must be presented on a gilded base—never hand-to-hand. When the time comes to present the painting, they will bow once, ten paces before the princess. They will bow again as they approach her seat, and extend the painting on the gilded base. Then they will bow again and take ten steps backward. Then they will bow again. Komar and Melamid run through the drill, again and again, bowing and shuffling in unison, until the routine comes almost as naturally as breathing.

Later that evening they return to the hall, dressed in dark suits and silk ties imprinted with tiny dancing elephants. All of Bangkok society is there, sparkling in diamonds and silk, holding drinks and plates of hors d'oeuvres, happily milling about at the world's premier exhibition of elephant painting. William Warren, a pillar of Bangkok's expatriate community, is there, too, signing advance copies of his latest lavish coffee-table book, *The Elephant in Thai Life & Legend*. And so far things are looking very good: it's only ten minutes into the event and already all the paintings have been spoken for. The $20,000 raised this evening will go to a local Thai charity, the Treasure Our Elephants Fund.

After about an hour, Khun Peg steps up to the podium and introduces Komar and Melamid to the assembled glitterati. The two artists lift the large painting, with its colorful brushstrokes

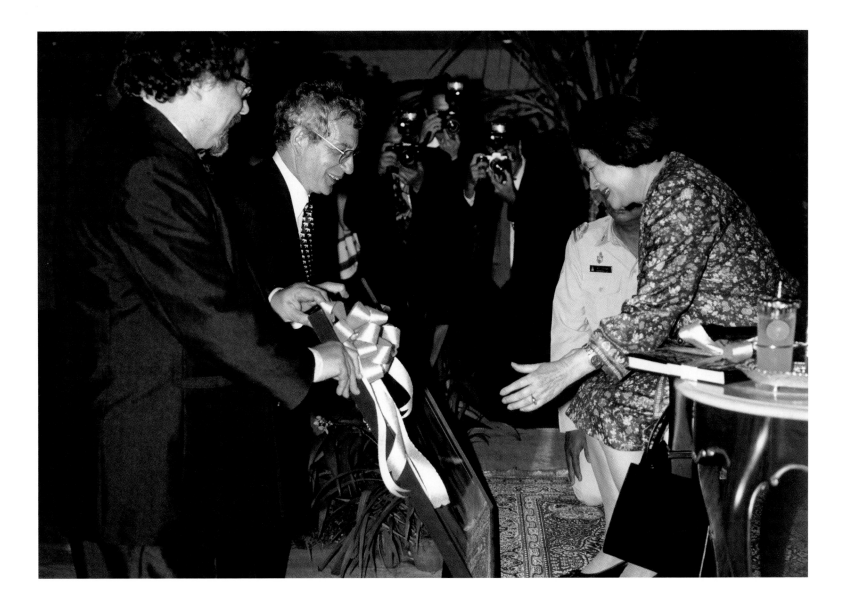

Komar and Melamid present a painting by Juthanam to Her Royal Highness, the Princess Galiyani.

twisting together like interlocking strands of DNA. Gripping the frame by its corners (the gilded base is nowhere to be found), they shuffle forward and—their hours of coaching notwithstanding—hand the painting directly to the princess with a smile and a stiff bow. The transaction is duly recorded by a small horde of journalists standing off to one side of the pedestal. Then Melamid steps up to the podium, leans into the microphone and, on behalf of the Asian Elephant Art and Conservation Project, offers his sincerest thanks to "Her Royal Highness, the Princess Giuliani."

The following week Komar and Melamid are back in their studio, wheeling and dealing, tirelessly promoting their young elephant artists' budding careers. A fax arrives from the Russian Arts Council in Moscow. Komar and Melamid have been invited to represent Russia at the 1999 Venice Biennale, one of the most prestigious international venues for contemporary art—a coup by any standards. The theme of this year's exhibition, organized by the Swiss megacurator Harald Szeemann, is "dAPERTutto," an Italian neologism that translates roughly as "open to all." Taking Szeemann at his word, Komar and Melamid decide to throw open the doors of the Russian pavilion and welcome in a few of their nonhuman collaborators: the painting elephants of Thailand and Mikki,

the chimpanzee photographer. They write to the mayor of Venice, requesting permission to bring an elephant from a local circus to Venice, teach it to paint, and set up a live demonstration in front of the pavilion. The request is denied—problems with insurance, the mayor regretfully informs them, not to mention complications with the local bureaucracy and animal rights groups—and what if the elephant were to drown in the canals of Venice?

The exhibition, sans elephant, is installed in the basement of the Russian pavilion, and features a selection of paintings from Lampang and Ayutthaya, photographs by Mikki, and a video of Komar and Melamid tossing paint with Renee. For the first time in the history of Western civilization, the art of animals is exhibited alongside that of some of the world's most renowned living human artists. "Abstract art is the ultimate democracy," Melamid proclaims to a crowd of critics at the press preview. "That's what it's about. It's taking painting from the academy to the people. Certainly my IQ is higher than an elephant's, but how much of my IQ do I use when I paint? It's not like Jackson Pollock was a mathematician or something, so maybe it's not so crazy to see that elephants and humans can compete in this arena. That's not to take away from Pollock's achievement, but not all human activities need to be at the highest possible levels of intelligence to be valid."

The critical reaction is mixed, ranging from snooty dismissal to flustered bewilderment to spirited praise of the installation as "one of the principal cultural and political innovations of the end of the century." As one critic rather turgidly explains: "Komar and Melamid seek to create a counter-metaphor which would suggest a cooperative development in the course of which humankind acquires greater awareness of its own origin from among the animal species.... This new collaborative approach is based on a critical revision of the modern project of ideological patronage imposed by humans as the hegemonic civilization."

Three months later, back in New York, elephants and art are in the news again, this time at the center of a roiling controversy touching on the limits of public arts funding, Christian iconography, and elephant dung. In September 1999, the Brooklyn Museum presents the controversial exhibition "Sensation: Young British Artists from the Saatchi Collection," which includes a painting by Chris Ofili titled *The Holy Virgin Mary,* a six-by-eight-foot canvas depicting a cartoonish figure of the Virgin in flowing blue-gray robes against a flat gold background. The painting is pretty, and its surface shimmers like a Byzantine mosaic. Small cutouts of vaginas and buttocks from pornographic magazines float around the Virgin's head like naked putti, and at the bottom of the composition are two balls of resin-coated elephant dung impaled with pins that spell out the words "Virgin Mary."

Gearing up for his imminent Senate campaign, New York's Mayor Rudolph Giuliani turns Ofili's painting into a cause célèbre when he threatens to cut the Brooklyn Museum's city funding unless the exhibition is canceled (an action later declared unconstitutional by a federal court). "This is sick stuff," he declares, accusing the trustees of turning the museum "into a preserve of Catholic-bashers, people who have no regard for animals and have no regard for the sensitivities of children."

Inevitably, thousands of visitors flock to the Brooklyn Museum to view the controversial painting, which is soon ensconced behind a Plexiglas shield to protect it from potential vandals. The news media offer hourly updates on the story. And as public opinion begins to shift in favor of the artist, descriptions in the press follow suit: what was first described in the *New York Daily News* as a "dung-splattered" and "dung-smeared" travesty is soon touted as a heartfelt depiction of the Virgin by an artist who is a devout Catholic himself—a painting that also happens to be "adorned" and "festooned" with shellacked lozenges of elephant dung.

Komar and Melamid follow the story with characteristic bemusement.

"Human shit is offensive," reflects Melamid, "but elephant dung is really nice. It even smells good, because elephants are vegetarians."

"It reminds me of old story of Peter the Great," says Komar. "At the time, there was huge British merchant community in Russia, and Peter the Great had the idea of sending good Russian shit—with no chemicals or preservatives—to England to use as fertilizer. Like elephant dung in a human painting, it is beautiful example of cross-cultural exchange."

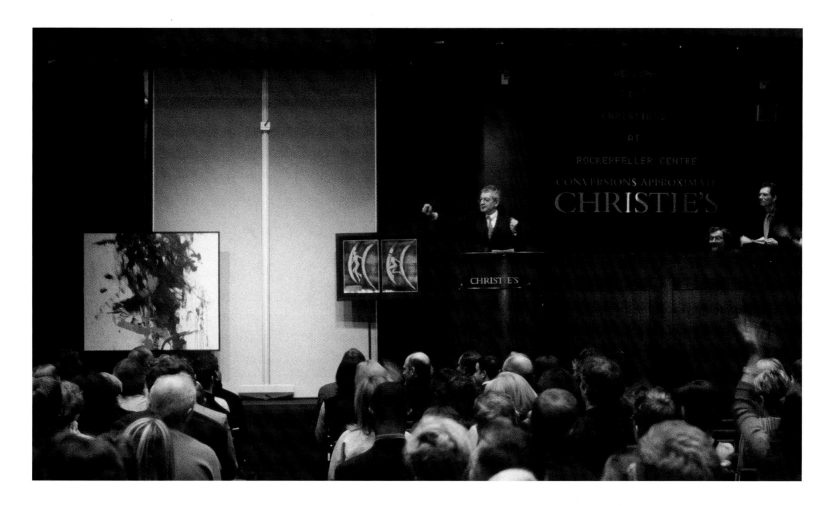

Live auction of luxury items at Christie's, New York.

"You know, this whole project is out of our hands now," says Melamid one afternoon in the studio, a few months later. "I myself am totally puzzled about how it happened. It was like a web of accidents that made it happen—not a grand plan or anything like that. Things happen without anyone knowing why or how—like miracles." And, indeed, things have been happening. In April, MTV gets wind of the project and sends Komar and Melamid to Kerala, India, where they are joined by a crew of world-weary teenagers who assist them in their efforts to paint with the local elephants. In August, Komar and Melamid and company travel to Bali, where they paint with elephants at the Bali Adventure Tours Adventure Park. The Balinese elephants catch on and their paintings are displayed at yet another gala exhibition, this time at the Four Seasons Hotel in Jimbarin.

In March 2000 a benefit auction of elephant paintings is scheduled to take place at Christie's New York headquarters. Assisting with the planning of this event are four new mem-bers of the team—Amy Douthett, a lanky British writer with an Oxbridge accent who has taken over as project manager; Rosemarie Ewing, an event planner with close ties to Christie's; Christine Sperber, co-owner of the Mimi Ferzt Gallery in SoHo that specializes in contemporary Russian art; and Jennifer Essen, a publicist who has volunteered to handle the press pro bono.

When asked how he has managed to convince these charming and talented young women (whom he addresses individually as "darling" and collectively as "the elephant girls") to devote so much of their time and energies to a project which offers them little in the way of financial gain and much in the way of ridicule and raised eyebrows on the part of friends and acquaintances, Melamid shakes his head in bewilderment. "It must be love. The only explanation for all this would be love."

Stuart Pivar enters his final bid for a painting by Ganesh.

He pauses to think. "Or, then again, maybe it's the power of art. You know, there was this interesting idea in Russia in the twenties about what art is. A guy named Alexander Bogdanov thought that art was really all about organization. A traditional painter organizes lines and colors on a canvas, but the real art of the future will be organizing people, making things happen in the world. Most of the time, the artist is like the CEO of a company. Like Warhol—he created the Factory and had people churning out his paintings and silkscreens like manufactured products. In our case, it's not a company that produces things, it's more like a modern, postindustrial business. My favorite comparison is to a consulting firm like Arthur Andersen. They consult with auto factories, window factories, bus companies, but they really don't know anything about any of these things. In a way, I'm in the consulting business, too. There are a lot of results, but they don't have anything to do with me. I don't produce anything. Paintings are being produced in Thailand, but it's the elephants and mahouts who are doing it. It's not even a Happening or an event—it's just these elephants painting and surviving, just like anyone else."

It's a chilly evening in March, and a crowd of about three hundred exceptionally well-heeled New Yorkers are gathered in Christie's elegant ground-floor galleries at Rockefeller Center, sipping white wine and discussing bids on their cell phones. Displayed on the gallery walls are fifty paintings by elephants from Thailand, India, and Bali, each with a clipboard and pencil nearby for recording bids during the first part of the evening's festivities, a silent auction. Later the clients will gather in an adjacent room for the second part, a live auction, where they will have the opportunity to bid on such "luxury items" as a private opera recital by baritone Chris Trakas, a framed photograph by Peter Beard, a trip for two to the Lampang Elephant Art Academy in Thailand, tea and a private skin care consultation with Christy Turlington, or their very own "most wanted" painting made to order by Komar and Melamid.

Journalists from nearly every major American newspaper drift through the crowd, furiously scribbling notes on what the gallery's wall text proclaims to be "The World's First Auction of Elephant Art." Komar stands in one corner, discussing the collaborative process with a correspondent from the Franco-German broadcasting service Arte; across the room Melamid is talking to a film crew from *60 Minutes*. The reporter seems skeptical. "Aren't you imposing your own ideas about art on these elephants, forcing them to do something that they wouldn't do on their own? I mean, isn't this a kind of coercion?"

"All culture is a process of coercion," says Melamid. "They put you in school when you're five years old, you don't have a choice. They make you learn to read, to write, they make you learn to draw. In art school, we trained for maybe twelve, fifteen hours a day—we had to swallow what our teachers fed us, just like the elephants are now consuming and digesting human culture. Elephants didn't discover painting on their own, but neither did we."

"Certainly the work raises all kinds of questions. But still, I think many people are still asking themselves: Is it art?"

"I don't pretend to know what art is, and I don't know why people believe in it, but I know that they do. It's a question of faith, maybe, needing to believe in something bigger than ourselves." Melamid hesitates. "But one thing I'm fairly sure of: if something makes you ask the question, Is it art?, there's a very good chance that it is."

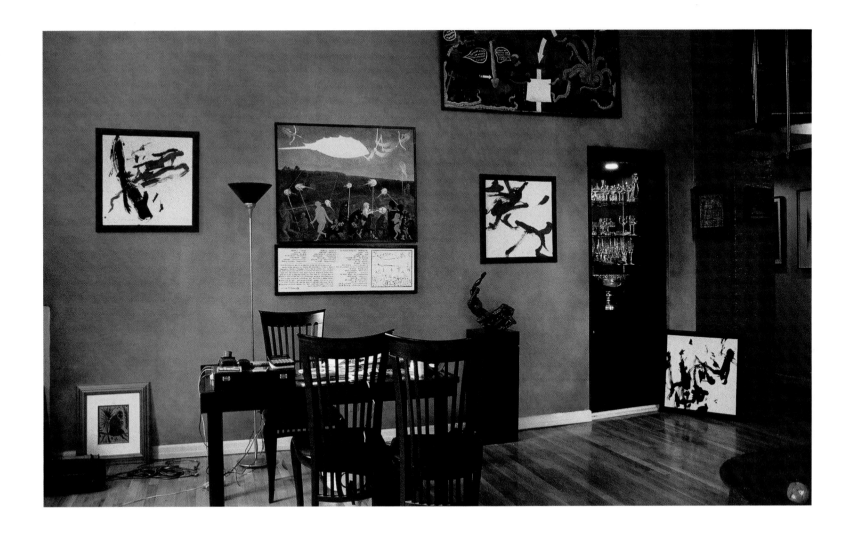

Paintings by Ramona of Bali in the home of gallerist Christine Sperber.

As the silent auction ticks down to its final moments, potential buyers scramble to pencil in their final bids, jealously guarding the clipboards next to their favorite paintings. A group of four friends who have pooled their meager resources triumphantly enters a final bid of $500—their firm upper limit—for a colorful painting by Bird of Ayutthaya. As they work out a tentative schedule for rotating the painting among their various abodes, they notice a man in a gray suit striding toward them purposefully, pencil in hand, his eyes trained on the wall behind them. Anxious glances shoot back and forth among the group. They could form a barricade, they could trip him, tackle him—four on one, no problem—or . . . "I heard a rumor that this one was actually done by a human," whispers the twelve-year-old son of one of the bidders. The man in the gray suit stops dead in his tracks. He squints at the painting for a moment, then casually saunters away.

The next morning Komar and Melamid are back in their studio, exhausted and giddy. The auction has succeeded far beyond their wildest hopes, raising a staggering $75,000 to be divided among the various regional outposts. Half of the proceeds will go toward basic living expenses for the elephants and their mahouts, improved facilities, art supplies, donations to local elephant-related charities, the other half toward special projects—a milk bank for orphaned elephant calves, a mahout training school in Lampang (see sidebar, p. 98).

All fifty paintings offered at Christie's found buyers, with prices ranging from $350 to $2,200. And bearing in mind that the financial value of a painting is determined almost entirely by

MILK BANK AND MAHOUT TRAINING SCHOOL

With funds raised at the Christie's auction, the Asian Elephant Art and Conservation Project plans to open a Milk Bank in Thailand to provide proper formula to elephant calves that are either orphaned or weaned too early. Prematurely weaned calves are often fed either a very poor milk substitute (such as boiled rice and bananas) or human-formula powdered milk, which is extremely difficult for calves to digest; such elephants suffer a shockingly high mortality rate. The Milk Bank would supply, through the auspices of local NGOs and government agencies, powdered milk formulas as well as a milk substitute. Supplies would include peripheral equipment such as nipples, tubes, food supplements (iron pills, cod liver oil), and also a booklet directed at elephant owners explaining the importance of proper sanitation and feeding techniques.

Another major effort under way is the Mahout Training School, which is designed to help address the problem of the rapidly declining quality of mahouts in Thailand and elsewhere. Located at the Thai Elephant Conservation Center in Lampang, the School will receive students from Malaysia and Indonesia, countries which have little or no tradition of keeping elephants. The School will feature accommodation for up to ten students, housing for teachers and staff, and a large teaching room. Funds from the AEACP will be applied toward scholarships, audio-visual teaching aids, and publications to be disseminated among mahouts.

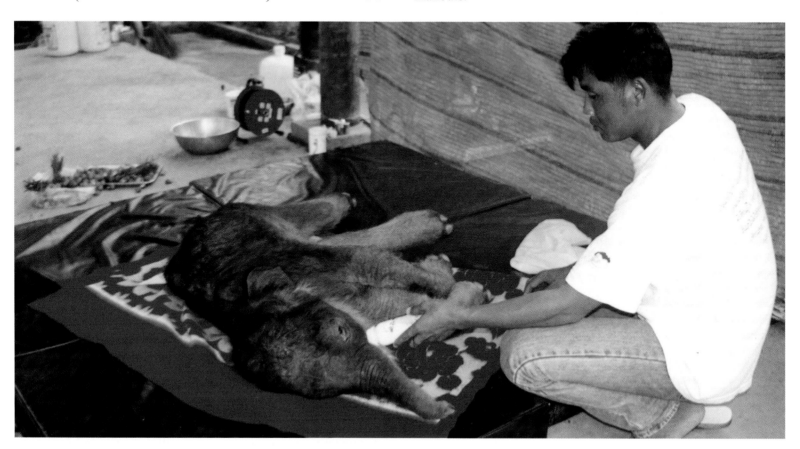

Bottle-feeding an orphaned calf.

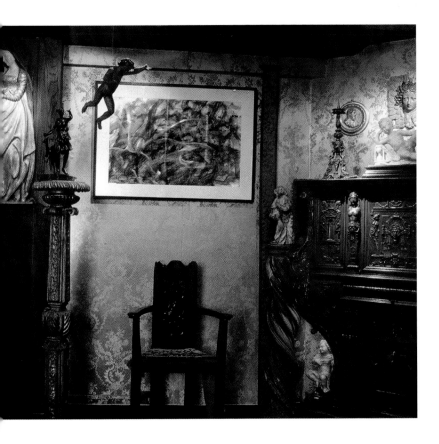
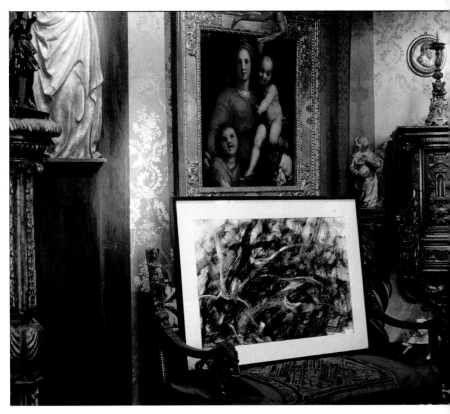

ABOVE LEFT: *A painting by Ganesh in the home of collector Stuart Pivar.*
ABOVE RIGHT: *Masterpieces by Ganesh and Pontormo in the home of collector Stuart Pivar.*

the market, by what people are willing to pay for it, the auction was a remarkable coup, not only for the Asian Elephant Art and Conservation Project but for the future of elephant art in general.

The highest bid was drawn by a handsome blue and gray abstraction painted by Ganesh, a five-year-old elephant based in Kerala, India. The winning bidder was Stuart Pivar, a wealthy collector, longtime friend of Andy Warhol, and founder of the New York Academy of Art, a small operation in Tribeca devoted to promoting the rather anachronistic style of academic realism. Melamid picks up the framed painting, which he and his partner have promised to hand-deliver and install, and they head for the subway.

Pivar, a thin, gray-haired man in his late fifties, opens the front door of his Upper West Side apartment and escorts the artists into a cavernous living room decorated with an eclectic mix of nineteenth-century salon paintings, medieval statuary, Renaissance furniture, and the gem of his collection, a fifteenth-

century panel painting depicting the Holy Family by the Italian master Pontormo. Pivar clears a space amid the clutter for his latest acquisition, which Komar and Melamid solemnly raise and mount to the wall. They take a few steps back and gaze at the work with hushed admiration.

"I never dreamed it would come to this," says Melamid after a few minutes. "An elephant painting hanging side by side with a priceless masterpiece by Pontormo! In a way, it proves the idea that great art—art that we can really believe in—is always tied to the miraculous. In the case of traditional Western art, like Pontormo, a painting should depict a miracle of God, something going beyond the human to the divine. Today, art doesn't have to depict a miraculous event—now the painting itself is the miracle."

"With elephant painting," says Komar, "we have art in its purest state—art that walks out of the museum and into the world."

"People can laugh at us," Melamid adds. "They can dismiss it all as a stupid joke, a travesty, a hoax. But let's not forget that art is not a tragedy, not a drama—it's a circus.

"And what is a circus without animals and clowns?"

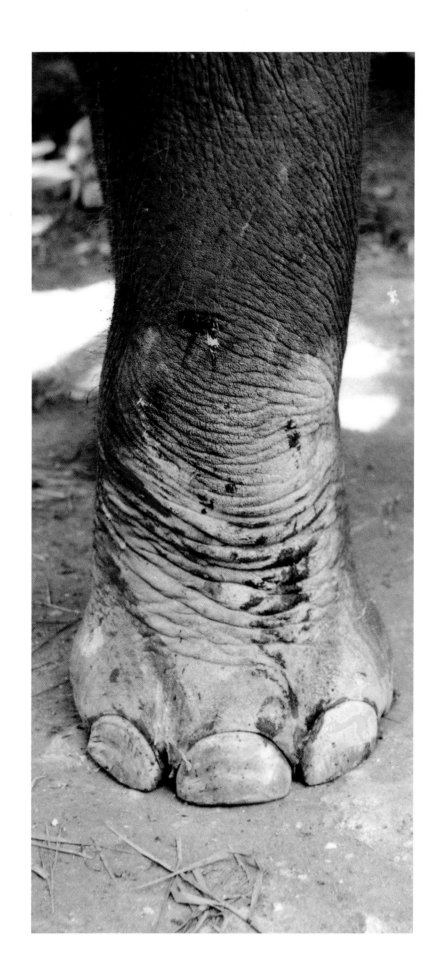

PHOTOGRAPHIC CREDITS